Artists for the Shah

Artists for the Shah

Late Sixteenth-Century Painting at the Imperial Court of Iran

ANTHONY WELCH

New Haven and London, Yale University Press

1976

Published with assistance from Prince Sadruddin Aga Khan,
Abby W. Grey, and Grey
Art Gallery and Study Center.

Library of Congress catalog card number: 75-18188
International standard book number: 0-300-01915-7

Designed by John O. C. McCrillis
and set in Times Roman type.
Printed in the United States of America by
The Murray Printing Co., Westford, Massachusetts.

Published in Great Britain, Europe, Africa, and Asia (except Japan)
by Yale University Press, Ltd., London.
Distributed in Latin America by Kaiman & Polon,
Inc., New York City; in Australia and New Zealand by Book & Film
Services, Artarmon, N.S.W., Australia; in Japan by
John Weatherhill, Inc., Tokyo.

To my parents

Contents

List of Illustrations ix

Preface xv

1. Historical Background 1

2. Siyavush the Georgian 17

3. Sadiqi Bek 41
 The Early Years, 41 The Later Years, 54
 Literary Works, 70 Artistic Works, 75

4. Sadiqi and Riza 100

5. Personalities and Patronage 150
 Ibrahim Mirza, 150 Isma'il II, 158 Muhammad
 Khodabandah, 163 Royal Princes and
 Princesses, 167 Tajik and Qizilbash Patrons, 171
 Provincial Patrons, 175 Shah 'Abbas I, 178
 Self-employed Artists, 185

6. Patrons and Artists 189

Appendixes 203

Selected Bibliography 221

List of Indexed Painters and Calligraphers 225

Index 227

Illustrations

FIGURES

1. *Rustam lassoes Kamus.* Siyavush. From the 1576–77 *Shahnamah.* Private collection, Great Britain. 23
2. *Isfandiyar kills the simurgh.* Siyavush. From the 1576–77 *Shahnamah.* Rothschild Collection, Paris. (Illustration from G. Marteau and H. Vever, *Miniatures persanes exposées au Musée des Arts Decoratifs,* Paris, 1912.) 24
3. *Khusraw enthroned.* Aqa Mirak. From the 1539–43 British Museum *Khamsah.* British Museum Or. 2265, fol. 6ov. (Illustration from L. Binyon, *The Poems of Nizami,* London, 1928.) 27
4. *A battle.* Siyavush. From the 1579 *Habib al-Siyar.* Present location unknown. (Illustration from *Sale Catalogue,* Octave Homberg Collection, 1931, lot 92.) 29
5. *Lion attacking a horseman.* Siyavush. Circa 1578. Walters Art Gallery, Baltimore. 31
6. Detail of figure 5. 33
7. *Two youths under a tree.* Siyavush. Circa 1590. Topkapi Palace Museum, Istanbul, H. 2135, fol. 11b. 34
8. *Archer attacking a dragon.* Siyavush. Circa 1590. Musée National du Louvre, Paris. 36
9. Detail of figure 8. 37
10. *Two men asleep in a landscape.* Attributed to Siyavush. Circa 1595. Present location unknown. (Illustration from E. Blochet, *Les enluminures des manuscrits orientaux de la Bibliothèque Nationale,* Paris, 1926, plate 74.) 39
11. *Portrait of Timur Khan Turkman.* Drawn by Sadiqi in 1593–94 and finished by Mu'in Musavvir in 1684. Oriental Institute of the Academy of Sciences, Leningrad. 63
12. *Garshasp fights the dog-heads.* Sadiqi. From the 1573

Garshaspnamah. British Museum Or. 12985, fol. 45b. (Photograph courtesy of Ellen Smart.) 76

13. *Bahram Gur shoots an onager.* Muzaffar 'Ali. From the 1539–43 British Museum *Khamsah,* Or. 2265, fol. 211. (Illustration from L. Binyon, *The Poems of Nizami,* London, 1928.) 77

14. *Zal before Rudabah's castle.* Sadiqi. From the 1576–77 *Shahnamah.* Collection of Ralph Benkaim, Beverly Hills, California. 81

15. Detail of plate 5. 82

16. Detail of plate 5. 83

17. *An outdoor entertainment.* Sadiqi. From the 1579 *Habib al-Siyar.* Present location unknown. (Illustration from *Sale Catalogue,* Octave Homberg Collection, 1931, lot 92.) 84

18. *A seated princess.* Sadiqi. Circa 1578. Private collection, Cambridge, Massachusetts. 87

19. *A young man offers wine to a young woman.* Attributed to Mirza 'Ali. Circa 1575. Museum of Fine Arts, Boston, 14.595. 88

20. *Two young men.* Attributed to Shaykh Muhammad. Circa 1575. Musée National du Louvre, Paris. 89

21. *Young woman.* Sadiqi. Circa 1580. Bibliothèque Nationale, Paris, sup. pers. 1171, fol. 32a. (Illustration from E. Blochet, *Musulman Painting,* London, 1929, plate 140.) 91

22. *Seated young man with sprig of flowers.* Sadiqi. Circa 1590. Bibliothèque Nationale, Paris, sup. pers. 1171, fol. 44b. (Illustration from I. Stchoukine, *Les peintures des manuscrits de Shah 'Abbas I à la fin des Safavis,* Paris, 1964, plate 29.) 92

23. *Seated young man with wine cup.* Sadiqi. Circa 1590. Bibliothèque Nationale, Paris, sup. pers. 1171, fol. 3b. (Illustration from E. Blochet, *Les enluminures des manuscrits orientaux de la Bibliothèque Nationale,* Paris, 1926, plate 81.) 93

24. *Seated man.* Sadiqi. Circa 1595. Museum of Fine Arts, Boston, 14.636. 95

25. Detail of figure 24. 96

26. Detail of figure 24. 97

27. *Animal sketches.* Attributed to Sadiqi. Circa 1595. Private collection, Cambridge, Massachusetts. 98

28. *Man on horseback attacked by a dragon.* Attributed to Sadiqi. Circa 1595. Collection of Prince Sadruddin Aga Khan, Geneva. 99

29. *Day-dreaming young man.* By Riza. Circa 1590. Fogg Art Museum, Harvard University, Cambridge, Massachusetts, 1952.7. 102

30. *Woman with beads.* By Riza. Circa 1590. Museum of Fine Arts, Boston, 14.614. 103

31. Detail of plate 8. 109

32. Detail of plate 9. 110

33. Detail of plate 9. 111

34. *Yusuf and his brothers.* Attributed to Shaykh Muhammad. From the 1556–65 Freer *Haft Awrang.* Courtesy of the Smithsonian Institution, Freer Gallery of Art, Washington, D.C., 46.12. 113

35. Detail of plate 10. 115

36. *Faridun crosses the Ab-i Darya.* Attributed to Riza. From the 1587–97 *Shahnamah.* Chester Beatty Library, Dublin, MS 277. 116

37. *Zal before Rudabah's castle.* Attributed to Sadiqi. From the 1587–97 *Shahnamah.* Chester Beatty Library, Dublin, MS 277. 118

38. *King Sarv, his daughters, and the three sons of Faridun.* Attributed to Sadiqi. From the 1587–97 *Shahnamah.* Chester Beatty Library, Dublin, MS 277. 119

39. Detail of plate 11. 121

40. Detail of plate 11. 123

41. *Jandal before Sarv.* Anonymous follower of Riza. From the 1587–97 *Shahnamah.* Chester Beatty Library, Dublin, MS 277. 124

42. *A king visits a hermit.* Sadiqi. Folio 10a from the 1593 *Anvar-i Suhayli.* Figures 42–55 all in the collection of the Marquess of Bute. 127

43. *Two birds fighting.* Sadiqi. Folio 17a from the 1593 *Anvar-i Suhayli.* 128

44. *Animals in a landscape.* Sadiqi. Folio 38a from the 1593 *Anvar-i Suhayli.* 130

45. *A king in the mountains.* Sadiqi. Folio 28b from the

1593 *Anvar-i Suhayli*. 131

46. *Birds in a nest*. Sadiqi. Folio 20b from the 1593 *Anvar-i Suhayli*. 133

47. *The husband cuts off his wife's nose*. Sadiqi. Folio 52a from the 1593 *Anvar-i Suhayli*. 134

48. *A king visits a hermit*. Sadiqi. Folio 309a from the 1593 *Anvar-i Suhayli*. 135

49. *A stork in a night sky*. Sadiqi. Folio 55b from the 1593 *Anvar-i Suhayli*. 136

50. *A simurgh*. Sadiqi. Folio 85a from the 1593 *Anvar-i Suhayli*. 137

51. *A dragon in the mountains*. Sadiqi. Folio 227b from the 1593 *Anvar-i Suhayli*. 138

52. *Two men by a stream*. Sadiqi. Folio 40b from the 1593 *Anvar-i Suhayli*. 139

53. *A king with a wounded woodcutter*. Sadiqi. Folio 313a from the 1593 *Anvar-i Suhayli*. 140

54. *The tortoise and the ducks*. Sadiqi. Folio 83b from the 1593 *Anvar-i Suhayli*. 141

55. *A woman weaving*. Sadiqi. Folio 22a from the 1593 *Anvar-i Suhayli*. 144

56. *A monkey-trainer*. Attributed to Riza. Circa 1595. Private collection, Cambridge, Massachusetts. 146

57. *Man in a landscape*. Sadiqi. Circa 1600. Private collection, Iran. (Illustration from *Hunar o Mardom*, n.s., no. 51, Tehran, 1966.) 148

58. *Zahhak enthroned*. Naqdi. From the 1576–77 *Shahnamah*. Collection of Prince Sadruddin Aga Khan, Geneva. 207

59. *Jandal before Sarv*. Naqdi. From the 1576–77 *Shahnamah*. Present location unknown. (Illustration from G. Marteau and H. Vever, *Miniatures persanes exposées au Musée des Arts Decoratifs*, Paris, 1912.) 208

60. *Zal presented to Sam*. Naqdi. From the 1576–77 *Shahnamah*. Metropolitan Museum of Art, New York, 34.72. 209

61. *Bizhan captured in Manizhah's chambers*. Naqdi. From the 1576–77 *Shahnamah*. Chester Beatty Library, Dublin, MS 256. 210

62. *Tahmuras fights the demons*. Murad Daylami. From the 1576–77 *Shahnamah*. Chester Beatty Library, Dublin, MS 256. 211

63. *Faridun crosses the Ab-i Darya.* Mihrab. From the 1576–77 *Shahnamah.* Chester Beatty Library, Dublin, MS 256. 215

64. *Rustam attacks an opponent.* Mihrab. From the 1576–77 *Shahnamah.* Collection of Prince Sadruddin Aga Khan, Geneva. 216

65. *Court scene.* Burji. From the 1576–77 *Shahnamah.* Present location unknown. (Illustration from G. Marteau and H. Vever, *Miniatures persanes exposées au Musée des Arts Decoratifs,* Paris, 1912, plate, 103.) 217

66. *The battle of Kay Khusraw and Afrasiyab.* 'Abdullah Shirazi. From the 1576–77 *Shahnamah.* Chester Beatty Library, Dublin, MS 256. 218

67. *Youth and old man.* Muhammad Isfahani. Circa 1565–75. Topkapi Palace Museum, Istanbul, H. 2156, fol. 20a. 219

68. *Young man and woman.* Muhammad Isfahani. Circa 1565–75. Topkapi Palace Museum, Istanbul, H. 2156, fol. 161b. 220

COLORPLATES

following page 78

1. *Zal and Rustam before Kay Khusraw.* Siyavush. From the 1576–77 *Shahnamah.* Metropolitan Museum of Art, New York, 35.48.

2. *Piran confers with Kamus and the Khaqan of Chin.* Siyavush. From the 1576–77 *Shahnamah.* Collection of Prince Sadruddin Aga Khan, Geneva.

3. *Firdawsi and the court poets of Ghaznah.* Muzaffar 'Ali. From the 1573 *Garshaspnamah.* British Museum Or. 12985, fol. 5a.

4. *Afrasiyab confers with Pashang.* Sadiqi. From the 1576–77 *Shahnamah.* Collection of Prince Sadruddin Aga Khan, Geneva.

5. *Faridun receives the ambassador from Salm and Tur.* Sadiqi. From the 1576–77 *Shahnamah.* Collection of Prince Sadruddin Aga Khan, Geneva.

6. *Young man in a blue cloak.* Riza. Circa 1587. Fogg Art Museum, Harvard University, Cambridge, Massachusetts, 1936.27.

7. *Young woman in green.* Riza. Circa 1587. Courtesy of

following page 78

the Smithsonian Institution, Freer Gallery of Art, Washington, D.C., 32.9.

8. *Rustam kills the white elephant.* Attributed to Riza. From the 1587–97 *Shahnamah.* Chester Beatty Library, Dublin, MS 277.

9. *Faridun spurns the ambassador from Salm and Tur.* Attributed to Riza. From the 1587–97 *Shahnamah.* Chester Beatty Library, Dublin, MS 277.

10. *Tahmuras fights the demons.* Attributed to Riza. From the 1587–97 *Shahnamah.* Chester Beatty Library, Dublin, MS 277.

11. *The simurgh carries Zal to her nest.* Attributed to Sadiqi. From the 1587–97 *Shahnamah.* Chester Beatty Library, Dublin, MS 277.

12. *A bird in a storm.* Sadiqi. Folio 16a from the 1593 *Anvar-i Suhayli.* Collection of the Marquess of Bute.

13. *Two men in a market.* Sadiqi. Folio 265a from the 1593 *Anvar-i Suhayli.* Collection of the Marquess of Bute.

14. *Isfandiyar kills two kylins.* Naqdi. From the 1576–77 *Shahnamah.* Collection of Prince Sadruddin Aga Khan, Geneva.

15. *The murder of Iraj.* Murad Daylami. From the 1576–77 *Shahnamah.* Chester Beatty Library, Dublin, MS 256.

16. *Isfandiyar kills two lions.* Murad Daylami. From the 1576–77 *Shahnamah.* Collection of Prince Sadruddin Aga Khan, Geneva.

Preface

Painting is one of the oldest and most vital traditions of Iranian culture. It is also one of the more widely appreciated Iranian art forms in the contemporary world. But in terms of both public awareness and scholarly investigation it has lagged far behind the art of painting in Europe. As a result, the systematic examination of the development of Iranian painting casts a pale shadow beside scholarly research into European painting, and a definitive history of painting in Iran has yet to be written. Much excellent work has been done, however. Valuable surveys have been published, fine exhibitions assembled, thorough catalogues produced, and stimulating articles written. This work has exposed the richness of Iranian art to a wider purview and laid the basis for further study.

I have attempted here to build on the pioneering work done by many scholars in this field by examining in detail a single period in the history of Iranian painting. I have necessarily focused on its key painters and patrons in order to reconstruct both the careers of these men and the social structure in which they worked. The period from the death of Shah Tahmasp in 1576 to the transfer of the Iranian capital from Qazvin to Isfahan in 1598 is a crucial time of transition in Iranian painting and in itself warrants close study. But it is also a period rich in literary and visual sources that make possible an intense scrutiny of particular painters and patrons. Partly because of the abundance of information, I have been occupied in this study with several problems concurrently—the basic identification of artists' works, fundamental biographical investigation, and the examination of patrons and their methods of supporting arts.

I have been working on this study since the summer of 1970. Large parts of it appeared in my 1972 doctoral dissertation for Harvard University, and I am indebted to that institution for the 1970–71 traveling fellowship that enabled me to complete much of my research. Further research in the summer of 1972 was aided by a grant from the University of Victoria, whose assistance in this and many other respects I gratefully acknowledge.

I owe thanks, of course, to the many museums, libraries, and

private collectors who allowed me to examine their treasures and reproduce them here. I owe a debt of great thanks to the following for their generous financial subventions which allowed me to provide this book with so many colorplates: Prince Sadruddin Aga Khan and Abby W. Grey and the Grey Art Gallery and Study Center.

I am indebted to a number of scholars who have either read my manuscript or discussed its problems with me and who have provided extremely helpful criticism: Lisa V. Golombek, Oleg Grabar, Basil Gray, B. W. Robinson, John M. Rosenfield, and S. C. Welch. To S. C. Welch and Martin B. Dickson I am also indebted for a manuscript copy of their forthcoming publication, *The Houghton Shahnamah,* and for their generosity in providing me with important information about Sadiqi Bek's *Qanun al-Suvar,* which will appear translated in its entirety there. I am grateful to three scholars— Manoutchehr Mohandessi, Jerome W. Clinton, and Roy P. Motta- hedeh—for their kindness in correcting and polishing my transla- tions from Sadiqi Bek's *Majma' al-Khawass.*

This enumeration of gratitude would be quite incomplete if I did not mention Yale University Press. In particular, I must thank the following: Dana Pratt, whose enthusiasm for Islamic culture and the arts of Iran was vitally encouraging; Anne B. Wilde, whose careful suggestions helped shape this book; and Judy Metro, who found flaws I had never suspected and excised them with admirable precision.

In the interests of the wider reading public I have omitted formal diacritical marks in transliterating Persian names and terms. I have nevertheless tried to make these words easily recognizable to scholars. Where both Muslim and Christian dates were useful, I have included the Muslim in parentheses following the Christian.

Specific debts are more easily acknowledged than fundamental gratitudes, but to my wife, Muriel, and our children, Nicholas and Bronwen, I owe more than I can say for sustaining me through the hours, weeks, and years it has taken to produce this book.

A.W.

29 December 1975
Victoria, British Columbia

Artists for the Shah

1. Historical Background

When a fourteen-year-old youth was crowned Shah of Iran in 1501, he became not merely one of this ancient land's youngest monarchs but also the first ruler of a dynasty which was to lead Iran through one of the richest and most celebrated periods of its history. The young king's name was Isma'il I, and his Safavi dynasty was one of the most unusual in Muslim history.

Its founder had been a holy man, Shaykh Safi al-Din (1252–1334), who was the spiritual leader of a Sufi religious order in northwestern Iran. During the fourteenth and fifteenth centuries Shaykh Safi's descendants, retaining his mantle of holiness, expanded his order until it became a powerful force, militant in devotion to its leader. The order coexisted only tenuously with the Turcoman tribes who dominated the fragile political structure of fifteenth-century Iran; more frequently it was at odds with them.

In midcentury the Safavis distanced themselves from Islam's prevailing religious orthodoxy, Sunnism, by adopting Shi'ism, a major Muslim sect which particularly stressed the role of the Prophet Muhammad's son-in-law 'Ali, from whom the Safavis themselves claimed descent. The adoption of Shi'ism was crucial. While orthodox Sunnis, the majority of Iran's population at the time, regarded the Safavis with increased suspicion, Shi'a tribes, largely Turkish-speaking, from Iran, Anatolia, and the Near East migrated to join the order in what they hoped would be a millenarian expansion of the Shi'a state. Some tribes, like the Shamlu, came from as far away as Syria. Others, like the Afshar, were already at home in northwestern Iran. All were united in fervid adherence to the personal leadership of the Safavis.

Spurred by both ambition and the threat of annihilation, the Safavis and their followers embarked on a vigorous military campaign in 1499 under the leadership of Isma'il (1487–1524), a visionary and charismatic youth who had inherited the leadership of the order when his father was murdered by political opponents. Within two years most of northwestern Iran had come under his sway, and he was crowned shah in Tabriz in 1501. Shi'ism was established as the state religion of Iran, and Isma'il I began the mili-

tary expansion of his empire to the east and west. Within ten years the Safavis controlled an area approximately the size of modern Iran.

Isma'il's accession was a break with Iran's Muslim past. In its early history the land had functioned as one part of a larger Muslim unity. Later, in the eleventh century, as the physical unity of Islam dissolved, Iran came under the control of Turkish-speaking rulers who had established a feudal state, decentralized and dependent upon a complex hierarchy of secular relationships. It was the dissolution of these patterns into anarchy in the fifteenth century that enabled the Safavis to come to power, and though they too were Turkish-speaking rulers, they introduced a new governmental system in which religious and political powers would eventually be centralized in one figure, the shah. But it was not easily achieved, and the struggle to replace a feudal system with a unitary nation-state marked the reigns of five Safavi shahs during the whole sixteenth century.

Isma'il's reign was turbulent. His followers, as we are told by contemporary European observers, accorded him almost divine status. Convinced of success and the easy access to paradise which death in battle promised, they gained decisive victories throughout Iran and made it possible for Isma'il to defeat archrivals such as the Uzbek Shaybani Khan who had occupied northeastern Iran. Isma'il's steady succession of victories and his vigorous personality kept tribal rivalries under control. But in 1514 superior Ottoman forces at Chaldiran decisively defeated the Safavi army and massacred thousands of Shi'a tribesmen. Humbled, Isma'il lost more than territory. The impetus of conquest was gone, the charismatic aura was shattered, and control over his Shi'a followers was drastically weakened. For the next and last ten years of his life he rarely led his troops but held uneasy court in Tabriz over the fragile coalition on which his power depended.

Despite the difficulties of his later reign the monarch had time for other matters, and in the tradition of Iranian monarchs he sought to perpetuate his memory through patronage of architecture, calligraphy, painting, and the other arts. Few buildings are known from his reign, and none of them marks a striking departure from the past. Like other contemporary monarchs in the Muslim world Isma'il shared enormous admiration for the works of the great late

fifteenth- and early sixteenth-century painter Bihzad, who had spent most of his life in Herat, the cultural capital of northeastern Iran. Near the end of the aged painter's career Isma'il even induced him to move to Tabriz, where he exerted a vast influence on Isma'il's manuscript painters.

Isma'il I died in 1524. He was succeeded by his son, Tahmasp, who was only ten years old. Refined and well educated, with a passion for the arts of painting and calligraphy, Tahmasp possessed nothing of his father's personal strength, courage, or charisma. Even Isma'il had found it difficult to control the unruly tribes under his aegis; for the young boy the task was impossible. The first two decades of his reign he was largely under the domination of feudal lords from various factions who struggled with each other at the expense of Iran's unity. Ottomans in the west and Uzbeks in the east took advantage of the unsteady situation. Persian-speaking Iranians, generally referred to as Tajiks, chafed under the increasingly despotic leadership of the Turkish-speaking tribesmen whose distinctive red headgear inspired the Ottomans to nickname them Qizilbash or "red-heads." Extremist religious groups also struggled for larger followings and more authority.

The young shah could not hope to control these anarchic forces, and for twenty years he rarely tried. He turned instead to art as a kind of refuge from the threatening world around him. Under his patronage the art of the precious book—the most refined and personal of Iran's Islamic arts—flourished as seldom before in the Muslim world, and a succession of sumptuous manuscripts was produced through the collective efforts of a superb assemblage of artistic talent. On his painters and calligraphers Tahmasp lavished attention and great wealth, and while the emerging political order of the Safavis veered dangerously close to extinction, its artists enjoyed almost unprecedented patronage.

The situation did not last. After twenty years of brilliant patronage of this highly personal art the thirty-year-old shah turned his attentions to the political situation he had so long neglected. He began to assert his own authority, not through personal sway over his followers but rather through craft and stealth. Rival tribes were skillfully played off against one another, and the shah rapidly became adept at politics. With dogged persistence he slowly eroded the authority of the great feudal lords and increasingly established

the central power of the shah in both religious and secular affairs.
In his policies, pursued intensely over the next thirty years, Tah-
masp set forces at work which were to result eventually in the firm
establishment of a centralized, autocratic nation-state at the end of
the sixteenth century.

The shah's reign of fifty-two years is of key importance in com-
prehending not only politics but the development of the arts in
sixteenth-century Iran. Though Tahmasp's long reign and complex
personality have vital bearing on the history of Iranian art before
1550, his patronage affects the second half of the century only in-
directly, and then more by its absence than by its presence. For after
1544 this gifted shah, whose energetic patronage had joined with
Iran's most talented painters, calligraphers, bookbinders, and illu-
minators to create most of the century's finest manuscripts, had
withdrawn from the cultivation of the arts and the aesthetic passions
of his youth and early manhood.

It was a thorough transformation. The monarch engaged in care-
ful, formal pieties. He issued prohibitions against wine, fornication,
and music, all among his chief youthful pleasures, and he avoided
the company of painters and panegyrical poets. In the latter part of
his life he seems to have become especially addicted to ablutions. He
took frequent baths, had his nails cleaned regularly, and observed
what he ate with meticulous care, sometimes deciding while chewing
a morsel that it was unclean and spitting it out with revulsion. He
cultivated an aura of holiness and gained an undeserved reputation
as a saint. Sadiqi Bek, the great late sixteenth-century painter, poet,
chronicler, and courtier, had known the shah and later wrote of him
with a mixture of sympathy and tongue-in-cheek "respect":

> [Shah Tahmasp] had such an inherent talent that his words
> were full of wit and humor. His whole life long he was able to
> speak in rhythmical words, when he chose to. . . . [The late
> shah] paid a great deal of attention to the 'ulama' [learned
> scholars in the laws and teachings of Islam] and pious men and
> men of talent. . . . Although he did not always speak in poetry,
> still, the jewels which sometimes fell from the sea of his poetic
> nature were like adornments for the ears and necks of men's
> thoughts. Below is one of his quatrains:
> > For a time we were tainted with the dust of luscious rubies,
> > For a time we grew dusty on the track of emeralds.

> But all this was a sort of pollution.
> Then we washed in the water of repentance
> and became calm.[1]

Sadiqi gives only hints of the monarch's change of life style. But writing in 1616, the cautious chronicler Iskandar Munshi, one of the most important sources for sixteenth-century history, describes the transformation succinctly:

> His Majesty was very friendly with this group [of artists]; whenever he was at leisure from the business of government and the cares of state, he would devote his attention to practicing painting, but in the latter part of his reign the multitude of his occupations left him no leisure for such work, and he paid less attention to the work of those masters, who bestowed life on the beautiful forms produced by their mixing of colors. Some of the officers of the library who were still alive were permitted to practice their art by themselves.[2]

Perhaps the shah's abnegation of the arts was not total. Our chronicler says simply that he "paid less attention" to the work of his artists. In any case his interest and patronage were apparently severely curtailed, and the results were crucial for the development of Iranian painting. Iskandar Munshi's last sentence is the most intriguing. Who were the officers of the library "who were still alive"? If they were allowed to practice their art, who gave them their livelihood? Did the shah allow other princes and nobles to step in as patrons? Or did the artists support themselves by selling their works to the highest bidder? How did the absence of the shah's patronage affect the kind and quality of art produced? The questions are numerous, but a look at some of the individual artists, poets, and scribes may yield at least partial answers.

By 1550 the shah's interest in the arts was apparently at a very low ebb. In that year he dismissed his grand vazir (chief minister of state) Qazi-yi Jahan, a noted patron of painting and calligraphy in his own right whose influence on the formation of Tahmasp's taste and the composition of the royal atelier is not yet known. Two years

1. Sadiqi Bek, *Majma' al-Khawass,* ed. 'Abdulrasul Khayyampur, pp. 8–9. English translations from this text are my own.
2. Iskandar Munshi, *Tarikh-i 'Alam-ara-yi 'Abbasi,* p. 174. English translation from T. W. Arnold, *Painting in Islam,* p. 141.

later he died, and his family was disgraced.[3] The shah's favorite brother, Bahram, who might have filled the patronage gap, had died in 1549. Tahmasp's two sons—Muhammad, age nineteen, and Isma'il, age seventeen—may have helped sustain some of the artists, but this is only a supposition. Bahram's son, Ibrahim Mirza, who was later to emerge as one of the great art patrons of the second half of the sixteenth century, was only six years old, and though his sponsorship during 1556–65 of the *Haft Awrang* manuscript of Jami was incredibly precocious, it seems unlikely that he had a role in the arts already.

Many of the artists simply left the country. The emigration of painters, calligraphers, doctors, poets, illuminators, bookbinders, and scholars from Iran during the second half of the sixteenth century was almost staggering. The perceptive official and chronicler Qazi Ahmad,[4] who wrote in the late sixteenth and early seventeenth centuries, and Sadiqi mention dozens of artists, craftsmen, and scholars who despaired of the sparse remuneration in Iran and left in search of a better future and fortune. If there were measures to prevent the educated elite from leaving the country, they were ineffective, for the large-scale emigration continued from the 1550s to the beginning of the twentieth century. The cumulative loss to Iran was awesome. The gain to other countries, in particular India, was enormous. How much of the decline of Iranian culture in the seventeenth century can we attribute to this cause? And how much of the shifting of the axis of Iranian culture from Iran to India is due to this migration?

Although the emigration affected all the arts, it seems to have been most pronounced among the poets of Iran. Shah Tahmasp had enjoyed the company of poets in the early years of his reign, but by the late 1540s, when his interest in painting and calligraphy was waning, he also drew away from the court poets, in particular the panegyrists. The shah's increasing austerities and ritualistic pieties were so severe, in fact, that they encouraged a notable change of poetic forms: from producing panegyrics of Iran's rulers, the celebrated Safavi poet Muhtasham turned to writing poems in praise of

3. The fall from grace was only temporary. Qazi-yi Jahan's son Sharaf-i Jahan rose to prominence again and was a noted poet at the end of the sixteenth century. "Among the great men and the sons of great men of Qazvin there are few who are his equal. He interested himself in composing poetry and now is famed as a poet" (Sadiqi Bek, *Majma'*, pp. 39–40).

4. Qazi Ahmad, *Calligraphers and Painters,* trans. V. Minorsky.

the Prophet and the holy Imams. He was rewarded accordingly, retaining Tahmasp's favor and sponsoring a whole new class of Safavi poetry.

Apparently other poets did not learn the lesson so well or were less able or willing to change their mode of expression. These men left the court, some seeking out provincial rulers, and others leaving Iran for India, Turkey, or Uzbekistan. The wealth of India was proverbial, and for poets out of favor at the Safavi court, it must have been all too tempting. Whereas a Safavi poet might at one time have been paid twenty to thirty tomans for a *qasidah* in praise of the shah,[5] there are instances of a Mughal ruler weighing a poet in gold. Others, whose eulogies excited less lavish enthusiasm, were still richly recompensed in jewels, lands, and titles.

Many poets, artists, and scholars were drawn to the Deccan, in particular to the court of Nizam Shah. Sadiqi's praise of him is rich:

> He was a ruler skilled in conversation and noble in spirit. Among the sultans of India none was such a lover of Persians ['Iraqi] and a worshipper of the Mughals as he. It was for this reason that when people of talent went from here, they took refuge with him, unless Fate drew them toward Humayun of India.[6]

Humayun's role in establishing Iranian influence in India is well known. His short exile at the Safavi court in 1544 appears to have neatly coincided with Shah Tahmasp's loss of interest in the arts. When he returned to India he drew numerous artists and literati with him, and more were to follow. The Mughal admired the paintings of Mir Musavvir, and first that artist's son Mir Sayyid 'Ali came to India and then the older artist himself. The painter 'Abd al-Samad moved to India too. Poets, scholars, astrologers, and Sufi shaykhs joined the exodus from Iran.

By all accounts Humayun was an appealing man with considerable gifts as a patron and as a leader. Even to Sadiqi, writing fifty years after the emperor's death in 1555, his was a great name:

> He was a ruler possessed of limitless generosity and munifi-

5. Often rendered in English as "elegy," the *qasidah* is a long poem usually consisting of more than twelve verses, each of which ends in a rhyme which is preserved throughout the poem. Subject matter is varied, and many celebrated qasidahs deal with panegyrical, satrical, religious, or didactic themes.

6. Sadiqi Bek, *Majma'*, p. 18.

cence and of noble temperament and good taste. He was exceedingly interested in the ornamentation and adornment of the library. After Abu'l-Ghazi Sultan Husayn Mirza very few kings among the dynasty of Chaghatay padshahs resembled him in charm of temperament.[7]

The process by which Iran was stripped of so many of its talented men continued throughout the sixteenth century. That the culture still flourished despite this depletion reveals how extraordinarily rich it must have been during the first two decades of Tahmasp's rule.

At least some poets were bitter about leaving Iran. Mawlana Qasim Kahi, who wrote a famous chronogram commemorating Humayun's death,[8] composed the following apprehensive verse:

> O Kahi, thou art the nightingale which adorns the garden of Kabul;
> Thou are not a crow and a kite to go to Hindustan.[9]

Apparently others felt that they were being used unfairly and that the shah cared more for painters and calligraphers than he did for poets. One poet complained bitterly:

> The scribe, the painter, the Qazvini, and the ass
> Obtained easy promotion without trouble.

And on a less sarcastic and more poignant note another bard lamented:

> My wine is pure, but the possessors of sympathy are devoid of taste;
> My gold is unalloyed, but the banker of speech is blind.[10]

The flight of poets to India, to both the Mughal and Deccani courts, which competed fiercely for what Iran was rejecting, continued unabated throughout the sixteenth century. Shah 'Abbas (r. 1587–1629) was no better a patron than Tahmasp in this respect, and the relative paucity of fine literature in Iran after 1500 is a reflection, at least in part, of the lack of enthusiastic and creative

7. Ibid., pp. 31–32.

8. E. G. Browne, *A Literary History of Persia,* 4:169–70.

9. M. A. Ghani, *A History of Persian Language and Literature at the Mughal Court,* 2:62.

10. Browne, *Literary History of Persia,* 4:97. Ghani, *Persian Language and Literature,* 2:167.

patronage. Except for Muhtasham and Hakim Shifa'i, India attracted all the best Persian poets.

For India it was, of course, a great boon, and the creative impetus in Persian literature shifted from Qazvin and Isfahan to Lahore and Agra. The new literary style in Iran in the sixteenth century was the Sabk-i Hindi, the Indian style. It was now Iran that listened to India's genius.

Shah 'Abbas's Indian contemporary, Akbar (r. 1556–1605), had a close companion, adviser, and "ghost writer," Abu'l-Fazl, who was of Persian extraction. Abu'l-Fazl's older brother, Fayzi, brought up and trained by the Khorasani Khwajah Husayn Mervi, was the great master of the Sabk-i Hindi and was the poet laureate of the Mughal court. His poetry was well known in Iran, but Sadiqi did not like it.

> [Fayzi] is the brother of Shaykh Abu'l-Fazl, who is one of the notables of India and an intimate of His Excellency Jalal al-Din Akbar Padshah. His pen name is Fayzi, and he is very pleased with his own poetry and prides himself on his style. It seems his 'Iraqi fellow poets were, out of respect and awe of him, unable to criticize his poetry, since he has chosen some very odd poems from his *diwan* [collected poetical works] and has sent them to 'Iraq.[11]

Fayzi was far from alone at the Mughal court; many Persian poets were there with him. Iranians now, however, went to India and sent their verses home. What a change from previous centuries when poetry emanated from Herat and Shiraz and traveled to India!

The emigration was not quite so pronounced among the calligraphers and painters, but it was still significant. Qazi Ahmad tells us that the calligrapher Mir 'Ali, one of the leading figures of late Timurid and early Safavi culture, wrote a poem in praise of Babur, who between 1526 and 1530 was carving out the early Mughal empire in northern India.[12] Mir Mansur, the pupil of Mawlana Dervish, one of the great early Safavi calligraphers, became the scribe of Babur's son, Humayun, in 1544 and left Iran to return to India with him. Mirza Muhammad Husayn, the son of a noted official under Shah Tahmasp, was also a fine calligrapher but left Iran to find em-

11. Sadiqi Bek, *Majma'*, p. 52. The use of the word *'Iraq* here refers to central and western Iran.

12. Qazi Ahmad, pp. 128–29.

ployment at the Mughal court. Both Mawlana Maqsud and Maw-
lana Muhammad Amin Mashhadi could not find suitable support in
Iran and left to work in India.[13] The list could go on and on.

The wealth that could fall to a calligrapher's lot in India is illus-
trated by the good fortune of the late sixteenth–early seventeenth-
century Mir Khalilullah, the nephew of the scribe Mir Muhammad
Husayn Bakharzi. Having become acquainted with the Safavi Shah
'Abbas I in Mashhad in 1595, the aspiring scribe gave the Iranian
monarch some lessons in calligraphy and returned with him to the
capital city of Qazvin. Despite these initial indications of favor, the
shah's patronage did not develop as fully as Mir Khalilullah appar-
ently felt he deserved. Evidently leaving Qazvin with a vow to prove
his true worth, the calligrapher went to India and settled at the
Deccani court of Ibrahim 'Adil Shah II in Bijapur. The Indian
monarch was famed for his lavish rewards for artistic talent, and
after a number of years at his court Mir Khalilullah had the satisfac-
tion of sending Shah 'Abbas a gift of Indian jewels valued at two
hundred tomans, a huge sum.[14]

Many scribes, painters, poets, and scholars were compelled to
follow similar peregrinations. Qazi Ahmad's famous teacher, Mir
Sayyid Ahmad, was for a long time honorably employed with the
Uzbeks in the east, but he eventually was well received at Tahmasp's
court. He was even given the important task of writing the letters
addressed to the Ottoman sultan and to the Turkish officials and
governors near Iran. Midway through his career, however, appar-
ently about 1550, he incurred the shah's anger. He was not only dis-
missed from his post, but according to Qazi Ahmad, he was also
required to repay all the salary he had received in the shah's service.
The outrageous penalty nearly ruined him. By selling some of his
property he managed to reimburse the shah. Though he initially
planned to leave for India, he retired instead to Mashhad and con-
tinued doing some scriptorial tasks for the shah there. In 1556 his
good fortune returned. Murad Khan of Mazandaran, who had met
the Mir in Mashhad, invited him to his court, and the calligrapher
stayed there for several years, returning to Mashhad again some
time before Tahmasp's death in order to see his own children. On
the accession of Shah Isma'il II in 1576 Mir Sayyid Ahmad was

13. All discussed by Qazi Ahmad.

14. Qazi Ahmad, p. 150. For the value of the toman see Walther Hinz, "The
Value of the Toman in the Middle Ages" in *Yadnama-i Minorsky* [Minorsky
memorial volume] (Tehran, 1969), pp. 90–95.

called back to Qazvin in great honor, and on that monarch's demise in 1577 he returned again to Mazandaran, where he died the next year.[15] Even for one of Iran's most celebrated calligraphers, life had not been easy.

India was also a refuge for artists in trouble with the authorities. The court painters 'Abd al-'Aziz and 'Ali Asghar "eloped" with one of Shah Tahmasp's favorite page boys and started out for India, where they were apparently sure of hospitable welcome, even though they had counterfeited the shah's seal on the way. The tacit alliance between the Safavi and the Mughals did not, it seems, include a treaty of extradition, and had they not been caught before they reached the Iranian border, they would almost certainly have been given a warm reception at the Mughal court.[16]

The same course was followed by Hakim Rukna, a physician, calligrapher, and poet at 'Abbas's court who was "always present with Abu'l-Ghazi 'Abbas, the padshah," and who was "a good drinker and graceful walker . . . and spoke every sort of poetry.[17]

> When there appeared some deterioration in the sovereign's health, Rukna was dismissed and requested to repay his salary. He had to liquidate his property and for a couple of years lived in Kashan practicing medicine. Then he went on pilgrimage to Mashhad where the shah paid no attention to him, and when the sovereign left for Balkh [in 1598], Rukna with his children took the way to India.[18]

There, despite his previous "malpractice," he was successful and became court physician to Jahangir.

No scribe, scholar, physician, or poet enjoyed a secure profession. A change of taste or a minor offense could banish him from the court and make it difficult to find other employment. Punishments could be financially crippling, and the principal alternative seems to have been the long and hazardous journey to India.

Painters too left the Safavi court, and their influence in India was a crucial factor in the development of Mughal painting. One of the foremost was Mir Sayyid 'Ali, the son of the great master Mir Musavvir. Father and son worked on the Houghton *Shahnamah* for years, and Mir Sayyid'Ali also contributed five paintings to the cele-

15. Qazi Ahmad, p. 140.
16. Sadiqi Bek, *Majma'*, pp. 254–55.
17. Ibid., p. 53.
18. Qazi Ahmad, p. 169.

brated 1539–43 *Khamsah* of Nizami.[19] His talents were evidently not fully appreciated, and he made enemies:

> [Mir Sayyid 'Ali] is the son of Mir Musavvir who in his own art excelled his peers and was one of the workers in the library of the late shah [Tahmasp].
>
> The Mir was also a very gifted painter. Because of a small annoyance he left 'Iraq for India and attained high rank under Jalal al-Din Akbar.
>
> They say that an estrangement arose between the Mir and Mawlana Ghazali and that each one disparaged the other; and the Mir drew a caricature of Ghazali. Due to this discord both of them were hurt.[20]

Soon afterward Mir Sayyid 'Ali moved to India. He was later joined by his father, and both painters died there.

Even Mawlana Ghazali, cruelly lampooned and offended by Mir Sayyid's caricature, abandoned the Safavi court for the richer fields of India and left behind a biting verse that indicates all too clearly his reason for departing:

> I am going to India, for there
> The affairs of clever people march nicely,
> Whereas liberality and generosity run away from the
> men of this time
> Into black earth.[21]

19. The *Shahnamah* (*Book of Kings*) of Firdawsi (940–1020) was probably written during the years 980–1010. Consisting of more than 60,000 verses, this superb epic poem is the first great masterpiece of classical Persian literature. Dealing with the heroic exploits of Iran's pre-Islamic champions and kings, it served as the model for dozens of later Iranian epics. It is the most frequently illustrated Iranian book. The most impressive of the Safavi *Shahnamahs* was produced about 1525–45 under the patronage of Shah Tahmasp. By any estimation it is one of the supreme achievements of Islamic art. About one-quarter of its 258 illustrations are in the Metropolitan Museum of Art, New York. The remainder, as well as the splendidly illuminated text, are in the possession of Arthur Houghton.

Nizami of Ganjah (1140–1202/03) is a towering figure of Iranian literature. His *Khamsah* (*Five Books*) ranks as one of the greatest poetic works in Persian. It consists of five long mathnawi poems: the *Makhzan al-Asrar* (*Treasury of Mysteries*), the *Romance of Khusraw and Shirin*, the *Romance of Layla and Majnun*, the *Romance of Iskandar*, and the *Haft Paykar* (*Seven Images*). Although there are many superb copies of the *Khamsah* and of its individual books, the 1539–43 *Khamsah*, produced under the patronage of Shah Tahmasp and now in the British Museum, is probably the finest ever created.

20. Sadiqi Bek, *Majma'*, pp. 97–98.

21. Qazi Ahmad, p. 185.

Of the three groups—poets, painters, and calligraphers—the painters seem to have emigrated in smaller numbers than the others. A few may have gone to the Uzbeks in the northeast, as did Shaykh Zadah about 1530, and some went west to the Ottomans. Shah Quli was a Persian artist who gained fame under the Ottomans; so too was Wali Jan. We know that Husayn Bek, the illuminator, and Qasim 'Ali, the bookbinder, also went to Istanbul, and there, with Wali Jan, became very successful.

But the Ottoman court was far less attractive than the Mughal. In our major sources the only clear mention of a calligrapher who went to Istanbul is Mawlana Ibrahim, son of the great scribe Malik Daylami, and he was a political and religious refugee.[22]

The clear choice for artists and literati compelled by politics or disfavor or lack of patronage to leave Safavi Iran was India, and it was to be a refuge for dissatisfied or maltreated Iranians for the next three centuries.

If Shah Tahmasp's austerity toward the arts at midcentury was discouraging to many of those who had flourished during the first two decades of his reign, it was at least not an attitude which he rigorously imposed on those around him. As a result there were other patrons in the imperial family who filled part of the gap, and their roles will be examined later. In particular, his gifted nephew Ibrahim became a patron of the greatest distinction in the art of the precious book, though his scope and resources were necessarily more limited. Even at its height the atelier under his aegis was composed of fewer painters and calligraphers than had worked for the youthful Shah Tahmasp. And only one manuscript—the Freer Gallery's celebrated *Haft Awranq* of Jami[23]—shares the superb quality of Tahmasp's great books, and the dates of its production, 1556–65, apparently define the limits of the prince's patronage.

The aging shah died in 1576, but the patterns set during his reign continued to influence politics and arts under his successors and

22. Ibid., p. 145.
23. Mulla Nur al-Din 'Abd al-Rahman Jami (1414–92) is generally considered to be the last great master of classical Persian literature. His *Haft Awrang* (*Seven Thrones*) consists of seven long poems in rhymed couplets. The most well known of them is the *Romance of Yusuf and Zulaykha* in which the love of Zulaykha for the beautiful Yusuf becomes the vehicle for Jami's exploration of the human being's relationship to God and the soul's yearning for proximity to the divine. The other six poems of his great work also deal with religious and ethical themes.

made the late sixteenth century one of the most turbulent periods in Iranian history.

In the last quarter of the century three successive shahs ruled over a country whose feudal and tribal organization practically defied effective control. The military aristocracy, which owed allegiance to the kings, was locked in fratricidal conflicts and until the last decade of the century paid Iran's ruler only the most nominal obeisance. The country's economy was shaky; many members of its intellectual and artistic elite were emigrating; and the impressive cultural achievement of the first decades of Safavi rule was in danger of abrupt termination.

It was a dislocating time for many Iranians, among them the artists and intellectuals whose previous sources of patronage were disrupted. Large numbers of Iran's most talented artists and men of letters took advantage of the traditional mobility within and between Islamic societies and left Iran for better prospects elsewhere. The borders between neighboring empires were open to men of talent and learning who wished to pass from one king's aegis to another's. Iran's two great neighbors—the Ottoman and Mughal empires—shared with the Safavis the same court language, Persian. And both Turkey and India made enormous efforts to attract the most able and gifted Iranians in all fields. Throughout this Turkish–Iranian–Indian world artists, poets, physicians, writers, and soldiers of fortune moved continuously in search of more stable conditions and more liberal rulers.

Historically, the years from 1576 until 1600 were characterized first by great instability and then by ruthless stabilization. Tahmasp's two elder sons—Isma'il II (r. 1576–77) and Muhammad Khodabandah (r. 1577–87)—came to the throne, and their two reigns brought the Safavi regime to near extinction. The latter's son, 'Abbas I (r. 1587–1629) restored the monarchy not to its former condition of feudal overlordship but rather to a new position of power as the focal point of a highly centralized, autocratic, and bureaucratic government.

Similarly, during the later years of the reigns of Shah Tahmasp and his two sons, manuscript patronage, which in the first seventy years of the century was carefully cultivated by patrician rulers of excellent taste and refined sensibilities, existed in the unsteadiest of conditions, almost wholly dependent upon the patron's whim and the stability of his government. But under 'Abbas I at the end of the

century we find this very patrician patronage altered and kings no longer acting as the supreme arbiters of national taste. The transfer of Iran's capital from Qazvin to Isfahan in 1597–98 marked not only a determined change in the social and governmental structure of the country but also a turning point in the arts in Iran.

These years at the end of the sixteenth century are therefore a transitional period of great significance, and the lives and works of its three major artists are valuable keys for understanding it. Siya-vush, Sadiqi Bek, and Riza were all men of high skills, and their work not only delineates the course of late sixteenth-century art history but also reveals the stunning artistic richness of the period.

Each of these three men represents a different cross section of patronage in sixteenth-century Iran. Siyavush, an artist "discovered" by Shah Tahmasp himself, flourished at the royal court and spent his entire career in service to four successive monarchs.

Sadiqi, a Qizilbash warrior by birth and upbringing, came to art late and struggled hard to make his way into the artistic establishment arount the shah. He achieved high standing under Isma'il II, lost ground under Muhammad Khodabandah, and became head of the royal atelier under 'Abbas I. In addition to being a painter, he was also a gifted and engaging writer whose literary works will be examined in some detail.

Riza, acknowledged in his own day as the greatest living master of painting, represents still a third strand. The scion of a gifted and favored artistic family and himself endowed with superb abilities, he came naturally to the court of Shah 'Abbas I as a youthful prodigy who could outshine all the traditional stars. He functioned briefly and spectacularly as a painter of royal manuscripts, but his basic character was too independent for this reliant role, and he rebelled against it. He was an active painter until his death in 1635, but since the main concern of this study is with the late sixteenth century, only the first half of his career will be considered.

All three painters knew each other, and at one time or another they collaborated on the same manuscripts or shared the same patrons. Near the end of their lives both Siyavush and Sadiqi fell under the influence of a younger man's style, and that man was Riza.

Although this study's terminal date, 1600, falls in the middle of 'Abbas's reign and Riza's career, it is an appropriate end point. With the Iranian capital now firmly established in Isfahan it is the

best date for marking the beginning of the new Isfahan style of painting. It also marks the advent of a new kind of monarch. 'Abbas was not a chief aristocrat presiding over an uneasy assemblage of feudal lords. In Isfahan he was an autocrat, directing the affairs of a highly centralized government and military organization whose control rested firmly in his hands alone. The sixteenth century's last twenty-five years delineate the movement of the Iranian monarchy from feudal overlordship to "enlightened despotism," —in politics *and* in art. Royal patronage, which under Shah Tahmasp and Ibrahim Mirza was centered on that most refined and sophisticated of the court arts—the precious book—received under 'Abbas I in Isfahan a broader base: the arts were no longer simply aesthetic means for personal fulfillment but effective statements of national convictions and important tools in Iran's economic growth. For the young Tahmasp, life's abiding passion had been art. For Shah 'Abbas I, this passion was clearly politics.

2. Siyavush the Georgian

Of the three major painters of the late sixteenth century—Siyavush, Sadiqi Bek, and Riza—only Siyavush seems to have passed placidly through the turbulence which was engulfing both the political and artistic life of Iran. From the scanty information available it seems clear that Siyavush spent almost his entire life under the royal aegis. Working from early childhood to old age in the ateliers of the shahs, he lived under four different monarchs, and, as far as can be deduced, thrived under each. A painter of high gifts and evident deligence, Siyavush is a key figure for our understanding of this period.

Two of our sources provide useful information about him. Qazi Ahmad, the bulk of whose treatise on calligraphers and painters was finished in 1596/97 (1005), devotes a short paragraph to him:

> Siyavush Bek was a slave of Shah Tahmasp. He came from Georgia and, while he was still a child, the shah assigned him to the *naqqashkanah* [atelier of painters]. He studied under Mawlana Muzaffar 'Ali and excelled in portraiture. In this work he is a rare phenomenon, in view of the expressive force of his *qalam* [brush] and his power of design. Now he has abandoned that occupation and does not work any more. As one of the royal *ghulams* [servants], together with his [Georgian] countrymen, he is now in Shiraz and is employed on [various] commissions, but he is a good artist.[1]

Writing some twenty years later in 1616, Iskandar Bek Munshi confirms some of Qazi Ahmad's information and adds some new facts of his own:

> Siyavush Bek the Georgian has been a page of his late Majesty [Shah Tahmasp], who having observed in him signs of ability gave him opportunities for the study of painting, and

1. Qazi Ahmad, *Calligraphers and Painters*, p. 191. The final sentence is a later comment by the author from a "second edition" prepared in 1606 (1015). It strongly implies that some Safavi painters retired from the royal atelier in the capital city to the pleasant provincial art center of Shiraz. The influence of aging court artists may be one of the principal factors for the virtual merging of the metropolitan and Shiraz styles in the sixteenth century.

he became a pupil of Master Hasan 'Ali, the painter; when he
had acquired some ability in that art, the fine work of his brush
made an impression on His Majesty, so that he himself looked
after his being instructed. While he was a pupil of His Majesty
he made excellent progress. He painted some very delicate and
fine work, and was an incomparable painter. In the reign of
Isma'il Mirza he was put on the staff of the library, and in the
time of the Nawwab he and his brother Farrukh Bek were ad-
mitted to the confidential circle of the fortunate prince, Sultan
Hamzah Mirza. In the reign of his present Majesty, the Shadow
of God, they both died after having been in his service for
a long time².

From these short accounts it is possible to reconstruct a rough
chronology of the painter's life.

Siyavush was a Georgian, a member of the largely Christian
minority in northwestern Iran who were to become among the most
steadfast supporters of the Safavi royal house in the seventeenth
century. The words "he came from Georgia" imply that the painter
was born there and was not the child of Georgian parents residing
at the Safavi court. It seems most likely that he was born about
1536/37 (943) and was taken as a young slave to Tabriz in 1544,
where he became, according to Iskandar Munshi, a page to Shah
Tahmasp himself.³ Still an active patron of manuscripts at that time,
Tahmasp noticed the potential artistic talent of his young servant
and assigned him to the tutelage of Hasan 'Ali, a noted painter and
calligrapher.⁴

2. Iskandar Munshi, *Tarikh-i*, p. 176; translation from Arnold, *Painting in Islam*,
p. 143.

3. This dating can be made with a fair, though not absolute, degree of pre-
cision. The Safavis conducted extensive military campaigns against the recalcitrant
Georgians on seven different occasions during Shah Tahmasp's reign: 1540/41
(947), 1543/44 (950), 1551 (958), 1554 (961), 1556 (963), 1560/61 (968), and
1568/69 (976). According to Iskandar Munshi, Tahmasp himself spotted Siyavush's
talent, something with which the shah would probably not have troubled himself
after 1548, about the time in which his interest in painting waned. Therefore, born
around 1536/37, Siyavush was forcibly brought to the royal court in 1543/44,
where he served first as a page and then, while still a child, was transferred into
the atelier for training.

4. In his treatise on painters finished in 1546, the painter and calligrapher Dust
Muhammad briefly mentioned Hasan 'Ali as a notable painter of his day (L. Binyon,
J. V. S. Wilkinson, and B. Gray, *Persian Miniature Painting* [1933; reprinted, New
York, 1971], p. 187). But this Hasan 'Ali is apparently not to be confused with any
of the following: the calligrapher Hasan 'Ali (Qazi Ahmad, pp. 140–41); the painter

He must have progressed rapidly, for the shah soon transferred him to the care of one of his most favored painters, Muzaffar 'Ali. It was a great honor and opportunity for the Georgian youth, since Muzaffar 'Ali had always been close to the shah and had at this point worked on two of the greatest Safavi manuscripts—the Houghton *Shahnamah* and the British Museum *Khamsah* of Nizami. Although Siyavush remained under the nominal guidance of the great patron–monarch himself, his real training was accomplished under Muzaffar 'Ali, who was also responsible for the instruction of Sadiqi Bek.

Both apprentice artists must have watched their master's work closely, though neither was at this point practiced enough to assist him in his painting. Despite the fact that the shah's interest in painting waned about the middle of the century, Muzaffar 'Ali still held his position in the royal atelier and probably continued to train his two gifted protégés until his own death in 1576/77. Both Qazi Ahmad and Iskandar Munshi held Siyavush in very high esteem, and we can assume that he was already an accomplished and productive artist by the time he came under the patronage of the short-lived Shah Isma'il II and produced his first ascribed, firmly dated work in the 1576/77 *Shahnamah*. At this time he was about forty years old, a mature and valued artist who had literally grown up in the naqqashkhanah.

During the reign of the inadequate and nearly blind Muhammad Khodabandah (1577–87) he continued to enjoy royal favor: both he and his brother Farrukh were "in the confidential circle" of Hamzah Mirza, the talented heir to the throne who was assassinated in 1586 during a campaign against the Turks.

Under Muhammad Khodabandah's son and successor, Shah 'Abbas I, Siyavush also fared well, although none of the major manuscripts produced under this monarch's patronage contains work which can be attributed to Siyavush. But he was not long active under 'Abbas. By 1596–97, when Qazi Ahmad had finished writing his entry on Siyavush, the painter had "abandoned that occupation" and was no longer working, although the author's second edition of 1606 adds that the artist was still alive and engaged on various commissions in Shiraz. Some time during the next decade Siyavush died, for Iskandar Munshi, writing in 1616, mentions his and his brother's deaths.

Hasan Naqqash (ibid., pp. 186–87); or the malevolent painter Hasan Muzahhib (ibid., p. 189; Iskandar Munshi, p. 177; Sadiqi Bek, *Majma'*, pp. 257–58).

Nothing is known of Siyavush's earliest work under the tutelage
of Muzaffar 'Ali, and we must begin our study of his art when he
was presumably about forty years old. In 1576 Isma'il II became
shah after an unsettling political struggle following the death of
Shah Tahmasp. Though his reign was turbulent and earned him an
unsavory historical reputation, he was evidently a patron of some
vision who set out to restore the Safavi atelier to its former greatness.
His reign was too short to do so, but he did bring together in Qazvin
an impressive array of talent, and available sources indicate that
fifteen painters were at work in his atelier: 'Ali Asghar, Zayn al-
'Abidin, Siyavush, Sadiqi Bek, Murad Daylami, Naqdi Bek, Mihrab,
Burji, 'Abdullah Shirazi, Khwajah Nasir, Shah Muhammad Isfahani,
Shaykh Muhammad, Hasan Muzahhib, Muhammadi, and Farrukh
Bek.

Of these men the first nine collaborated in the production of a
great copy of the *Shahnamah,* surely intended to be Isma'il II's con-
tribution to the tradition of sumptuous Safavi manuscripts. Al-
though it was dispersed by the French dealer Demotte shortly after
the First World War, it has been possible to locate fifty-two minia-
tures from the manuscript. All of them illustrate scenes in the first
half of the *Shahnamah,* and as a result it seems clear that the manu-
script was never finished. The life of the king was abruptly cut short,
either by murder or by an overdose of drugs, after he had reigned
for about eighteen months. A large manuscript, its pages measured
some forty-three by thirty centimeters. Its scribe was a gifted master
of *nasta'liq,* and its nine illustrators were the leading younger paint-
ers of the royal atelier, men for the most part a generation younger
than the painters who had supplied the twenty-eight miniatures for
the 1556–65 Freer *Haft Awrang.* With almost all the older masters
dead, Isma'il II had to draw on their students in order to refurbish
the royal atelier, weakened by Shah Tahmasp's pious neglect of the
arts.[5]

5. The cursive *nasta'liq,* invented in the early fifteenth century by Mir 'Ali
Tabrizi and perfected in the early sixteenth century by Mir 'Ali Haravi and Sultan
'Ali Mashhadi, is one of the most frequently utilized scripts in Iran.

The 1576–77 *Shahnamah* for Shah Isma'il II has been discussed in A. Welch,
Catalogue of the Collection of Islamic Art of Prince Sadruddin Aga Khan,
1:169–78; A. Welch, "Painting and Patronage under Shah 'Abbas I," *Studies on
Isfahan, Iranian Studies* 7 (1974): 458–507; A. J. Arberry, E. Blochet, B. W. Rob-
inson, and J. V. S. Wilkinson, *The Chester Beatty Library, A Catalogue of the
Persian Manuscripts and Miniatures,* 3:256 (entry by B. W. Robinson); B. W. Robin-

Siyavush played a large role in the illustration of the manuscript. Of the fifty-two known miniatures, thirteen are his work, more than twice Sadiqi's contribution of six paintings. It seems clear that the two senior students of Muzaffar 'Ali (the only two whom our sources mention) dominated the project, and it leads one to suspect that the old master himself, known to have died not many months after Tahmasp's demise, may have been the initial director of the *Shahnamah* for Isma'il II. He would also understandably have favored his two major pupils.

Not all Siyavush's work in the 1576–77 *Shahnamah* can be discussed in detail here, but four key paintings will be examined closely in order to gain an understanding of his work.

The first of these miniatures (plate 1) bears his name in the left-hand margin beneath the first branch of the tall tree.[6] Zal and Rustam have come to congratulate Khusraw on his accesssion to the throne. The new shah sits on a solid octagonal gold throne before a semicircle of warriors and attendants. The ground is a very dark green, spotted with a few flowers. In the background purple and pink rocks, containing only hints of the miniature grotesques with which earlier Safavi painters had so often peopled their landscapes, move like two large claws to crush a single tree between them. Obviously pleased with his visitors, the shah looks to the left at Zal, a paunchy, pixie-like old man whose blue-clad belly and sagging shoulders are not shown in their most complimentary profile. His son Rustam, a not too bright-looking young man with a fine-haired beard and tiny eyes, is dressed in a brown, tiger-striped coat and holds his cross-eyed bull mace between his legs. While these three principal characters are depicted with a great deal of individuality and even humor, the five attendants are similar, idealized types: round beardless faces with eyebrows that are simple black

son, *Persian Miniature Painting*, p. 62; B. W. Robinson, "Rothschild and Binney Collections: Persian and Mughal Arts of the Book," *Persian and Mughal Art* (London: P. and D. Colnaghi and Co., 1976), pp. 32–47 (hereafter referred to as Colnaghi); and in B. W. Robinson, "Isma'il II's Copy of the *Shahnamah*," *Iran* 14 (1976). Robinson has adeptly reconstructed the manuscript's original structure and has determined that it was never completed.

6. Most of these fifty-two *Shahnamah* pages bear artists' names in innocuous places. All are written in the same fine small nasta'liq, probably the hand of a contemporary librarian or connoisseur, perhaps even Isma'il II himself. I have found no reason to doubt them.

On a more general note, it became a relatively common practice in the sixteenth century to add the painter's name to a manuscript illustration. Only rarely, how-

curves. The use of color is thoroughly typical of the later Qazvin palette: the shah's flowing, red cloak is outlined in two fine curves against his blue robe, while his rich green undergarment is visible in short vertical curves at his feet. As we would expect in an artist trained by Muzaffar 'Ali, the color is more thinly applied than in early Safavi painting.

Rustam appears again in another miniature where the hero lassoes and unhorses Kamus (fig. 1). Wearing the same fine plume as in the previous miniature and riding a spotted horse plunging hard toward the left, the hero leans forward as he strains at the rope. Kamus, anxiously staring up at Rustam, is sprawled unceremoniously on the ground, his left foot tossed high in the air and his right bent painfully under him. In the center of the picture is a brilliant, eye-catching cluster of blue flowers, standing out strongly against the pale pink ground and abruptly marking the line between victor and vanquished. Siyavush's formula for grass is evident here, as in the last miniature: tufts made up of eight to ten short, calligraphic blades, the center one usually taller than the rest. In the warriors on both sides of the background hill we find a great variety of faces: two ancient men with wispy white beards; two mature soldiers, each holding a hand in front of his chest, a characteristic pose in Siyavush's work; several beardless younger men; and at the right a humorous profile of an astounded man with his eyes drawn to a slit and

ever, can we be certain that it was the artist who signed his own name. More often, as in this manuscript, the names of the different painters are written in the same hand, implying that this documentation was supplied by the owner or his librarian or the director of the manuscript project. In some cases we are also likely dealing with names applied by a later, though not necessarily modern, connoisseur. Although a historian must naturally approach such evidence with caution, this information can be invaluable.

In addition to his four miniatures discussed below, nine others are known: *Capture of Kay Ka'us by the King of Hamawaran* (reproduced in *Sale Catalogue,* Maggs Bros., London, November 1961, no. 880); *Suhrab questioning his mother Tahmina* (reproduced in Colnaghi, no. 19 xi); *Rustam and Suhrab wrestling on horseback* (Colnaghi, no. 19 xii, not reproduced); *Rustam leading his army* (reproduced in G. Wiet, *Miniatures persanes, turques, et indiennes de la collection Sherif Sabry Pasha,* Institut Francais, Cairo, 1943, pl. 33); *Siyavush and Garsiwaz* (Colnaghi, no. 19 xiii, not reproduced); *Siyavush hunting with Afrasiyab* (Colnaghi, no. 19 xiv, not reproduced); *Kay Khusraw, Farangis, and Giw crossing the Jihun River* (reproduced in Colnaghi, no. 19 xv); *Farud watching the approach of the Iranian Army* (Keir Collection, Richmond; reproduced in *Sale Catalogue,* Sotheby and Co., London, 13 July 1971, lot 354, and 7 December 1971, lot 194); *Kay Ka'us welcomes Kay Khusraw* (reproduced in Colnaghi, no. 19 xvi).

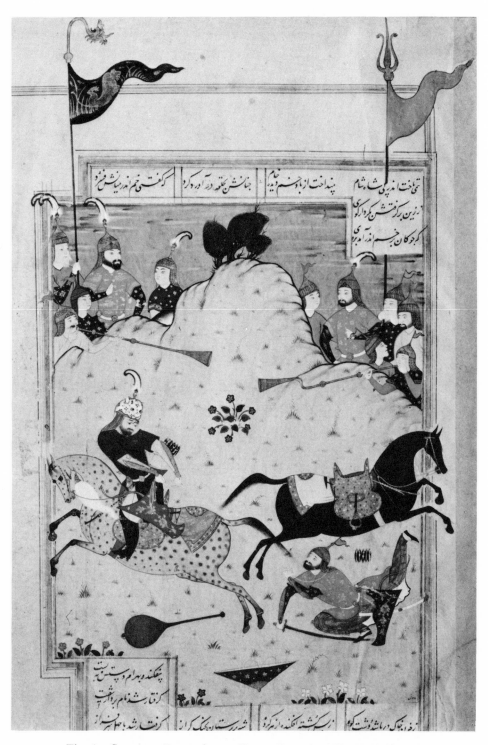

Fig. 1. SIYAVUSH. *Rustam lassoes Kamus.* From the 1576–77 *Shahnamah.*

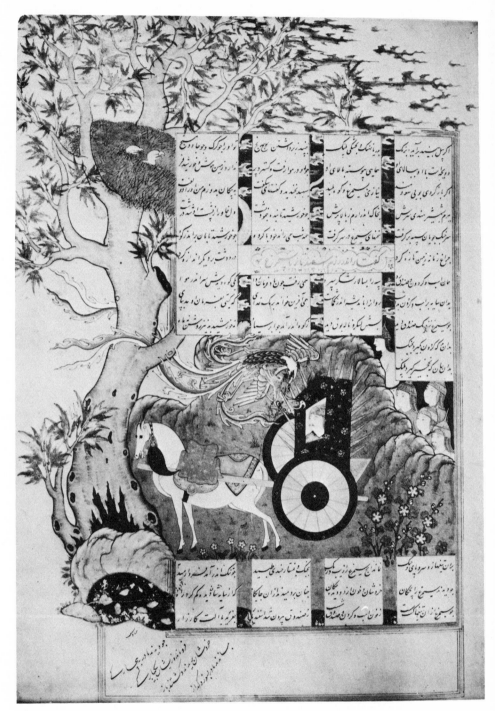

Fig. 2. SIYAVUSH. *Isfandiyar kills the simurgh*. From the 1576–77 *Shahnamah*.

his mouth hanging open. Siyavush's name appears at the lower right.

In another miniature Isfandiyar is shown killing the simurgh (fig. 2). While the mustachioed hero, looking tired and a little bored, sits impassively in his decorated tank, the simurgh impales herself violently on the projecting spikes. Blood spurts out of the bird's body, and her tail feathers curl behind her like blown flame. The great tree at the left seems to try to shield and pull back the wounded animal, while the jagged marks at the base of the tree echo her own agony on the spikes. High in the tree the simurgh's brood helplessly hears its mother's cry. This is powerful nature painting, intense in feeling and completely dominating the insignificant and unconcerned human beings below the tree.

The hero's plump white horse stands richly caparisoned and gracefully nonchalant, not even cocking an elegant ear in alarm. Behind the massive rise of rocks in the background hide five soldiers: four are the idealized types we have seen in the two previous paintings, but the fifth, shown in profile, is a toothless old man in a narrow helmet who is stuffed uncomfortably between two columns of text. He is another example of Siyavush's gift for humorous portrayals.

With the fourth and final miniature we come to a full understanding of Siyavush's work in the *Shahnamah*. Here Piran confers with Kamus and the Khaqan of Chin (plate 2). In a semicircle in front of the two kings is a dense group of twenty-six men; behind them on the hill are six others. While the king in blue is puffed up in bombastic pride and even holds his hand to his chest in the expression of defiance we noted in figure 1, the monarch in red gazes sadly with downcast eyes and fallen face as he hears Piran announce that Rustam is coming to aid the defeated Iranians. He gestures limply toward Piran, as if pleading for more encouraging news. His associate's throne is reasonably stable on its thin legs, but this king's throne wobbles and seems ready to topple him on his face. The background rocks, like those in the three other miniatures, are heavily outlined with a shaded dark line. In the center of the miniature between the two monarchs is a bright yellow quiver filled with arrows; its brilliant color leaps out from the pale purple background, like the central cluster of blue flowers in figure 1.

In the figures around the two kings we notice Siyavush's gift for individual characterization: thin faces with scraggly beards; thick faces with round, close-cropped beards; defiant faces; frightened

faces; empty-headed dolts and beautiful, moon-faced youths. None
of the many expressive gestures is repeated, and most are strikingly
distinct. We note too Siyavush's profile favorites, three of them this
time, all at the bottom of the page. One of them, slightly to the right
of center, is a beardless old man with a large nose and round chin.
Another, somewhat thinner and wearing a helmet, stands next to
him. Both are apparently toothless and seem to be telling each other
a joke in the midst of this desperate scene. Beside them is a helmeted
warrior, viewed from the back, a faceless robot. In the lower right
a fascinating face catches our attention—a man in three-quarter
pose who is wearing a turban. He has a pointed chin, pursed mouth,
fuzzy side whiskers and eyebrows, and a high forehead. He watches
the kings' dilemma with an expression implying his own awareness
of their impending fate. We find this same face repeated in another
three-guarter pose at the lower left.

From these four miniatures it is clear that Siyavush, then about
forty years old, was an accomplished master of the bright, solid
colors and curving lines which are hallmarks of the developed
Qazvin school. His compositions are carefully thought out without
being rigid and often show a tendency toward circular arrangement,
as in plates 1 and 2. He sets himself less daring compositional chal-
lenges than did the earlier master Aqa Mirak (fig. 3), and he inclines
away from the gentle, lyrical looseness of composition typical of his
own master Muzaffar 'Ali (fig. 13). His companion painter Sadiqi
Bek creates strict, almost frozen intellectual orders in his paintings
(plate 4). Siyavush is a warmer painter, in color and line as well as
in composition.

Siyavush is fascinated by people, and he avoids treating them as
ornament or filler. He not only depicts many different human types,
but he also shows a strong empathy with the people he represents.
He understands and sympathizes with the emotions at work in his
characters: Zal's slightly amused contemplation of the king in plate
1; Kamus's terror in figure 1; the dismay in the face of the red king
and the defiance in the face of the blue king in plate 2.

Muzaffar 'Ali created richly lyrical natural settings (fig. 13 and
plate 3). In Sadiqi's paintings nature forms a rather cold, decorative
backdrop (fig. 14). Siyavush avoids an ordered, ornamental land-
scape and instead invests a few elements with intense power; the
tree is being crushed between two moving claws of rock in plate 1;
the towering, almost inflamed tree in figure 2 pulls at the brilliant,

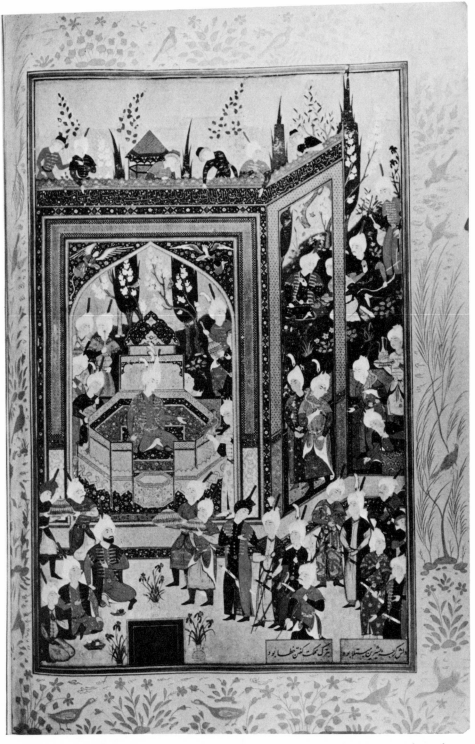

Fig. 3. AQA MIRAK. *Khusraw enthroned.* From the 1539–43 British Museum *Khamsah.*

fiery simurgh: the flowers in figure 1 leap out like jewels in a sub-
dued setting. His natural scenes do not have the overall lyricism of
Muzaffar 'Ali's but seem rather to direct their energies into a few
flamboyant outbursts, highly concentrated accents, which visually
dominate each painting.

He is also a painter with a sense of humor. His doltish youths and
toothless old men recall the comical faces in some of Sultan
Muhammad's work.[7] Siyavush's associate Sadiqi adheres almost
without fail to strictly ideal types. And though Siyavush instead in-
vests his paintings with a great diversity of faces and gestures, his
figures lack the richness of texture, modeling, and line characteristic
of the work of the best earlier masters, such as Mirza 'Ali and Sultan
Muhammad. His individuals lack a sense of depth or of convincing
personality. Although they may be humorous and sometimes almost
profound, the men who move in Siyavush's paintings seem strangely
unindividual. Even if they are not the ideal types in Sadiqi's work,
they are still types. The red king (plate 2) is a picture of anxiety and
hesitation. But he is not a convincing individual. The figures who
people the royal court in Mirza 'Ali's world most definitely are.[8]
Although Siyavush is more gifted than Sadiqi in representing the
diversity of humanity, his characters are one-dimensional and his
considerable gifts cannot round them out.

After the death of the shah, Siyavush apparently remained in
Qazvin, as did his colleague Sadiqi, in the hope that his successor
Muhammad Khodabandah would either complete the great *Shahna-
mah* begun by his younger brother or would embark on a similar
venture to establish himself as a patron of painting, an art of which
he is known to have been fond. But their hopes were not fulfilled.
Lacking royal patronage, Siyavush and Sadiqi both sought out other
connoisseurs of painting, and one manuscript testifies to the fact that
they worked for subroyal patrons. A 1579 manuscript of Khwanda-
mir's *Habib al-Siyar* was produced for one Mirza Abu Talib ibn
Mirza 'Ala al-Dawlat, who was apparently a Tajik official at the
court in Qazvin.[9] A man of some means, he commissioned a fine

7 E.g., his rendering of the beginning of the Feast of 'Id from the c. 1527 *Diwan*
of Hafiz in A. U. Pope and P. Ackerman, *A Survey of Persian Art*, [1938; re-
printed, Tokyo, 1964], pl. 900).

8. E.g., F. R. Martin, *The Miniature Paintings and Painters of Persia, India, and
Turkey*, pl. 137.

9. Published in *Sale Catalogue, Octave Homberg Collection* (Paris, Galeries
Georges Petit, 3–5 June 1931), lot 92. I have been unable to find the present loca-

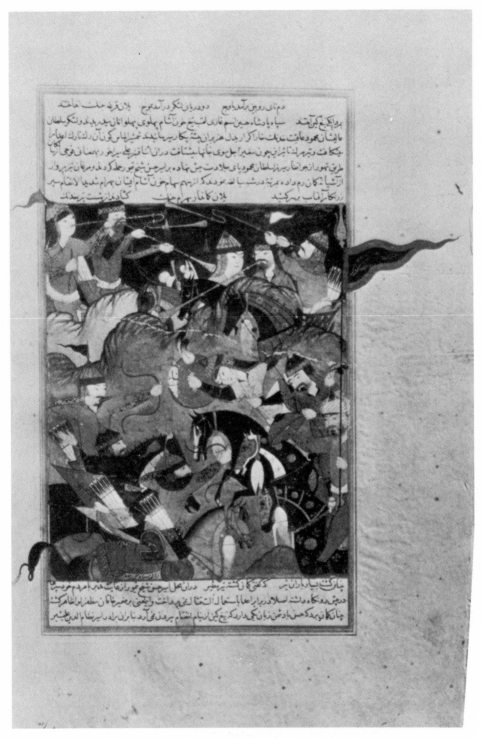

Fig. 4. SIYAVUSH. *A battle*. From the 1579 *Habib al-Siyar*.

calligrapher to write the book and painters to supply it with nine paintings. One painting—a battle scene (fig. 4),—has been supplied with Siyavush's name, while a second painting—an outdoor entertainment (fig. 17)—bears Sadiqi's. Both attributions appear to have been written by a contemporary connoisseur, probably a librarian or perhaps the owner himself (see fn. 6). A third page appears to be the work of a Shirazi master. The basic composition of Shah Isma'il II's atelier seems therefore to have survived until at least 1579. That a Tajik official is able to utilize such talent, formerly surely beyond his reach and means, is evidence of the benign neglect of Muhammad Khodabandah. This absence of exciting prospects drove the ambitious Sadiqi from the court altogether. Siyavush was more patient and, remaining in Qazvin, became associated with Prince Hamzah and stayed in his entourage until the talented young heir apparent was assassinated in 1586.

Although 'Abbas I became shah in the following year, there is no evidence that Siyavush was engaged in any of the great manuscript productions of his reign. Thus for proof of his talent as a painter we have only the contributions he made to the 1576–77 *Shahnamah* and the 1579 *Habib al-Siyar*. Fortunately these miniatures do not make up the entire corpus of the artist's work. There are four drawings which can be firmly attributed to his hand, and these additional works widen our perspective.

The first is in black ink with some light red tint (fig. 5). From some reeds at the lower left a light red lion charges out to attack a mounted horseman who is trying to defend himself with a small dagger. The landscape is dry and nearly barren. The reeds, a few tufts of grass, and two trees are the only vegetation in view. A mound of hardened earth below the lion's feet seems to support his headlong lunge at the horse and rider. In the background a red-outlined, slightly shaped rise of rocks hovers like heavy clouds over the struggle below. This is the sparse but highly charged natural setting we associate with Siyavush, whose landscapes rely on single, striking elements rather than on an overall lyrical or ornamental effect. The details are typical of his style: the grass tufts with eight

tion of this manuscript. Three paintings from the manuscript are reproduced in the above publication: one by Siyavush, one by Sadiqi, and one by Mir Muzaffar Yazdi, an otherwise unknown painter apparently trained in Shiraz. I am indebted to Basil Gray for drawing my attention to this important manuscript and to B. W. Robinson for providing me with valuable information about it.

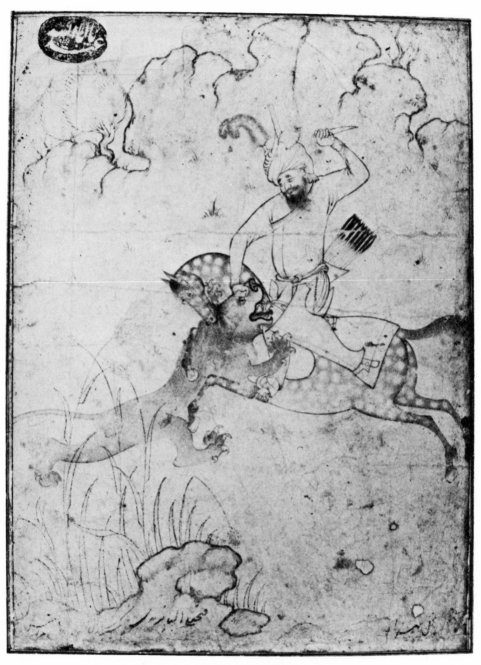

Fig. 5. SIYAVUSH. *Lion attacking a horseman*. Circa 1578.

blades and a single central blade taller than the rest; rocks outlined in a strong, though not heavy, line—an unbroken brush movement. The horse itself recalls the animals in figure 1.

What is most obviously characteristic of Siyavush's work, however, is the rendering of the victim's fear and stunned defense (fig. 6). He has been taken completely by surprise by the lion's attack, and the drooping eyes, fallen face, and raised eyebrows remind us strongly of the anxious king in plate 2. But again one feels a strange absence of personality. Fear is present as is shock and an instinctual energy of self-defense. But do we feel the same indefinable quality of "presence" that we do in Riza's painting *Young woman in green* (plate 7), or in his drawing *Woman with beads* (fig. 30), or, most strongly, in his profound drawing of a monkey-trainer (fig. 56)? Though we can acknowledge Siyavush's highly accomplished line, whether in the crisp outline of the man or in the almost painterly line in the fur of the horse and the lion, though we recognize the deliberate and highly effective concentration of natural elements, and though we have to admire his ability to render human states and conditions, we still find in his work a disturbing lack of "presence," especially in comparison with Riza's work.

The mound of hardened earth beneath the lion's feet bears the artist's name—Siyavush—in a worn but clearly indentifiable red nasta'liq. The stylistic similarities between this drawing and Siyavush's miniatures in the 1576–77 *Shahnamah* are strong enough to suggest that the drawing was done about the same time. It is thus contemporary with Sadiqi's earliest drawing—the *Seated princess* (fig. 18)—and this fact indicates not only that both painters were gifted draftsmen but also that they had specific reasons for turning out these highly polished drawings, neither of which could in any sense be considered a study. Both artists must have been drawing in order to fill definite commissions or to sell their works to the highest bidder.

Two later drawings by the artist were, however, apparently done for the shah himself. The same inscription appears on both (fig. 7 and 8): "The servant of the King of Holiness, Siyavush the Painter."[10] The first drawing shows two youths sitting under a leafy tree in an arid landscape (fig. 7). Turbans removed and shaved heads shining

10. *Ghulam-i shah-i vilayat Siyavush naqqash.* The inscription in figure 7 is written on the rock below the youth at the left. In figure 8 it is in the lower right.

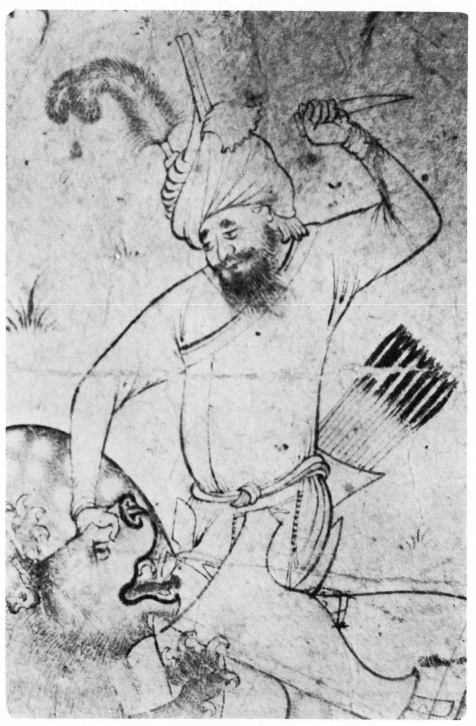

Fig. 6. SiyAvush. Detail of *Lion attacking a horseman* (fig. 5).

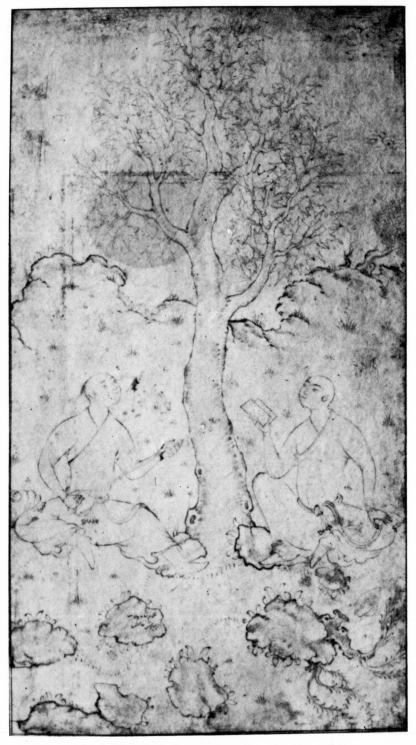

Fig. 7. SIYAVUSH. *Two youths under a tree.* Circa 1590.

in the sun, the two young men entertain themselves—one playing the oud and the other reading poetry. The easy symmetry of the composition conveys the peaceful, lyric calm of the setting. We have noted before Siyavush's gift for representing nature. Here, instead of depicting the violent energy of the simurgh's death (fig. 2) or the clawlike mountain force that is crushing a tree in its way (plate 1), he turns to a scene of man at peace in a serene setting. Siyavush's natural surroundings are most often evocative of the human passions at work in his scenes. While Sadiqi makes of nature a decorative backdrop for the actions he illustrates (plate 4), Siyavush makes nature live, though, to be sure, it lives a mirror-life, reflecting human actions rather than its own. Only Riza is able to create both living nature and living human personalities, existing in an often empathetic union with each other (plate 9).

The drawing of two youths beneath a tree by Siyavush reveals the same sensitive, delicate touch we have seen in the lion attack (fig. 5). The landscape is sparse, the nearby rocks and the background ridge all outlined in the dark, slightly shaded line we have noted before. But the line has changed. It is no longer a single, continuous movement of the brush; instead, it is broken in places and occasionally moves in a brief staccato rhythm. Staccato brushwork and almost nervous dabs of ink are one of the stylistic hallmarks of Riza (fig. 29). So too is the undulating, flowing line which we can follow along the hem of the youths' garments. The inscription to the "King of Holiness" can apply only to Shah 'Abbas,[11] and stylistically it is clear that the drawing should be dated about 1590. The fact that Riza is known to have been working in the royal naqqashkhanah by this time leads one to suspect that the differences between the drawing of two youths and the lion attack of a decade earlier are due to the influence of Riza on Siyavush.

Figure 8, Siyavush's most impressive drawing, strengthens this suspicion. From a mass of cliffs and boulders a mounted archer rushes down at a fire-breathing dragon who is tearing his way down a mountain toward a fallen man. Characteristically, Siyavush accentuates the desperate struggle below by an almost violent clash in

11. A fine early miniature by Riza (plate 6) carries the monarch's seal, reading " 'Abbas, the servant of the King of Holiness, in the year 1587" (*Bandah-yi shah-i vilayat 'Abbas sanat 995*). The year refers to the date of 'Abbas's coronation in Qazvin and not to the date of the painting's completion. The title King of Holiness refers to 'Ali, from whom the Safavis claimed descent.

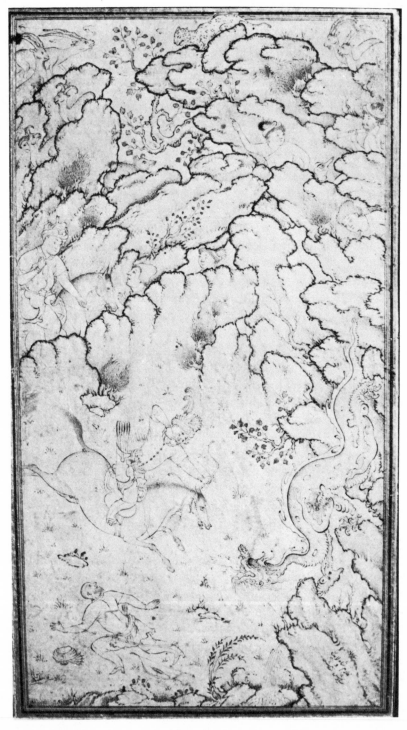

Fig. 8. SIYAVUSH. *Archer attacking a dragon.* Circa 1590.

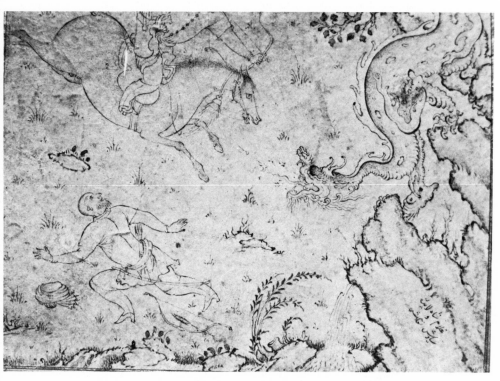

Fig. 9. SIYAVUSH. Detail of *Archer attacking a dragon* (fig. 8).

the natural setting above. The archer charges headlong, firing arrows, while his horse breathes rage and opens his jaws to tear at the dragon. Surprised by the sudden and unexpected attack, the dragon turns from his prey toward the horseman and prepares for a life-or-death battle (fig. 9). Above, the rocky cliffs are divided into two rough halves, each appearing to move toward the other with ineluctable force: their clawlike formations recall Siyavush's first miniature from the 1576–77 *Shahnamah*. Caught between these natural energies is a single, gnarled tree toward which one rocky face is approaching like a brutal scissorblade. Unaware of either the elemental forces moving around them or the human and animal duel below them, six men move in the back hills, their round faces and varied expressions typical of Siyavush's hand. So too is the frightened profile of the fallen hunter, and his awkward sprawl clearly recalls Kamus in figure 1. The hero's charging horse has not changed much from Siyavush's earlier types in the *Shahnamah*.

The inscription in the lower right—in all respects identical with that of the previous drawing—indicates that the drawing was completed under Shah 'Abbas I, and it must be dated like the other work, about 1590. While Siyavush's typical grass tufts have not changed from his earlier style and while the trees' exquisite finery reveals the same delicate hand we saw at work in figure 5, the rocky outlines show the occasional staccato touches and broken contours characteristic of Riza. The delicate shading of the horse and some of the rocky faces, particularly in the lower right, again suggest the influence of the younger master.

A final work bearing no signature may be one of the last drawings the master did, and it shows more conspicuously than the others the sign of Riza's influence (fig. 10). The leaves clustered around the small rocks in the foreground are new in Siyavush's work but abound in Riza's work. The seashell-whorl clouds in the upper right are also a new addition and are again a well-known component of Riza's art. Familiar Siyavush features remain: the grass tufts, the outlined rocks, the light, gentle line of the figures. Though touched by Riza's innovations, Siyavush nevertheless retained a striking degree of independence in this drawing, which should be dated about 1595. Unlike Sadiqi, Siyavush did not try to compete with Riza, and his art remained strikingly consistent throughout his career.

We know little of the last years of his life. Writing in 1596–97,

Fig. 10. Attributed to SIYAVUSH. *Two men asleep in a landscape.* Circa 1595.

Qazi Ahmad says that Siyavush was no longer working, at least in Qazvin, and Iskandar Munshi records that he had died by 1616, after he had been in Shah 'Abbas's service "for a long time." Presumably, the last three drawings we have examined number among his works in the early 1590s, when he was in his late fifties. He apparently retired from active work as an artist only a few years later.

3. Sadiqi Bek

The Early Years

One of the major literary figures of late sixteenth-century Iran is also one of its most noteworthy painters. Of the leading artists of the Safavi period Sadiqi Bek alone has left us important autobiographical material,[1] and it is a measure of the changing aesthetic climate in sixteenth-century Iran that this should have been one of his concerns. It had not been a concern for his great predecessors: neither Bihzad nor Sultan Muhammad nor any of the early Safavi poet-painters, such as Aqa Mirak and Muzaffar 'Ali, saw the necessity of leaving literary accounts of their lives. Dust Muhammad's *Account of Past and Present Painters,* the only other significant literary record left by a major Safavi painter, dealt with his illustrious predecessors and contemporaries and scarcely mentioned the author.[2]

However, these were all men of an older generation. In Bihzad's day it was rare for an artist to sign his work. Of Sultan Muhammad's considerable surviving oeuvre between 1525 and 1540 only two paintings bear his signature (both in the c. 1527 *Diwan* of Hafiz). But in the last quarter of the sixteenth century signed works became commonplace. Artistic production was no longer carried out anonymously or supported by anonymous patrons, and there was among artists a heightened sense of individuality which went hand in hand with a new desire to connect their names with their work. To this increasing sense of individual artistic personality or self-awareness Sadiqi added his own large measure of ego—an ego that evolved on different lines from that of his contemporaries and lent wit and interest to his writing.

This is not to say that Sadiqi's two major literary works dealing with art and artists—the *Qanun al-Suvar* (Canons of Art) and the *Majma' al-Khawass* (Assembly of Worthies)—are autobiographical accounts in our sense. Neither contains a clear, concise résumé of

1. The artist is known by both his formal name and his *takhallus,* or epithet, Sadiqi. Qazi Ahmad refers to him as Sadiq, and Iskandar Munshi calls him Sadiqi. The name Sadiq appears on most of his drawings, while the name Sadiqi is used on his paintings.

2. A translation of this account is found in Binyon, Wilkinson, and Gray, *Persian Miniature Painting,* pp. 183–88.

the significant events in the author's life. In both works information about the author's life is scattered piecemeal throughout the entries and is advanced more as evidence for some of the author's assertions than as strict autobiography. But despite the nature of the presentation, it is clear that the sense of "I" is strong; certainly the pronoun itself occurs far more often than in any earlier literary account of artists and poets. The artist has become much more important in his own eyes.

It is undoubtedly this sense of personal worth which impelled Sadiqi to supply us with additional information of the rarest sort in the history of Iranian art. In 1601/02 (1010) he completed a holograph of his *Kulliyat* (Collected Works). Not only did he consider his own literary works important enough to warrant this definitive edition, but he also supplied them with a brief introduction giving the date of his birth, 1533/34 (940), and a few salient details of his early life. A later chronicler, Valih-i Daghistani, has supplied us with the date of Sadiqi's death, 1609/10 (1018).[3] As a result, Sadiqi is the only Iranian artist until recent times whose dates are securely established.

Despite the absence of an orderly and coherent autobiography, we can therefore still construct a biography of the artist which is more nearly complete than any we possess for a Safavi artist. Our account is based upon five major sources: Sadiqi's *Qanun al-Suvar, Majma' al-Khawass,* and introduction to his *Kulliyat;*[4] Iskandar Munshi's extensive paragraph in his *Tarikh-i 'Alam-ara-yi 'Abbasi* (History of Shah 'Abbas and His Predecessors); and Qazi Ahmad's equally informative account in his treatise, *Calligraphers and Painters.* The last two accounts deal mainly with the mature years of the artist's life and concern themselves more with his art and character than with the particular events of his life.

Sadiqi Bek was born in the Varju district of Tabriz. His parentage is not mentioned, although his excellent connections at court and his participation in Qizilbash military activities indicate that he was

3. This information is contained in T. Gandjei, "Notes on the Life and Work of Sadiqi," *Der Islam* 52, no. 1 (1975).

4. *Qanun al-Suvar:* Persian text with Russian translation edited by A. U. Kaziev (Baku, 1963). M. B. Dickson's full translation of Sadiqi's treatise will appear in S. C. Welch and M. B. Dickson's forthcoming publication, "The Houghton *Shahnamah.*" Translations of Sadiqi's text here, however, are my own. *Majma' al-Khawass:* Chaghatay text with Persian translation edited by 'Abdulrasul Khayyampur (Tabriz, 1948). *Kulliyat:* Discussed by both Khayyampur and Gandjei.

well born. At this time his tribe, the Khodabandalu, was one of the leading clans of the original Shi'a tribes which had supported the first Safavi shah, Isma'il I, and which had obtained for him his throne.[5] Apparently the Khodabandalu came from Syria in the late fifteenth or early sixteenth century to aid Isma'il and were a branch of a larger grouping, the Shamlu, who were to figure prominently in the later struggles for succession from 1576 to 1587. Sadiqi was one of the few Turcomans who chose an artistic career; most of the calligraphers and painters of the period were Persian-speaking Tajiks.[6] As we shall see later, he does not seem to have been entirely reconciled to his unusual calling.

His mother tongue was Chaghatay Turkish, the language in which he wrote the *Majma' al-Khawass,* although he was also fluent in the other two literary Turkish languages of the period which were used by Ottoman and Qizilbash poets. Like most members of the Turkish-speaking military aristocracy at the Safavi court, he also spoke and wrote fluent Persian. The *Qanun al-Suvar,* his verse treatise on the techniques and aesthetics of painting, is composed in competent though not excellent, Persian, and there are numerous Persian poems scattered throughout the Chaghatay text of the *Majma' al-Khawass.* Like the Mughal emperor Babur, who also wrote Chaghatay prose and Persian verse, Sadiqi saved his poetic expressions for the more traditionally poetic language.

In 1543 when the ten-year-old Sadiqi was in Abarquh, presumably with his family, he came into contact with the poet Mir Qurbi. His brief account of that poet is typical not only of his prose style and his rather acerbic wit but also of his lively sense of self-worth:

> [Mir Qurbi's] place of origin is not known. He was a man who was always falling in love and was someone who did not care about worldly things. In the city of Abarquh he had fallen in love with a youth named Maqsud. Mornings he would walk about, sighing and weeping passionately.
>
> He wrote a riddle in his lover's name. When he was writing the name in an unmetrical way,[7] I met him and said: "This

5. Sadiqi himself informs us that he belonged to the Khodabandalu. See Sadiqi Bek, *Majma',* p. iv., and Gandjei, "Life and Work of Sadiqi," p. 112.

6. Turcomans is a generic term for the Turkish-speaking tribes (including Turkmans, Afshars, Khodabandalu, Shamlu, etc.) living in eastern Anatolia and Iran.

7. I.e., in order to conceal his beloved's identity.

riddle is written about Maqsud, and see how it actually is in verse."

At that time I was about ten years old, and the Mir was extremely astonished. Indeed, he said a prayer for my well-being, and as a prize he gave me a *ghazal*.[8]

At this point all certainty vanishes in our presentation of his life. Not until the last decade of Sadiqi's life can we assign any positive dates to the events which he mentions in passing. They are only with difficulty strung together in what I hope to be their correct order. The following account is advanced as the most logical and likely ordering of the events mentioned in the five sources.

Sadiqi, unlike so many of the great Safavi artists, did not come from one of the leading artistic families. He seems to have been the first in his family to have taken up an artistic career, and he did so rather later in life than did most artists of the period: "In my early youth my life was passed in the employ of sultans. An occupation other than this one I deemed below me and unworthy of the family tradition."[9]

The family tradition to which he refers was almost certainly a military one, and we know that even after he became a renowned artist, Sadiqi still considered himself one of the military caste which supported the Safavi throne, for Iskandar Munshi writes: "In accordance with the natural disposition of a Turk and the habits of the Qizilbash, he made pretensions to hardihood and bravery and gave himself airs over the heroes of his period. . . . In the battle with the Turkmans at Astarabad he displayed foolhardy deeds of daring.[10]

His early manhood then was spent as a Qizilbash warrior. When he was twenty years old in 1553, his father was killed, very likely in one of the recurrent feuds between the rival Qizilbash clans. At this point, perhaps in fear for his own life, Sadiqi fled west into

8. Sadiqi Bek, *Majma'*, pp. 84–85. Subsequent citations of page numbers in this chapter are to this work.

Utilizing the same meter as the qasidah, the *ghazal* (often translated as "ode") similarly preserves the same rhyme throughout its length. The ghazal differs from the qasidah chiefly in being shorter (rarely more than twelve verses) and in having a more restricted subject matter (usually love of a physical or mystical sort).

9. Sadiqi Bek, *Qanun*, verse 1. His own account differs from that of Iskandar Munshi, writing some twenty years later, who reports that Sadiqi conceived a liking for painting when he was quite young.

10. Iskandar Munshi, *Tarikh-i*, p. 175; translation from Arnold, *Painting in Islam*, p. 142.

Ottoman territory. He ended up in Aleppo, Syria, the homeland of his tribe, the Khodabandalu. There he moved in cultivated circles, for he became well acquainted with the Ottoman poet Baqi Chelebi (p. 115), who is known to have lived in Aleppo from 1554 to 1559.[11]

How long he stayed in Aleppo is unclear, but his sojourn there was apparently followed by a move to Baghdad, where he lived for some years and came to be on friendly terms with the poet 'Ahdi (p. 281), the author of the *Gulshan al-Sh'ara*.[12] These are the only two major Ottoman cities Sadiqi mentions; he presumably never went to Istanbul in search of patronage at the Ottoman court.

As a believing Shi'a, the most significant part of Sadiqi's stay in Ottoman territory was surely his journey to the Shi'a holy sites in 'Iraq. He visited both Karbala' and Najaf, and two sizable accounts in his *Majma' al-Khawass* refer to his pilgrimage. In his entry on Muhammad Pasha he writes:

> He is the son of Iskandar Pasha, the Beklerbek of Yemen.[13] In all the countries which I have traveled, I have not seen a youth so sociable or one who loves Iran more. The Ottomans agree on his intelligence, loftymindedness, and bravery: they do not doubt it. He has no equal in ability in the Arabic, Persian, and Turkish languages.
>
> One evening during the ten days before 'Ashura' we were on our way to visit the tomb of the Imam to whom obedience is due, the Imam Husayn the martyr, on him be peace.[14] In the middle of our journey [Muhammad Pasha] wanted to speak several elegiac verses and at the time of the kissing of the threshold [of the tomb] desired that [these verses] reach the ears of the honorable Sayyids. As he went his way, he versified one qasidah of forty verses to the rhyme of Karbala'. When each verse was finished, he gave it to one of his talented attendants. When it was morning, he took the verses from the attendants, and he connected each verse with the others.

11. Gandjei, "Life and Work of Sadiqi," p. 114.

12. Ibid., p. 114.

13. Iskandar Pasha was recognized as the ruler of Yemen by the Ottoman Sultan Salim I in 1517 (923) but was deposed by Rumli Kamal Bek four years later.

14. The holy day of 'Ashura' is observed on the 10th of Muharram, the first month of the Islamic year. For Shi'a Muslims it commemorates the death of their third Imam, Husayn (the son of 'Ali and grandson of the Prophet Muhammad), who died in the year 61 (680). It is a time of great private and public mourning and of pilgrimage to Karbala', the site of his martyrdom.

This verse is the beginning of that qasidah:

> The blood of the martyrs of Karbala' began to boil;
> Many flowers opened in the garden of Karbala'.

[pp. 33–34]

Sadiqi's birth and upbringing were elevated enough that he was able to associate with the highest nobility in all parts of Iran, as well as with well-born aristocrats from other parts of the Near East. But he also had connections with well-placed men in the learned elite, both in Iran and in the Ottoman domains. During his stay at the holy sites he became ill and was cared for by one of the leading literati families in Baghdad.[15]

But even at the holy sites of Shi'ism, Sadiqi kept his critical eye open. In what is perhaps the harshest attack on any personality in the *Majma' al-Khawass* he inveighs with bitterness against one Mawlana Sahabi:

> Robed in solitude and isolation he resided at the holy shrines, especially at Najaf. For a period of seven years he performed such hypocritical austerities at that threshold that he made the majority of the servants and pilgrims his disciples. One time, when he was living in this deceitful manner, I came on pilgrimage to the holy sites. Several obscene, lewd, and devilish acts were perpetrated by this ill-bred fellow which in the end all of his disciples denied. He still continues in the same path [acting piously as before], as if he were not the perpetrator of these odious deeds. [pp. 304–05]

After several years in the Ottoman Near East Sadiqi returned to Iran, and it would seem likely that the years from about 1559 to 1565 were spent in the service of various amirs. For much of this time he was associated with Mahdiquli Khan, a Turcoman noble who later rose to great power under Shah 'Abbas I. Sadiqi knew him best before he became celebrated, and in his entry on him he writes:

> He is a Qaduraqa'i and is well known by the name of Qadurqalu [a reference to his place of origin]. At first he was

15. Sadiqi Bek, *Majma'*, p. 127: "[Qilich Bek] is the nephew [sister's son] of Farahshad Chelebi who was ministerial scribe in Baghdad. When I visited the holy shrines, I became sick and for a time lived in seclusion in the ministry of the above-mentioned. To alleviate my affliction he prepared a banquet with wine and beautiful attendants, and in this way he consoled me."

called Sulagh [a term of derision] among the Qizilbash. He traveled a great deal while in attendance on the amirs, and we were together on most of these trips. Perhaps these words seem impolite, but it may be that, since they are the truth, that great man will not mind them.

In any case now, due to the effect of the special attention of Shah 'Abbas Bahadar Khan, he has risen into the amirate.[16]

This period came to an end about 1565, when Sadiqi, thirty-two years old, decided to abandon "the service of sultans," entirely typical of a Qizilbash youth, and to turn instead to art. His course of action was unusual, since most of Iran's artistic elite was Tajik, and his change of profession must have astonished many of his contemporaries. As preparation for his new way of life, Sadiqi studied for the next three years with the great calligrapher–poet Mir San'i in Tabriz, and it seems most likely that this period ran from about 1565 to 1568, the year in which the master died.[17] Earlier in his life Sadiqi had studied poetry with Hafiz-i Sabuni (pp. 179–80), as well as with Faza'i of Hamadan (p. 247), but it seems clear from his touching account in the *Majma' al-Khawass* that his principal master, to whom he was devotedly loyal, was Mir San'i:

He is of the people of Nishapur. He was a dervish-like and ascetic person, and in the art of poetry he was one of my guides. I have studied most of the obligatory treatises on poetry with him. For a period of more than three years I never saw him place his head on the pillow of rest, even though at this time he was nearly ninety years old.

In the capital city of Tabriz he became enamoured of a druggist's apprentice. From his house to the street of his beloved was a distance of one mile, and he traveled it continuously, yet he never became tired.

The grace and elegance of his nature is more than can be described. . . .

In colors and sprinkling of paper, as well as in such things

16. Ibid., pp. 35–36. Mahdiquli Khan's rise to fame was swift after 'Abbas became shah. In 1587 (996), the year of 'Abbas's coronation in Qazvin, he was appointed governor of the dynasty's original center, Ardabil, and in 1603 (1012) he was installed as governor of Tabriz. K. M. Röhrborn, *Provinzen und Zentralgewalt Persiens im 16. und 17. Jahrhundert* p. 35.)

17. Qazi Ahmad, *Calligraphers and Painters,* p. 150.

as vermilion and white and lapis-washing, he was also well informed.

His praiseworthy traits are so numerous that the description of them will not fit in this article. [pp. 75–76]

Sadiqi is not alone in his praise of Mir San'i. His gifts as a calligrapher are praised by Shah Tahmasp's talented brother, Sam Mirza,[18] as well as at length by Qazi Ahmad, whose account marvelously corroborates Sadiqi's:

> Mir San'i Nishapuri, although a poet in his day, wrote nasta'liq excellently and with taste. His verses are known and copies of his collection of poetry are found everywhere. . . .
>
> Mir San'i lived like a dervish and ascetic and was distinguished for his equanimity and subtlety of mind. In conversation and address he had no equals. He finally went from Khorasan to 'Iraq and thence traveled to Azarbayjan and settled down in Tabriz. He became enamoured of the late Mirza 'Abd al-Husayn, nephew of Mir Rasti, muhtasib [superintendent of police]. In this love he reached the stage of burning passion. Like a madman he wandered in Tabriz and like a moth he was consumed in the fire of his love for the young man. Within a short time the bird of his soul flew away and flitted to another world. He [Mir San'i] was buried opposite the doors of the house of the young man, below the building of Jihanshah.[19]

Clearly, Sadiqi's study with Mir San'i, nearly sixty years his senior, took place in the last few years of the poet–calligrapher's life, for Sadiqi is intimately aware of the Mir's life as an aged man. Sadiqi, who seems to have enjoyed a close relationship with his master, was undoubtedly sympathetic with his teacher's love plight. For during his stay in Tabriz Sadiqi too fell in love with someone much younger than himself. By Sadiqi's own admission it is obvious that the son of Mawlana Nami had many admirers among the Tabrizis.

> [Mawlana Nami] is of the people of Ordubad. He was a pious and kindly person. When he came to Tabriz with his son, who was named Badr, I was seized with love for the boy.

18. Sam Mirza, *Tuhfa-yi Sami,* ed. Vahid-i Dastgirdi, *Armaghan* 16, 1314 (1936).

19. Qazi Ahmad, pp. 149–50.

One day he entered into controversy with my master Mir San'i
on the subject of poetry. I chose silence for myself, because I
was under some constraint toward both sides. My master
secretly told me: "Take his side, since I will forgive you but he
will torment you [for taking my side]." There can be no com-
passion greater than this. May God requite him in Paradise.

The above-mentioned Mawlana was too easy tempered and
patient. He would even recite [amorous] verses written about
his son in public places and not be embarrassed. Thus the
flame of my affection cooled, and my affection changed into
indifference. [p. 214]

Mir San'i's own fatal passion must have followed shortly after the
cooling of Sadiqi's ardor for Badr, and soon after the Mir's death in
1568 Sadiqi, now thirty-five years old, must have left Tabriz for the
capital city of Qazvin.[20] During his three years in Tabriz he had un-
doubtedly studied not only poetry but also calligraphy and the arts
of gold-sprinkling and color washes, two skills for which Mir San'i
was famous and which Sadiqi used to good effect in his painting.

Mir San'i's death, though faithful to the professed heart-struck
despair of so much of Safavi poetry, must have been hard on Sadiqi,
for he certainly held the older man in high esteem. Those Sadiqi
fully respected were few—among them Muhammad Pasha, Mir
San'i, and Muzaffar 'Ali—but his respect for them was nearly
boundless. When he had no respect for a person, he despised with
the full vehemence of his acid tongue. Certainly there is nothing
gentle about his treatment of Mawlana Sahabi. More frequently, as
we shall see, he mixed general approbation with sarcastic jabs.

It was a mature and well-trained man who left Tabriz on Mir
San'i's death in 1568. He already had a rich and eventful life as a
warrior and a courtier. Yet Sadiqi was apparently not altogether
satisfied with his career even then.

Due to an innate inclination for higher things, my inner self
at times could hear a voice which said: "You should renounce
the companionship and the customs of these sultans; you should
forgo covetousness and their dalliance; mark my final words

20. Although Tabriz was no longer the capital of Iran, it still held its own as an
important center of commerce and culture. Clearly some of the impressive artistic
talent assembled by Shah Tahmasp had stayed on in that city after the monarch
moved to Qazvin.

and never forget them. Your true vocation is art; search for it unflaggingly for the rest of your life. Follow it relentlessly and hold onto it forcefully. For life without art is bleak.[21]

His three years of study under Mir San'i was a period of trial for Sadiqi: working with the wise and kindly old master, he was learning the rudiments of his new profession and discovering whether he was entirely suited for it. The death of the Mir probably only strengthened his decision to devote his life to painting.

At last the spirit of the voice took over my whole existence, and I discovered now that I could forswear my earlier way of life forever. My heart experienced nothing but thoughts of pure joy while the quest of my true profession—art—grew steadily more passionate. My spirit soared toward heaven. Like the noble falcon it would not chase after common quarry. From my more sublime perspective everything seemed all too easy. I held onto only one real aspiration—to be inspired by a touch of the Bihzad.[22]

It was only natural that a talented and well-educated member of the Safavi elite should gravitate toward the acknowledged high classical master Bihzad, who, though now some thirty-five years dead, had left behind a numerous and gifted progeny, some of whom were still living: "I was transported with rekindled ardor and searched everywhere for a master and follower of the Bihzadian line."[23] Of the three great early Safavi masters still alive—Mirza 'Ali, Shaykh Muhammad, and Muzaffar 'Ali—the last came closest to satisfying this requirement. The son of the early Safavi master Haydar 'Ali[24] and the nephew (sister's son) of Bihzad himself, Muzaffar 'Ali's apprenticeship had been served at least in part under his celebrated uncle. His excellent training and his own large share of genius brought him early fame and excellent opportunities: he and Mirza 'Ali were the only masters to work on three of the greatest Safavi manuscripts—the Houghton *Shahnamah,* the British Museum *Khamsah* of Nizami, and the Freer *Haft Awrang* of Jami. His mellifluous line and highly lyric style were coupled with a gentle and

21. Sadiqi Bek, *Qanun,* verses 1–6.
22. Ibid., verses 7–13.
23. Ibid., verses 14–17.
24. There is a single, surviving miniature signed by Haydar 'Ali—a splendid painting of a Safavi nobleman and his horse (Freer Gallery of Art, 37.20).

kindly temperament, which must have doubly appealed to Sadiqi. From Sadiqi's own words it is obvious that he found many similarities between Mir San'i and Muzaffar 'Ali, and it seems clear that he was drawn to these older and probably wiser men. But let us see how Sadiqi describes his painting master in his own words:

> Then I met my mentor, an enlightened man, a savior to shed light upon my path. [He was] righteous and extremely forbearing and no one could compete with him as a teacher of the arts. [First] apprentice then beneficiary of Bihzad, he had been a fount of steady pleasure to that formidable master. Sitting on the loftiest throne in the academy of painters, he always directed his keen eyes toward a far horizon. So great was his skill in brushwork that praise would issue forth from 'Utarid [i.e. Mercury, the embodiment of sagacity and the protector of the arts].[25]

Muzaffar 'Ali had been singularly honored by Shah Tahmasp and Ibrahim with the choicest of commissions. He had also been an especial favorite of the shah himself. He must have had many students, but the only two who are clearly identified are Siyavush the Georgian and Sadiqi Bek. Sadiqi's praise of his master is full and rich, not only in the *Qanun al-Suvar* but also in the *Majma' al-Khawass:*

> He was of the people of Torbat and the son of Mawlana Haydar 'Ali and the nephew [sister's son] of Master Bihzad. In painting he was my master. He was accomplished in all kinds of arts and, outside of being somewhat ill-starred, he had no fault. I heard sometimes from the late shah [Tahmasp] that he preferred him to Master Bihzad. He imitated several fragments of Mawlana Mir 'Ali and Sultan 'Ali, who were masters of calligraphy; and the owners of the fragments, although they were connoisseurs, were not able to distinguish them from the originals. It was ordered that "Royal Painter" be written on these fragments. . . .
> Sometimes he took a delight in poetry too.[26]

25. Sadiqi Bek, *Qanun,* verses 18–23.
26. Sadiqi Bek, *Majma',* pp. 255–56. The two other major accounts of Sadiqi's master (Qazi Ahmad, p. 186; and Iskandar Munshi, *Tarikh-i,* p. 174; translation in Arnold, *Painting in Islam,* p. 142) add further details but do not measurably increase our understanding of the relationship between the two men.

Sadiqi left Tabriz then in 1568 and went to Qazvin to study under Muzaffar 'Ali, "that revered shaykh among men."[27] Some of Shah Tahmasp's former affinity for art seems to have returned at this time, perhaps along with the recall of his favorite nephew Ibrahim Mirza in 1568 from the government of Mashhad. It is likely that Muzaffar 'Ali, to whom have been attributed three of the miniatures in the Freer *Haft Awrang*,[28] had accompanied the young prince to Khorasan and had stayed there with him along with the painter's uncle Rustam 'Ali and cousin Muhibb 'Ali, both scribes for the Jami manuscript. Short of going to Mashhad, therefore, Sadiqi could only have studied with Muzaffar 'Ali after 1568. Though it would seem likely that a good Shi'a would have made the trip to Mashhad at some point in his life, Sadiqi, otherwise careful to mention his many journeys and wide experience, leaves no record of ever having been in the holy city.

For the next eight years, until Muzaffar 'Ali's death in 1576, the year also of Shah Tahmasp's demise, Sadiqi remained largely in Qazvin, where he learned his trade thoroughly and absorbed gossip about the royal court. He was clearly aware of most of what was happening in government and within the aristocracy, and his *Majma' al-Khawass* is filled with intimate details of the last years of Tahmasp's reign. Ibrahim Mirza, for instance, "greatly delights in jests, so much so that he became proverbial for this among many people. Because he could not control his tongue, he was killed in the time of Shah Isma'il II" (pp. 25–26). This is an interesting addition to our knowledge about the brilliant prince: with too sharp a tongue and perhaps too exact a sense of his intellectual superiority, he made the mistake of offending the paranoid shah, who had already executed two of his brothers and several of his leading officials. Sadiqi evidently knew and understood both men well.

He presents us with a strangely favorable account of the powerful royal councillor Mirza Salman, a slippery schemer who may have poisoned Shah Isma'il II and who rose to the highest governmental position under Muhammad Khodabandah by unscrupulously framing the shah's half sister Pari Khan Khanum:

> He is of the people of Isfahan. He had a very cheerful temperament and loved company. In the reign of the last shah

27. Sadiqi Bek, *Qanun*, verses 31–35.
28. These attributions are the work of S. C. Welch in his forthcoming study (with M. B. Dickson), "The Houghton *Shahnamah*."

[Tahmasp] he worked in the Chamber of Accounts [Daftar].
In the reign of Shah Isma'il II he rose to the ministry [Vazirat],
and in the period of Shah Sultan Muhammad he became grand
vazir [vazir-i 'azam], or really one should say noblest vazir
[vazir-i akram]. He possesses a very poetic nature and has
brought to completion a whole diwan. [p. 41]

But though his formal entry here is glowing enough (perhaps for
political reasons), Sadiqi manages unobtrusively to slip in a deadly
barb against the high councillor in a later account about the poet
Mawali Turkman:

[Mawali Turkman] is not the son of anyone important but
because he was ambitious he rose far from a lowly post of
service to a high position of attendance [on the shah]. He be-
came a confidant of Prince Sultan Hamzah. He speaks very
coarse [Turklike] poetry. The verse below he wrote as a parody
of Mirza Salman Isfahani.

So what if the shah married your daughter;
The Prophet also married the daughter of [his follower]
Abu Bakr.[29]

Many of the imperial princes are described in Sadiqi's *Majma'
al-Khawass,* but not all his comments are wholly favorable, and one
suspects that his regard for Shah Tahmasp's teenage son Mustafa
was not of the highest:

[Sultan Mustafa Mirza] was the esteemed son of the late
shah [Tahmasp]. He was worthy of the title "Shah in Appear-
ance and in Reality," and "Sun of Loveliness and Beauty" was
[a title] suited for him.
His piercing eyelashes were brave in the killing of the brave,
and his laughing pistachio was charming in making tumult.
His temperament was very refined and amorous.[30]

Our account is as much a study of Sadiqi's lively prose style as it
is of his obvious familiarity with the court and all its leading figures.

29. Sadiqi Bek, *Majma',* p. 129. In other words, "Your daughter brought no
more advantage to the shah than did Abu Bakr's to the Prophet." To a Shi'a, of
course, the analogy with Abu Bakr, whose daughter 'A'isha did marry the Prophet,
would not have been a compliment.
30. Ibid., pp. 27–28. "Piercing eyelashes": many people fell in love with him
because of his beautiful lashes. "Laughing pistachio": his laughing lips.

He was often critical, even of those in positions of great power, and though the *Majma' al-Khawass* was written before 1602 and perhaps after the death or disgrace of many of those whom he regards askance, it seems probable that his overt attitude toward many of his contemporaries at the Safavi court was cynical and even contemptuous.

Still, he must have moved easily among the Turcoman military aristocracy to which his family belonged and in which he had served for a good part of his life. He was familiar too with all the chief artists at the court of the shah and was eventually to rise under Shah 'Abbas to the high post of *kitabdar,* or director of the royal library. He conversed with shahs—Tahmasp, Isma'il II, and 'Abbas—and he knew royal princes—Ibrahim, Badi' al-Zaman, and Mustafa among others. But though he rose to high position and knew literally all the right people, he seems to have avoided becoming a sycophant and to have preserved his basic independence throughout his career. Indeed, only a courageous and strong-willed man could have left us the following account of the son of the powerful Shahquli Sultan Ustajlu:

> [Murad Bek] is the son of Shahquli Sultan, the governor of Kirman. He was an amorous and intelligent youth. Due to the crooked conduct of the heavens and his addiction to opium, he left the affairs of his kingdom and began to carve wooden spoons. And in this occupation he had great talent.[31]

THE LATER YEARS

Sadiqi's pronouncements on the men of his time have not only left us an account of the many people he knew during his long, active life, they have also supplied us with an intimate look at the author's own lively and often irascible personality. With this haphazard autobiography alone we would have more information about Sadiqi than about any other Iranian painter, but Sadiqi's two books

31. Ibid., p. 27. Shahquli Sultan was governor of Erivan from 1558–72 (966–980). At the time of Shah Tahmasp's death in 1576 he was governor of Herat and amir al-'umara' of Khorasan, and it is probable that for some time he had served as the lalah of Prince Muhammad Khodabandah (Röhrborn, *Provinzen und Zentralgewalt Persiens,* pp. 7, 19, and 43). His son Murad Bek was for some time the commandant of Tabriz (ibid., p. 7), but at the time of the siege of Sabzavar in 1581 he was ordered executed by Prince Hamzah, according to Sadiqi.

are not our only sources. Both Qazi Ahmad and Iskandar Munshi
have left us considerable discussions of Sadiqi which amazingly
correspond not only to each other but also to the picture Sadiqi
leaves us of himself in his writings. Qazi Ahmad's account, written
in 1596–97, is the shorter of the two:

> Sadiqi Bek belongs to the Afshar tribe. In painting and por-
> traiture he is unequaled and unrivaled. At present he is acting
> as kitabdar to the shah ['Abbas I]. He composes very good
> poetry; there exist many qasidahs, qit'as, ghazals, and ruba'is
> by him. In painting he brought the harmony of colors, portrai-
> ture, and details to such perfection that men of clear vision are
> amazed in contemplating his work. Nor in gallantry and
> bravery does he regard himself inferior to the champions of his
> time.[32]

As a Turcoman whose "family traditions" would not allow him
to think of any career save one "in the service of sultans," we can
imagine that Sadiqi, even after he turned to art, was not wholly
reconciled to a peaceful courtier–artist's existence. Certainly his
early life, with his long sojourn outside Iran and his many travels,
had been turbulent enough, and even though Sadiqi in 1596–97
was the head of 'Abbas's large atelier and in his sixties, he still gave
the appearance of hardihood and military courage.

Iskandar Munshi's much longer commentary is even more infor-
mative:

> Sadiqi Bek was a Turk of the Afshar tribe, a man of the
> world and a man of parts. Sadiqi was his pen-name. He con-
> ceived a liking for painting when he was quite young; he at-
> tached himself day and night to the paragon of the age, Master
> Muzaffar 'Ali, who observing in him signs of ability and prog-
> ress, devoted himself to training him, and [Sadiqi Bek] while
> he was his pupil attained the highest possible perfection. At
> one time when, out of pride and obstinacy, he lost interest in

32. Qazi Ahmad, p. 191. A *qit'a* (fragment) is a portion of indeterminate length
of a qasidah. Though the term implies an unfinished or dependent quality, many
qit'as were intended as complete poems. A *ruba'i* (quatrain) is a complete poem.
Edward Fitzgerald's translation of the Ruba'iyyat of Umar Khayyam contains the
most celebrated renderings of this form in English.

Both Qazi Ahmad and Iskandar Munshi describe Sadiqi as an Afshar, although
he himself states that he is a member of the Khodabandalu. Their mistake is pre-
sumably based upon his service in the 1580s under Afshar tribesmen.

painting because the market for it was dull and things were
not going as he wished, he abandoned it and, stripping himself
of all superficialities, took to the life of a wandering dervish
and travelled about from place to place. Amir Khan Mawslu,
while he was Governor of Hamadan, heard about him, induced
him to abandon the garb of a dervish, and took him into his own
service and treated him in a humane manner. In accordance
with the natural disposition of a Turk and the habits of the
Qizilbash, he made pretensions to hardihood and bravery and
gave himself airs over the heroes of his period. In the reign of
Sultan Muhammad Nawwab Sikandarshan he took service
under Iskandar Khan Afshar and Badr Khan his brother; in
the battle with the Turkmans at Astarabad he displayed fool-
hardy deeds of daring, but at no time did he neglect the practice
of painting, so that in the end he made excellent progress and
became an unsurpassed painter, a fine artist, and an unequaled
designer, and with a brush as fine as a hair he painted thou-
sands of marvellous portraits. He was endowed with ability
and talent and had the gift of poetry and eloquence; he com-
posed excellent qasidas, ghazals, and *mathnawis;*[33] the follow-
ing fine verse occurs in his mathnawi *Jangnamah:*

> The arrows like locusts in their flight
> Proved disastrous to the corn-land of life.

Since some of his verses will be quoted in the section on Poets,
it is unnecessary to quote more here. In the reign of Isma'il
Mirza [Shah Isma'il II] he was on the staff of the library. In the
reign of his present Majesty, the Shadow of God [Shah 'Abbas
I], the high office of librarian was conferred upon him and he
enjoyed the royal clemency and favour. But he was of a dis-
agreeable, jealous, and suspicious disposition, and his surly,
unpleasant character never left him free from self-seeking, and,
in accordance with his disposition, he always behaved towards
his friends and associates with a discourtesy which went beyond
bounds, but they willingly purchased from him those worthless
goods which are unsaleable in the market of merit. But he
passed the limit of moderation and went to excess in his bad

33. A *mathnawi* (couplet-poem) is generally of considerable length and consists
of many rhymes instead of the single rhyme of the ghazal and the qasidah.

behavior towards everybody, and for this reason he fell out of favor and was dismissed from the office which had been entrusted to him. But to the end of his life his official designation remained unchanged and he continued to draw his salary from the treasury.[34]

Iskandar Munshi and Qazi Ahmad both deal almost solely with the second half of Sadiqi's life, after he had left Mir San'i and had begun his training with Muzaffar 'Ali. It is in this period after 1568 that we find most of our firm dates for the artist's life. He matured rapidly as a student of the older master, and by 1573 he undertook a major assignment—a miniature in the 1573 *Garshaspnamah*, the last significant manuscript to have been produced before Shah Tahmasp's death. He was not working completely independently: his master painted and signed the manuscript's first illustration and perhaps added one more, unsigned. But Sadiqi's painting is inscribed, clearly indicating that he was already known and respected for his work. The only other inscribed miniature is by Zayn al-'Abidin, an artist with an impressive lineage and an impressive future.

In 1576 the new shah, Isma'il II, set about to reestablish the royal atelier. Muzaffar 'Ali died that same year, but his two principal students, Sadiqi and Siyavush, helped fill the gap left by their master's demise. So too did a whole coterie of new artists—Mihrab, Burji, Murad Daylami, Naqdi, and 'Ali Asghar. Sadiqi was evidently close to the erratic, half-crazed shah, for his own sympathetic prose account of Shah Isma'il II in the *Majma' al-Khawass* differs strikingly from most of the other historical evidence about the king's personality: "[Shah Isma'il II] had good taste and was very dignified and awe-inspiring, and he had a predilection for painting. Although he had a fearful exterior, in his heart he was very gentle and good-natured" (pp. 11–12). Sadiqi seems to have enjoyed the shah's especial favor and attention, and as we shall see later, his role in the production of the 1576–77 *Shahnamah* was a major one.

But the erratic king died before his great *Shahnamah* was finished. His successor, Muhammad Khodabandah, had some knowledge of painting but apparently was not inclined to complete the *Shahnamah*

34. Iskandar Munshi, *Tarikh-i*, p. 175; translation from Arnold, *Painting in Islam*, p. 142.

begun by his younger brother. The book remained a fragment, although its size—some fifty surviving miniatures from the first part of the *Shahnamah*—indicates that Isma'il II had intended to produce a truly monumental work to rival the accomplishments of his father Tahmasp and his cousin Ibrahim. Perhaps Muhammad Khodabandah distanced himself from the great manuscript because of his antipathy toward his younger brother, who had murdered most of the Safavi family and who had clearly planned to kill Muhammad Khodabandah and his children.

Then too, Shah Muhammad's reign was extraordinarily turbulent. Until 1579 his wife, Khayr al-Nasa' Begum, sought to limit the power of the unruly Qizilbash, and the shah at least halfheartedly supported her efforts. But in the summer of that year the amirs murdered her, and the shah in dismay virtually retired from active participation in government. His withdrawal from political life was accompanied by a similar withdrawal from patronage. Neither great buildings nor great manuscripts can be ascribed to his patronage.

These lackluster ten years could not have been satisfying to Sadiqi. At the time of Isma'il II's death in 1577 he was forty-four years old and seemed well on the way to becoming one of the great figures in the artistic hierarchy of Iran. With his patron's death his rise to fame and power was abruptly terminated, and the sudden change in fortune was apparently a bitter blow. With royal patronage inadequate or nonexistent, Sadiqi seems to have temporarily abandoned his career because, as Iskandar Munshi reports, "the market for it was dull and things were not going as he wished." He left the court, dressed himself as a dervish, and traveled for some time in western Iran. In the course of his peregrinations he came to know Amir Khan Bek, whom he describes as his "brother of the [Sufi] order" (pp. 119–20).

Amir Khan was a member of the Turkman tribe allied with the Tekkelu tribe in support of Muhammad Khodabandah. As governor of Hamadan during the first two years of the weak shah's reign he was one of the most powerful Qizilbash emirs. He must also have been a patron in his own right, for he took Sadiqi into his service and treated him well.

During his stay at the amir's court in Hamadan Sadiqi made wide contacts among the intellectual and artistic elite of the city. He knew, for instance, the poet Mawlana Halaki Hamadani, who had been in Hamadan since he had entered Bahram Mirza's service

many years before.[35] "For years I was friends with [Mawlana Asad]," he writes about another poet from Hamadan who "in the expression of love has no equal." He was also on good terms with the local poets Jani and Panahi. Another one of his contacts was with Khwajah Aqa Mir, one of the sons of a great noble of the city. He was a calligrapher and had such an affection for Sadiqi "that those poems which he wrote, he first read to me" (pp. 273, 252–53, 276).

Sadiqi taught both painting and poetry during his stay at Amir Khan's court. One of his students was Mir Ibrahim, an otherwise unknown talent of Safavi Iran:

> Mir Ibrahim [Dardi] is from a small town in the region of Hamadan called Sarkan. He is a very modest and polite person. In the prime of his beauty he came to Hamadan for education and, having come into contact with me, began to learn poetry and painting. In a short while he had learned a great deal and painted well and wrote pleasing poetry.
>
> They say that at the court of Shah Vali in Kirman he is somewhat withdrawn. God give him success.[36]

But not all Sadiqi's involvements were as pleasant as this one apparently was. He has nothing but scorn for Mawlana Rashki Hamadani:

> In the art of gold sprinkling ['alaqahbandi] he is superior to his associates, but he indulges in endless lewdness, is impudent, and is a bad fellow. For this reason he joined the nightwatch in Tabriz, and it was not long before troublemakers and ruffians punished him with the total dishonor which he deserved.[37]

His only other mention of a Hamadan personality is of one who nearly ended his career there. Sadiqi's association with Mir 'Aziz Kamanchahi nearly brought him to disaster:

35. Sadiqi Bek, *Majma's,* pp. 172–73. Shah Tahmasp's favorite brother Bahram Mirza assembled a very impressive atelier of poets and artists in Hamadan before his death in 1549. In a typical sarcastic aside Sadiqi mentions that Mawlana Halaki wrote a book called the *Shawq u Dawq (Pleasure and Delight)* "of which only one verse became well known."

36. Ibid., p. 92. Thus Sadiqi was at this time an accomplished and well-known painter, actively sought after for instruction.

37. Ibid., p. 196. Sadiqi sees Mawlana Rashki's faults with the clarity of one who probably shares them, for his comments about the unfortunate man read surprisingly like those of Iskandar Munshi about Sadiqi himself.

Although [Mir 'Aziz Kamanchahi] was coarse bodied, he had many skills. First, he played the *saz* [a musical instrument] well and wrote compositions; and second, he had studied on an elementary basis and was well informed about astronomy and the stars.

For a time I was boon companion in attendance on Amir Khan Turkman. Because of one of the attendants [on the khan, Mir 'Aziz] came into conflict with me and a discord arose between us. After getting to the root of the conflict, the khan saw that right was on my side and restrained him.

A few days later he set out for Isfahan but through a strange chance was killed by highwaymen. Due to the above reasons, I was falsely accused, but at last it became known that he had been killed by a highwayman.[38]

Amir Khan's political star was rising. In August 1578 he achieved a signal victory over an Ottoman army, and in 1579 he was rewarded by being granted the governorship of Azarbayjan. From his new position in Tabriz he sought a royal alliance by suggesting he marry the late Shah Tahmasp's sister, Fatima. Perhaps due to this new political perspective or to the unfortunate accident to Mir 'Aziz Kamanchahi, Sadiqi's association with Amir Khan ended at this point, and when Amir Khan went from Hamadan north to Tabriz, Sadiqi went back to the capital city of Qazvin.

Thus the next firm date in his life documents his return to familiar associations. A Tajik patron, Mirza Abu Talib ibn Mirza 'Ala al-Daulat, commissioned the earlier discussed copy of Khwandamir's *Habib al-Siyar,* which is dated 1579 (987) and which contains signed work by Sadiqi and Siyavush. Although the book was an impressive accomplishment with its fine, *naskhi* calligraphy and nine miniature paintings,[39] it was not a royal manuscript on the level of the 1576–77 *Shahnamah*. Its scribe, Ziya al-Din Muhammad al-Agrahi, is otherwise unknown, and no other reference has yet been found to its patron. That a Tajik, presumably an official of the court in Qazvin, would commission a major manuscript, illustrated

38. Ibid., p. 286. Iskandar Munshi's account of Sadiqi's character makes one wonder if he is really as innocent of Mir 'Aziz's death as he would like his readers to believe. Indeed, his rival's violent demise may have been one of the factors contributing to Sadiqi's departure from Hamadan.

39. In use since about the year 1000, *naskhi* is a stately, cursive script which was widely used in precious manucrips.

by painters trained in the royal atelier, would have been all but im-
possible earlier in the century and is a measure of the shah's lack
of interest in active patronage.

The queen's murder in the summer of 1579 brought political mat-
ters to a head around the throne, and the resulting disorders may
have made life too uncomfortable for Sadiqi. Unlike the majority of
painters who were Tajiks, Sadiqi was a Turcoman, and while the
Tajiks could and generally did avoid the bitter rivalries between the
various Qizilbash tribes, Sadiqi probably could not. The queen's
murderers were principally members of the Turkman and Tekkelu
tribes. They were openly hostile to the Afshars and the Shamlus,
with which Sadiqi's smaller Khodabandalu clan was closely as-
sociated. In the same year that Abu Talib's manuscript was com-
pleted, life probably became not only uncomfortable but also
dangerous for Sadiqi in Qazvin, and he left the city in search of
safer territory.

Initially, he seems to have gone north to Gilan and Mazandaran,
where he spent a good deal of time after 1579. He was well treated
in Lahijan by Mawlana 'Abd al-Ghafur, a highly regarded young
noble (p. 233). During this period he also came to know many other
key figures in the region.

> ['Ali Khan Mirza] is the younger brother of Murad Khan.
> He is a romantic youth, sensitive and sociable.
>
> He is so given to amorous pursuits that, if he did not have to,
> he would attach no importance to any affair other than one of
> passion, even though it were the sultanate itself.
>
> In one of the intervals between reigns I went by chance to
> Gilan. He was also there. He was as kind and hospitable toward
> me as was possible. May God cause him to attain all his desires.
>
> He composes all kinds of Persian and Turkish poetry, and his
> pen name is Sadiq. [p. 66]

Sadiqi knew 'Ali Khan's older brother Murad Khan as well, and
he held Murad in greater respect:

> [Murad Khan] is the son of Timur Khan. At first he was a
> protegé of the late shah [Tahmasp] but due to several in-
> auspicious actions, he was deprived of the felicity of the shah's
> favor. He was a very lively and courageous youth, and due to
> this he received a strange wound in his eye. It is hoped that the

eye of his heart will become illuminated by the light of happiness.

He has talent in the varieties of verse, and his pen name is Figari.[40]

With his penchant for knowing all the right people Sadiqi apparently also cultivated the attention of Jamshid Khan, who ruled in part of Gilan from 1557 (965) until his death in 1583/84 (991). But from the succinctness of his entry on this ruler we can assume that Jamshid Khan's munificence was not the equal of the two sons of Timur Khan: "[Jamshid Khan] was not a bad ruler. Truly he was so like his equals and his peers that, like them, his fame was not without foundation. He had a poetic sense" (pp. 18–19). Sadiqi mentions only one poet who enjoyed the favor of Jamshid Khan, one Khalil Zargar (p. 246), who properly understood his role at court and wrote a *Jamshidnamah* [Epic of Jamshid].

We do not know exactly how long Sadiqi stayed in these northern provinces, but it must have been for some time, and he must have traveled widely, for he became acquainted with other important personages in the area, notably Khan Ahmad, an art patron of some significance. Sadiqi writes knowingly of him in the *Majma' al-Khawass:*

> They say that among the Lords of the Marches there was none superior to him. In the early part of his life he favored a group of entertainers like wrestlers, fencers, runners, and lion-keepers. It seems most likely that he has never turned away from his door anyone who was deserving.
>
> In the arts of music and in metaphysics and astronomy he was knowledgeable, and he did not play badly the various sorts of musical instruments. [p. 238]

40. Ibid., pp. 30–31. The Ustajlu family of 'Ali Khan Mirza was well connected and well born. Timur Khan, 'Ali Khan's father, was the lalah of Bahram Mirza's second son, Badi' al-Zaman, for the latter part of that prince's appointment in Sistan from 1558–77. And Murad Khan was a prominent patron in his own right, who during his reign in Mazandaran generously received Mir Sayyid Ahmad Mashhadi after that great calligrapher had been peremptorily dismissed by Shah Tashmasp.

Sadiqi's superb portrait (fig. 11), begun in 1593/94 (1002) and finished ninety years later by Mu'in Musavvir as a token of respect for the earlier master, apparently does not depict the father of 'Ali Khan and Murad Khan, for the inscription identifies the figure as Timur Khan Turkman, rather than Ustajlu. Possibly, however, Mu'in Musavvir, writing the inscription so many decades after the fact, may have mistakenly named the individual.

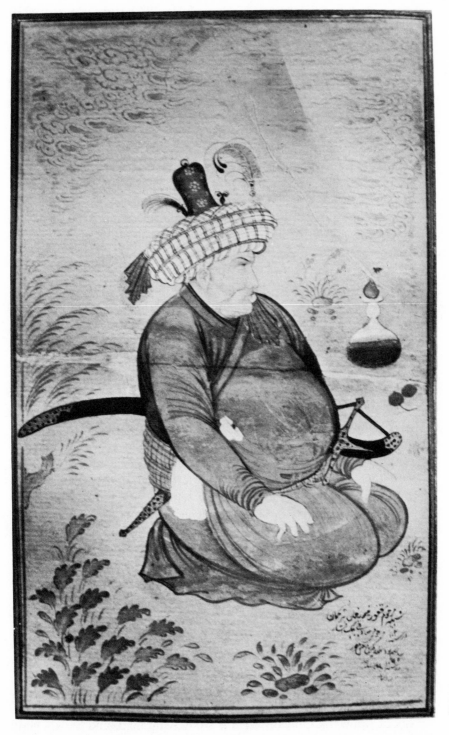

Fig. 11. *Portrait of Timur Khan Turkman.* Drawn by SADIQI in 1593–94 and finished by MU'IN MUSAVVIR in 1684.

It is certain that the artist spent time at his court, not only because of this somewhat facetious account of the Gilani ruler but also because of Sadiqi's several references to others who were favored with Khan Ahmad's attention. The poets Nur al-Din Muhammad (pp. 46–47), Mawlana Kami (p. 57), and Gharibi Kashi (p. 227) were all in attendance on the khan. So too was the historian and enigmatist Mir Haydar Kashi (p. 84).

In none of these accounts does Sadiqi mention his own artistic activity, though we can probably assume that he played the role of a painter as well as of an educated courtier while he was in Gilan and Mazandaran. According to Iskandar Munshi, Khan Ahmad was an important patron of painting, but we have no work by Sadiqi that we can ascribe to this period of his life.

In the spring of 1581 the trouble between the government in Qazvin and the distant province of Khorasan in northeastern Iran came to a head. Two large tribes, the Afshars and the Shamlus, both hostile to the Turkmans and Tekkelus who were gaining increasing control over the shah, joined forces under the leadership of 'Ali Quli Khan Shamlu, the governor of Herat, and renounced their loyalty to Shah Muhammad Khodabandah. In his place they put his ten-year-old son 'Abbas, who had been resident in Herat since 1573 as nominal governor.

Though this declaration of independence did not develop into a formal revolt until six years later, it was no longer wise or safe for Sadiqi, associated with the Shamlu through his Khodabandalu tribe, to return to Qazvin. He apparently left Gilan and Mazandaran at this time and moved to join his fellow tribesmen in northeastern Iran.

He took service with Iskandar Khan and Badr Khan, two Afshar brothers prominent in the conspiracy, and almost immediately saw action. They moved against the center of regional resistance to their authority, Mashhad, whose governor, Murtaza Quli Khan, was a Turkman. It is clearly to one of the battles of this campaign that Iskandar Munshi refers when he writes that "in the battle with the Turkmans at Astarabad [Sadiqi] displayed foolhardy deeds of daring." The painter–poet was still very much the Qizilbash warrior.

Still, despite his activities with the dominant powers in Khorasan, Sadiqi does not seem to have found a permanent source of patronage, and his life for the next few years was spent at various courts. After the battle at Astarabad he lived in the city itself, for he writes about Mawlana Ghiyath: "He is from Astarabad, and he is a good

conversationalist and a pleasant companion. He has traveled widely, and most of my time in Astarabad was spent in his company" (pp. 250–51).

He did not stay long but proceeded to Yazd in central Iran. There he found employment and security under a new master, Khwajah Ghiyath Naqshband:

> [Khwajah Ghiyath Naqshband] is of the people of Shiraz and one of the sons of Shaykh Sa'di Quds Sarah. He has many arts: first, in the art of illuminating and writing poetry he can be called the rarity of the age and the pearl of his time. The kings and princes of Iran and Turan seek the products of his invention. In agility and power and archery he has no equal, but even with these qualities he is very mild and kind.
>
> After the capture of Astarabad I entered into his service in Yazd and was not only his intimate but stayed in the same house with him as well. If on any one day he did not have guests, on that day food and drink were not agreeable to him. [p. 187]

Khwajah Ghiyath must have been wealthy and important to have been able to gain the services of a man of Sadiqi's distinction and reputation, but it is unknown what position he held in Yazd. Indeed, Sadiqi also knew the governor of the city, Muhammad Bek Amani, who used to invite Sadiqi into his presence to listen to the poetry which the governor had penned.[41] Surely, Sadiqi was known as a connoisseur of poetry. That his appraisals of Muhammad Bek's poetry were favorable is shown by the fact that the governor sent him a number of gifts. But it is astonishing that Sadiqi, who had studied with some of Iran's most celebrated literary and artistic figures and who was himself already a well-known poet and painter, should serve, not under the governor, but rather under Khwajah Ghiyath, apparently not a member of the Qizilbash aristocracy but a Tajik. Sadiqi's position in Yazd, hardly a center of Safavi culture, is dramatic proof of the severe disruption of normal patterns of royal patronage during the reign of Shah Muhammad.

It is not clear how long Sadiqi remained in Yazd. But it is likely that this provincial city could not have held much appeal for a man

41. Ibid., p. 37. On one of his visits to the governor Sadiqi was also fortunate enough to meet Mawlana Mu'min Husayn, who was "the most learned name in the region of Yazd" (p. 58).

of Sadiqi's training, ambition, and talent. During the whole of the fifteenth century the northeast Iranian city of Herat, capital of Khorasan, had been the cultural center of Iran, and though it had been supplanted in the sixteenth century by Tabriz and Qazvin in the west, it had now gained new importance. 'Ali Quli Khan Shamlu and his ward, Prince 'Abbas, were there as the focal points of the conspiracy which in 1587 would place 'Abbas on the Safavi throne. And their power was growing. It attracted talent. The painter Habibullah of Savah, a leading artist in the late sixteenth and early seventeenth centuries, had been serving under 'Abbas since 1578. Another painter, Muhammadi, was also there, for he painted a portrait of 'Ali Quli Khan himself. The Shamlu governor had a talented scribe and poet from his own tribe, Yulquli Bek Shamlu, who served as his librarian. It does not seem likely that Sadiqi would have ignored these facts, or that he would have been ignorant of the strong possibility that 'Abbas would soon be shah. It seems more than plausible that he would have left Yazd, perhaps about 1585, to join the rapidly growing following around 'Abbas. This hypothesis is borne out by the fact that when 'Abbas ascended the throne in Qazvin in 1587, the painter–poet was given a coveted and lucrative position as head of the royal library. It seems that the appointment was not merely in recognition of Sadiqi's formidable artistic talents but also a reward for the painter's political perspicacity. For it was basically a bad choice. Even by this time Sadiqi had a reputation for being ill-tempered and unable to get along with associates. His difficult personality is not only apparent in many of the pages of the *Majma' al-Khawass* but also in the statements about him both by Qazi Ahmad and Iskandar Munshi.

His tenure lasted only ten years, and much of it was stormy. Still, one great *Shahnamah,* whose surviving fragment of sixteen pages can be securely attributed to the early years of 'Abbas's reign from about 1587 to 1597, must have been produced under his direction, and three of its extant miniatures can be firmly ascribed to Sadiqi's hand. As we shall see, it brought Sadiqi together with a major rival, Riza, a superbly gifted younger master who was rapidly to emerge as the leading artist at 'Abbas's court, where he at first rivaled and then eclipsed Sadiqi himself.

Despite Riza's probably very disconcerting presence, Sadiqi prospered in his new position. Within four years he had amassed enough wealth, security, and prestige that he could usurp the usual role of

princes and commission his own manuscript, the 1593 *Anvar-i Suhayli*. It was a proud and haughty man of sixty years who appended the following colophon to his manuscript: "It is written as it is ordered by the rare man of the time, the second Mani and Bihzad of the Age, Sadiqi Musavvir." Judging from the information transmitted by Iskandar Munshi, the high praise is self-praise: Sadiqi's ego was large, and the chronicler's disparaging description of the artist would seem to be singularly apt. He offended people easily and with evident pleasure, as his *Majma' al-Khawass* so amply indicates. His temper was short and his wit caustic. Though highly favored and regarded by the tolerant shah, he eventually proved ill-suited to direct the atelier and was dismissed, apparently about 1596/97 (1005).

His peculiar personality was not the only factor involved in his dismissal. Sadiqi also had the enmity of 'Ali Riza with which to reckon. The chief calligrapher of the Safavi court under Shah 'Abbas, 'Ali Riza was Sadiqi's match in ambition and his superior in cunning. At the time Sadiqi entered into 'Abbas's service in 1587 as director of the royal library, 'Ali Riza was in the employ of the great Qizilbash amir Farhad Khan Qaramanlu, who was soon to rise to great power as 'Abbas's principal general. The scribe rose rapidly too. Within six years 'Ali Riza had become so celebrated that the ambitious shah commandeered him from the general, and in July of 1593 he began writing for the royal court. He rose to high post almost immediately, for the shah soon placed under his direction all the other court calligraphers.[42]

From this position of power 'Ali Riza moved against Sadiqi, who up until that time had been secure in his position as director of the shah's library and hence of the production of manuscripts. Certainly Sadiqi's less than agreeable personality made 'Ali Riza's task of subversion less arduous, although the exact manner in which he brought about Sadiqi's removal from office is not known. In any

42. Qazi Ahmad, p. 172. N. Falsafi, *Zindigani Shah 'Abbas Awwal*, pp. 53–56, gives much of the information about 'Ali Riza which is presented here. This great Safavi calligrapher under Shah 'Abbas I is not to be confused with the painter Riza, his contemporary at the royal court. Writing in 1596/97 (1005), Qazi Ahmad speaks high praise of 'Ali Riza and hopes "that he will succeed in attaining every success and high post." In his second edition ten years later he is more reserved in his good wishes, probably because he, like Sadiqi and others in the royal establishment, had had a taste of Ali Riza's art politics. The calligrapher was not a man to be trifled with. Years later in 1615/16 (1024) he engineered the murder of one of his chief rivals in nasta'liq, the great scribe Mir 'Imad.

case the painter's dismissal occurred very soon after the completion of Qazi Ahmad's "first edition" of 1596/97 (1005), where he speaks of Sadiqi as the kitabdar of Shah 'Abbas I. In the following year he no longer held his post, for Jalal al-Din Muhammad describes him then as the former librarian.[43]

If 'Ali Riza's enmity and Sadiqi's own personality were key factors in his fall from grace, one additional factor may have been crucial as well. Although it was accepted practice for the kitabdar to take a personal share out of the funds expended for materials in the production of manuscripts, Sadiqi took tradition one step further: he stole and subsequently sold one of the shah's most precious paintings. Shah 'Abbas's contemporary, the Mughal emperor Jahangir, reports the incident in his *Memoirs,* when he describes the return of his ambassador Khan 'Alam from his 1618 journey to Isfahan:

> As for the beautiful and costly things that the Khan 'Alam brought, it was indeed the assistance of his destiny that gave such rare things into his hand. Among them was the picture of the fight of Sahib Qiran [Timur] with Tuqtamish Khan, and the likenesses of him and his glorious children and the great Amirs who had the good fortune to be with him in that fight, and near each figure was written whose portrait it was. In this picture there were 240 figures. The painter had written his name as Khalil Mirza Shahrukhi. The work was very complete and grand, and resembled greatly the paint-brush of Ustad Bihzad. If the name of the painter had not been written, the work could have been believed to be his. As it was executed before Bihzad's date it is probable that the latter was one of Khalil Mirza's pupils, and had adopted his style. This precious relic had been obtained from the illustrious library of Shah Isma'il I, or had come to my brother Shah 'Abbas from Shah Tahmasp. A person of the name of Sadiqi, a librarian of his, had stolen it, and sold it to someone. By chance [the painting] fell into the hands of Khan 'Alam at Isfahan. The Shah heard that he had found such a rare prize, and asked it of him on the pretense of looking at it. Khan 'Alam tried to evade this by artful stratagems, but when he repeatedly insisted on it, he sent it to him. The Shah recognized it immediately when he saw it. He kept it by him for a day, but at last, as he knew how

43. Gandjei, "Life and Work of Sadiqi," p. 113.

great was our liking for such rarities, he—God be praised—
made no request whatever for it, but told the facts of the case
[about its being stolen] to Khan 'Alam, and made the picture
over to him.[44]

The passage is of great value on many levels. Not only does it
testify to the high connoisseurship of both Jahangir and Shah 'Ab-
bas, but it also indicates that both patrons shared a marked predi-
liction for early fifteenth-century Timurid painting and that as a
result 'Abbas knew it would be an exceedingly pleasing gift for his
Mughal counterpart. It also makes clear that Sadiqi's daring was
extraordinary, for he had stolen one of Shah 'Abbas's most valued
and well-known treasures. That he had been able to sell it indicates
that there was an equally daring wealthy man in Isfahan who may
have known that the painting belonged to the shah but still was will-
ing to buy it and presumably conceal it in his own collection.

The theft must have occurred before Sadiqi was dismissed from
his post in 1596/97 (1005). Despite the kitabdar's opprobrious
conduct, the shah generously allowed Sadiqi to retain both his title
and his salary after this date, although the real power of the office
passed to 'Ali Riza. Sadiqi was surely very bitter, and he must have
watched for an opportunity to unseat the usurper.

At the beginning of his directorship in 1596/97 'Ali Riza was
charged by the shah with the creation of a great *muraqqa'* (album of
paintings and calligraphies), called the *Kharqah-i Namah* (Book of
Fragments), intended to contain samples of the finest work of Iran's
best calligraphers and painters. It was an impressive commission,
perhaps originally intended for Sadiqi and certainly guaranteed to
arouse his envy. For some reason, however, 'Ali Riza was slow in
the completion of this prestigious task. By the following year the
book was still not finished, and Sadiqi moved against his enemy.
Probably hoping to unseat 'Ali Riza from the post he had once oc-
cupied himself, the painter lodged a formal complaint with the shah
against the calligrapher, whom he apparently accused of being dere-
lict in his duties. Absent from the capital and heavily involved with
his crucial campaign in Khorasan against the Uzbeks, the shah still
had time and energy to deal with the petty squabbles within the ar-
tistic hierarchy of the distant capital city. Obviously alarmed, 'Ab-

44. Jahangir, *Tuzuk-i Jahangiri*, trans. Alexander Rogers, ed. Henry Beveridge
(London, 1909–14), 2:116.

bas ordered 'Ali Riza to proceed immediately to the royal camp and to bring with him the entire studio of painters, gilders, and binders who were at work on the *Kharqah-i Namah*. The peremptory summons had the desired effect. By 1599/1600 (1008) the album was complete.

Sadiqi's attempted countercoup had failed. For the rest of his life 'Ali Riza continued to hold the monarch's high regard, and the calligrapher outlived the painter by many years. In fact, it is reported that Shah 'Abbas would sometimes even sit beside 'Ali Riza and himself hold the candle by which the master wrote. It was an almost unheard-of honor. The monarch's esteem appeared to be boundless: he considered 'Ali Riza's script equal to that of Mir 'Ali Haravi, the universally acknowledged high classical master of nasta'liq, and it was to 'Ali Riza that the honor was given of providing inscriptions for the great Isfahan mosques—the Masjid-i Shah and the Masjid-i Shaykh Lotfallah—and for the tomb of the Imam Riza in Mashhad.

Deprived of power, though not of salary and title, for the remaining years of his life, Sadiqi still kept very active. He continued to be one of the leading court artists, and a few fine drawings can be securely attributed to this period. But much of his time after 1596/97 must have been spent writing. The *Qanun al-Suvar* was completed about 1597/98 (1006), and his key work, the *Majma' al-Khawass,* was finished between then and 1601/02 (1010). An *'Abbasnamah,* modeled on the *Shahnamah,* had probably been composed soon after the shah's accession. Seven other works also belong to the period before 1601/02, while a *Jangnamah* (Book of War), mentioned by Iskandar Munshi, must have been written in the years between 1601/02 and 1610, when Sadiqi died.

Literary Works

To judge from the pages of the *Qanun al-Suvar,* and the *Majma' al-Khawass,* Sadiqi was one of the most engaging, if not one of the best, writers of the Safavi period. His Chaghatay prose in the *Majma' al-Khawass* is simple and direct, full of sharp observations and pointed humor; and his Persian poetry is at least as good as anything produced by his Safavi masters. Although his praise of certain personages, particularly important patrons, is occasionally so rich as to suggest sycophancy, his descriptions of most people are more often colored with either humor and affection or laughing scorn and outright contempt. There are few entries which are wholly

favorable and not obsequious, and these are almost exclusively limited to his entries on his cherished masters Mir San'i and Muzaffar 'Ali. In any case Sadiqi's is not a moderate temper, and the personality revealed in the pages of the *Majma' al-Khawass* makes Iskandar Munshi's description of the poet–painter all the more credible.

Our treatment of him here is necessarily largely restricted to his role as an artist, but it is clear that he considered himself at least as much a poet as a painter. In Isfahan in 1601/02 (1010) he compiled a brief list of his literary works, and his very considerable output is evidence enough of his dual role: certainly he must have spent as much time composing his ten major literary works as he did painting miniatures. His works, briefly described, follow:

1. *Zubdat al'Kalam,* a collection of his qasidahs
2. *Fathnamah-i 'Abbasi,* a poetic chronicle in the meter of the *Shahnamah* and dealing with the battles of Shah 'Abbas
3. *Sharh-i hal,* didactic adages and stories in the meter of Nizami's *Makhzan al-Asrar*
4. *Sa'd u Sa'id,* a romance in the same meter as Nizami's *Khusraw u Shirin*
5. *Hasil-i hayat,* a collection of his Persian and Turkish poems
6. *Majma' al-Khawass,* written in Chaghatay Turkish and modeled on the *Majalis al-Nafa'is* of Mir 'Ali Shir Nawa'i. It contains 480 entries on leading poets, artists, and patrons from the time of Shah Isma'il I to the period of Shah 'Abbas I
7. *Qanun al-suvar naqqashi,* a verse treatise, written in the meter of Nizami's *Khusraw u Shirin* and dealing with the techniques of painting
8. *Mulamma'at,* a collection of his writings and letters in Persian and Turkish
9. *Tazkirat al-shu'ara,* a treatise of mu'amma
10. *Hazziyat*[45]

Like any wise courtier Sadiqi also composed the requisite occasional verses which were panegyric in nature, such as his couplet

45. See Gandjei, "Life and Work of Sadiqi," and A. R. Khayyampur's introduction to Sadiqi's *Majma'.* Sadiqi's 1601–02 list does not include his *Jangnamah* mentioned above.

commemorating and dating the circumcision of 'Abbas's first son, Safi, in 1587 (995).

Among these many works the *Qanun al-Suvar* provides us with Sadiqi's own, theoretical image of the artist in sixteenth-century Iran. But the *Majma' al-Khawass* gives us an oblique and probably more revealing view of his personality.

Sadiqi's entries on Muzaffar 'Ali and Mir San'i are full of warm affection and high praise. It is obvious that with both men Sadiqi found himself in a nearly ideal student–teacher relationship: he admired them not only for their abilities and for what they could impart to him but also for the kind of men they were. Implicitly, they were the models of virtue for him, even if it is equally apparent that he did not or could not really emulate them. Both had had a good measure of bad luck, as had Sadiqi: Muzaffar 'Ali was "somewhat ill-starred" in Sadiqi's words, and Mir San'i ended his life in a passionate love affair whose tragicomic character Sadiqi clearly perceived. Yet both were also men who had by Sadiqi's own account become wise in their old age and reconciled to the occasional misfortunes in their pasts.

Sadiqi himself did not attain this wisdom. There is no hint of reconciliation or temperance on the author's part in the *Majma' al-Khawass*, presumably written near the end of his career. Those he disdained in his youth, he still disdains. His language is more cynical than sarcastic, and his inability to live with other people's faults seems to have left him bitter and still all too clearly perceiving the weaknesses and foibles of his fellows. His humor is not simple jovial laughter; it is belligerent, often vicious. Sadiqi is not exorcising his own bitterness; he is luxuriating in his vengeance.

His entry on Qamati Gilani is a mixture of pomposity and poison which is typical of Sadiqi at his most vindictive:

> He has a romantic and dervish-like temperament and does not mix with people. His penname fits him very well. I, who have traveled in every important country, have not met anyone of his great height. In his person is verified the *hadith* [traditional saying] of the Prophet that "Tall people are the greatest fools."[46]

46. Sadiqi Bek, *Majma'*, p. 237. "Qamati" could be translated approximately as "big man."

He must have taken great joy in skewering people on his barbs, and some, perhaps like poor Mir Muhammad Aywaghali, must have suffered publicly under his scorn: "As he is a little stupid, he gilds his poems with gold and lapis, so that they become a bit more agreeable " (p. 126).

Although he was a painter himself, he does not seem to have valued highly his contemporaries in his own profession, for though he devotes hundreds of entries to the leading poets of his day, he mentions only five painters, four of whom are of the previous generation and are deceased. To Mawlana Shah Muhammad he gives the briefest of entries and mentions only that he was a painter who lived in Mashhad (p. 264). To his teacher Muzaffar 'Ali he of course affords much praise. He mentions Mir Sayyid 'Ali as well, "the son of Mir Musavvir . . . and a very gifted painter." As far as it goes, the entry is gentle; but what obviously gives Sadiqi most pleasure is his mention of the bitter hostility between the painter and Mawlana Ghazali which we have cited earlier. In his lengthy discussion of the painter Khwajah 'Abd al-'Aziz, one of the principal figures of the Houghton *Shahnamah*, Sadiqi dwells at great length on that painter's kidnaping of the shah's favorite page boy or catamite. The shah spared the painter's life but did allow his nose and ears to be cut off in punishment by the boy's outraged father. Sadiqi found it a source of great amusement: "Afterwards, thanks to his art, he made himself a new nose, which was much better than the real one" (pp. 254–55).

But all these men flourished two decades before Sadiqi. What of artists of his own generation? He mentions only one, Ustad Hasan Muzahhib, a painter whose work is as yet unknown. The entry merits quotation in full:

> He is of the people of Baghdad and the son of Ustad Qiwam al-Din Baghdadi. Although his father had many good qualities, he is the reverse of him. In his own art he has no equal. It is as if the saying of the Prophet of God—"All who are short are troublemakers"—was uttered with regard to him. If he were able, he would not spare any of his equals any harm or injury. Many odd and heedless acts have been perpetrated by him. He even counterfeited the seal of the late Shah Isma'il II, was disgraced, but still lived safe and sound. He is incredibly

lucky in these things. Since this short space is not sufficient for a description of the deeds he did, we must be content with a mention of some of them.

First, he threw a piece of porphyry with such force from a high roof onto his father's head that if Fate had not helped his father, he would now be among those who have been dead a thousand years.

And I heard from his father that he himself had made a petition which was signed and sealed by the most important people of Baghdad and sent to [western Iran]. In it was written: "Whoever kills Hasan Muzahhib, I am ready to answer for the deed, in this world and the next."

And yet another story is this. There was a young man named Qasim Bek Sehaf in Tabriz. He had taken the above-mentioned mawlana to his house and had become close friends with him. When the mawlana had gained their confidence, he started sexual relations with a Caucasian slavegirl [belonging to Qasim Bek]. After all this was found out, Hasan Muzahhib was afraid of being killed, and by means of a trick, he bought the girl from the youth. Now he has a legitimate son by her, whose apprentice the mawlana is not fit to be.[47]

Thus it is right what has been said:

A man of bad origins will not be faithful to anyone.
The man of bad origins never fails to do evil.

It would not be fair to exaggerate Sadiqi's malevolence. He can and does say kind things about his contemporaries, but the comments are usually as short as this entry about Yulquli Bek Shamlu:

He was the director of the library of 'Ali Quli Khan, the Beklerbek of Herat. He is a very self-effacing, polite, and good-natured youth. His pen name is Anisi.

He has a powerful poetic gift. He composed one mathnawi entitled "Mahmud and Ayaz," but it has not yet become well known. [p. 107]

Yet it is clear enough that Iskandar Munshi's judgment of Sadiqi's character is by and large correct. Small wonder then that he was dismissed as 'Abbas's library director. If his tongue was as caustic as his pen, one wonders how he managed to live to a ripe old age.

47. I.e., the son is even more evil than the father. Ibid., pp. 257–58.

Artistic Works

Sadiqi's first firmly ascribed work occurs in the 1573 *Garshasp-namah*, where a single miniature bears his name.[48] The page, folio *45b*, depicts Garshasp fighting the dog-heads (fig. 12); Sadiqi's name appears at the bottom between two columns of text. In the background against a lavender hill Garshasp and two other heroes struggle with four of the demons. In the background around a silver-gray mountain three more warriors warily watch the battle below, while two more dog-headed demons await an advantageous point to enter the fray. The bright colors, applied in rather thin pigment, are characteristic of Muzaffar 'Ali's palette, as is the firm outlining of the figures and the attempted lyrical curve of the landscape. Sadiqi seems to have learned some lessons well from the master with whom he had been studying for the last five years. But other lessons he has not learned.

Muzaffar 'Ali's last ascribed work is to be found in the same *Garshaspnamah:* folio *5a* is an illustration of Firdawsi's meeting with the court poets of Ghaznah (plate 3). The great poet stands at the left on one side of a little stream, while his interviewers sit around a picnic cloth on the other side. The landscape is idyllic; trees are full of blossoms, grass is a rich green, and birds sing in the tall cypress at the left. Nature is lyric and gentle, as it always is in Muzaffar 'Ali's work: there are no harsh lines or jagged notes, and even the psychological confrontation between Firdawsi and the court poets is expressed not in terms of tension but in terms of respect. The painter has chosen to depict the moment after Firdawsi has spoken, and the poets are clearly deeply impressed: one strokes his beard thoughtfully; the other two offer Firdawsi a place beside them.

Sadiqi's painting (fig. 12) on the other hand relies on tension: the twist of the mountain to the left is too abrupt to be of Muzaffar 'Ali's conception, and the almost sudden shift of the landscape to the left is countered by the movement of the battle toward the right. The bright orange-red of the foreground heroes sets an uneasy contrast with the lavender hill behind them; so too does the almost phosphorescent yellow central demon against the purple-blue of Gars-

48. This manuscript, acquired by the British Museum in 1966 (Or. 12985), also contains one miniature ascribed to Muzaffar 'Ali and one to Zayn al-'Abidin. It has been discussed in the *British Museum Quarterly* 31 (1967), pp. 27–32, and in B. W. Robinson, *Persian Miniature Painting*, no. 48 and pls. 22–24.

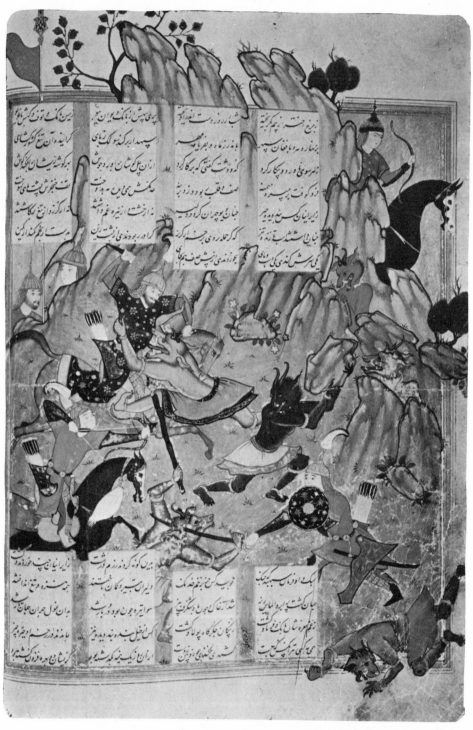

Fig. 12. SADIQI. *Garshasp fights the dog-heads.* From the 1573 *Garshaspnamah.*

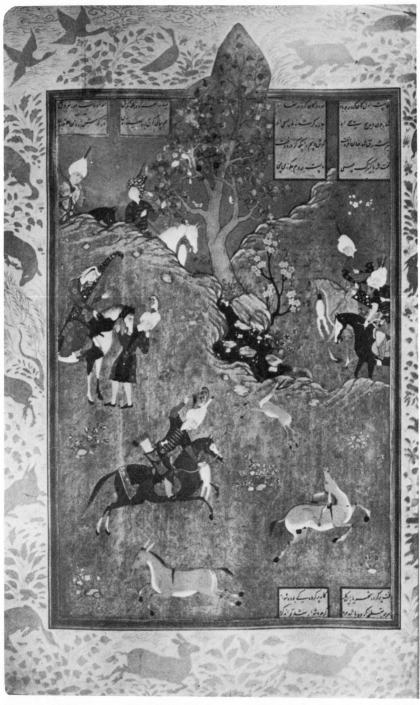

Fig. 13. MUZAFFAR 'ALI. *Bahram Gur shoots an onager.* From the 1539–43 British Museum *Khamsah.*

hasp's horse. The landscape is pointed and jagged. The easy, open circle which is central to Muzaffar 'Ali's composition in plate 3 is countered in his student's work by a long, narrow isosceles triangle which juts outside the lower right frame of the miniature. Whereas Muzaffar 'Ali's few battle scenes are never painful, whereas his fatally wounded onager in the British Museum's *Khamsah* of Nizami (fig. 13) gently expires singing a graceful and melodious aria, Sadiqi's dog-headed demon twists in agony on the ground, while another screams as his head is cleaved by a sword.

The composition itself does not flow. Nature is a backdrop: there is no sense of interaction between natural setting and human beings, as there is in Muzaffar 'Ali's painting. Figures seem locked in place, like jewels in an enamel setting.

By his own account Sadiqi had actively sought out Muzaffar 'Ali, and with good reason. For figure 12 alone indicates that Muzaffar 'Ali was a teacher who brought out his student's gifts and natural propensities and allowed them to develop in their own individual directions. The student does not turn out second-rate Muzaffar 'Alis. Sadiqi has learned the elements of his teacher's craft, but he has learned how to use them in his own way.

The miniature in the *Garshaspnamah* is Sadiqi's earliest known work and not one of his most satisfying. Three years later he was a leading figure in one of the most ambitious manuscript productions of the period, the 1576–77 *Shahnamah* for Shah Isma'il II.

The general outlines of the manuscript have already been discussed with regard to Siyavush. Of the miniatures presently known which bear artists' names six are ascribed to Sadiqi, making him one of the leading contributors to the great manuscript. Only Siyavush produced a significantly larger number than he. Though he was still a relatively young man, Sadiqi was in high favor at Isma'il's court. Perhaps this was not only due to his ability as a painter but also to his many activities outside the world of art. By his own written account in the *Majma' al-Khawass* he was a confidant of the unstable shah, and this close tie may have aided him in securing an important place in the manuscript's production.

Surely Isma'il II was striving to prove himself as gifted, sensitive, and energetic a patron as his father Tahmasp and his cousin Ibrahim. Like Tahmasp, Isma'il allowed his favorite painters almost unheard-of-liberties. But it was not only the shah with whom Sadiqi was on close terms. His Qizilbash origins, his military prowess, and

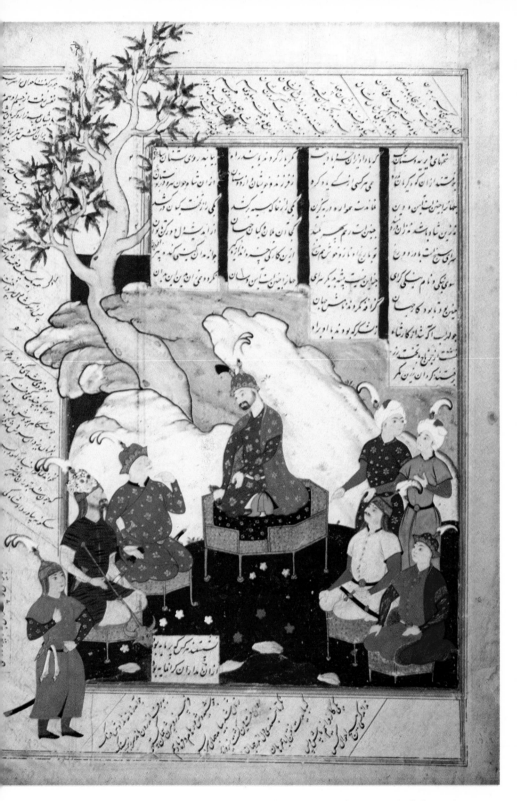

Plate 1. SIYAVUSH. *Zal and Rustam before Kay Khusraw*. From the 1576–77 *Shahnamah*.

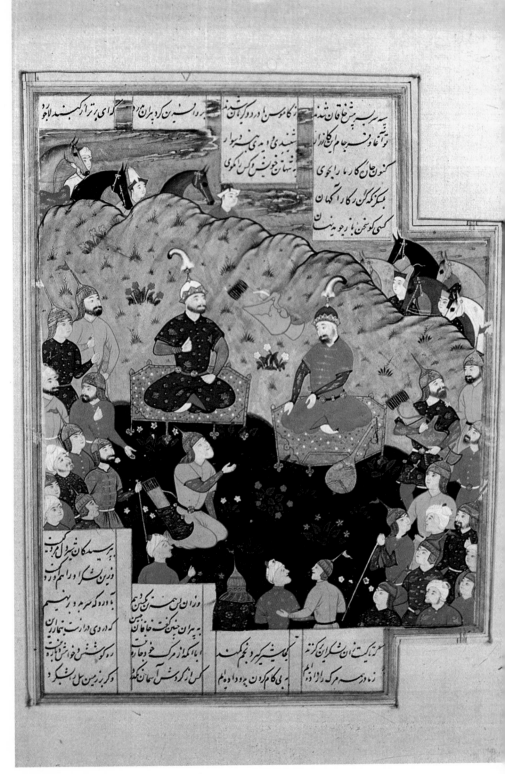

Plate 2. SIYAVUSH. *Piran confers with Kamus and the Khaqan of Chin.* From the 1576–77
Shahnamah.

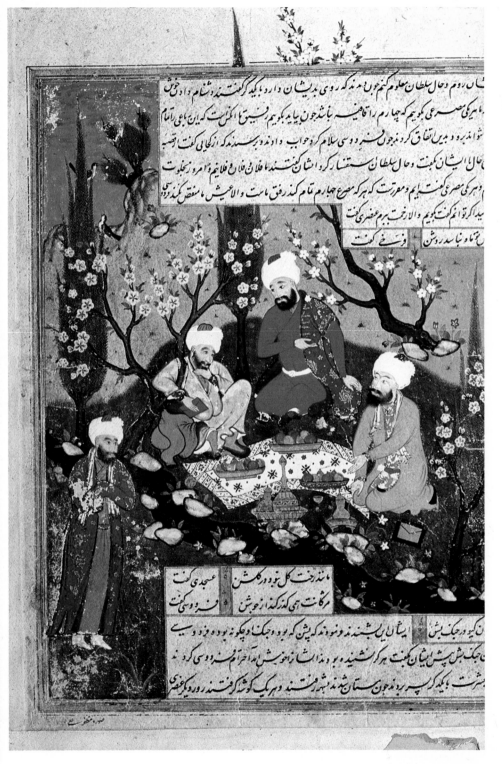

Plate 3. MUZAFFAR 'ALI. *Firdawsi and the court poets of Ghaznah*. From the 1573 *Garshaspnamah*.

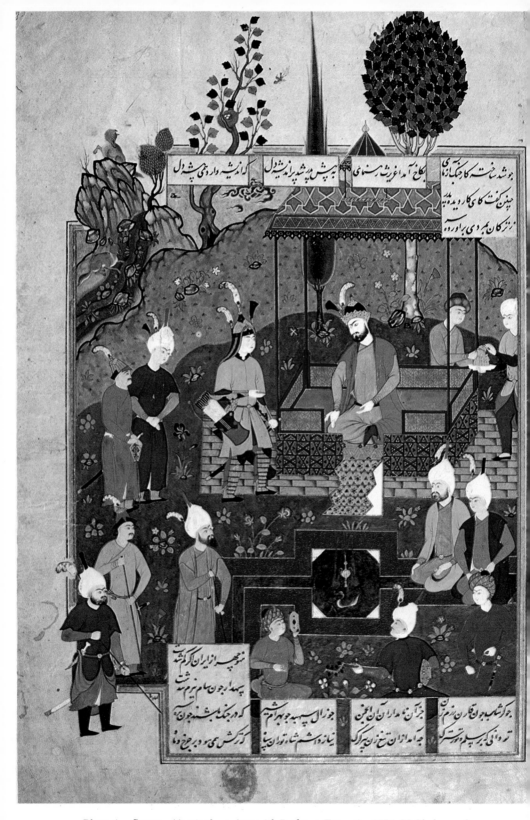

Plate 4. SADIQI. *Afrasiyab confers with Pashang.* From the 1576–77 *Shahnamah.*

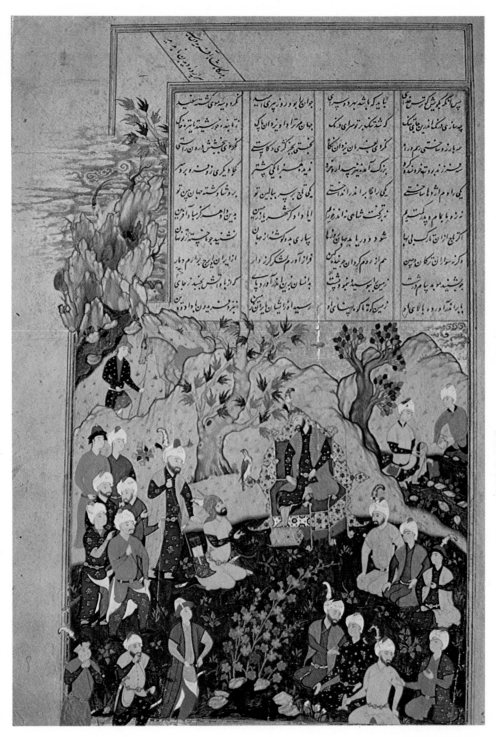

Plate 5. SADIQI. *Faridun receives the ambassador from Salm and Tur.* From the 1576–77 *Shahnamah.*

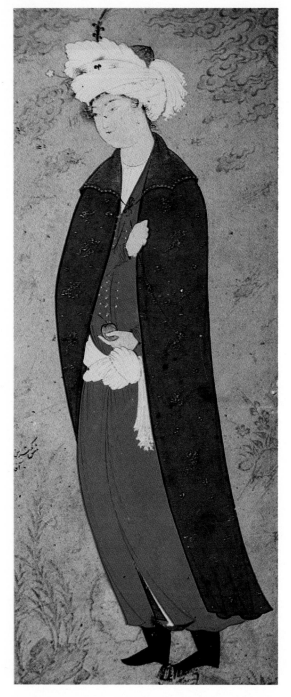

Plate 6. RIZA. *Young man in a blue cloak*. Circa 1587.

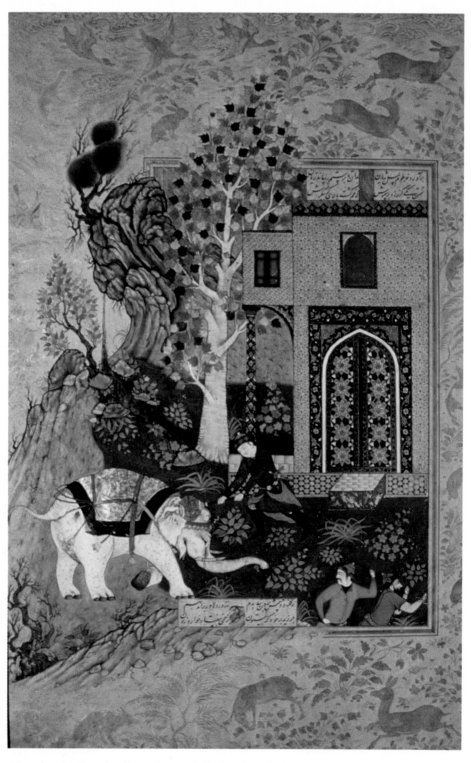

Plate 8. Attributed to RIZA. *Rustam kills the white elephant.* From the 1587–97 *Shahnamah*.

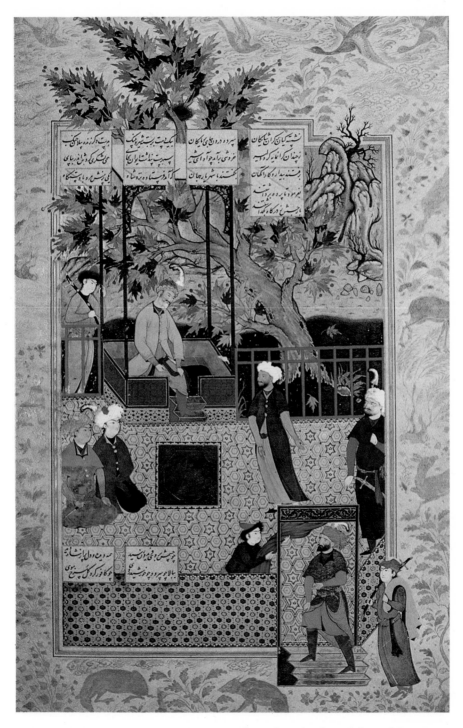

Plate 9. Attributed to RIZA. *Faridun spurns the ambassador from Salm and Tur.* From the 1587–97 *Shahnamah*.

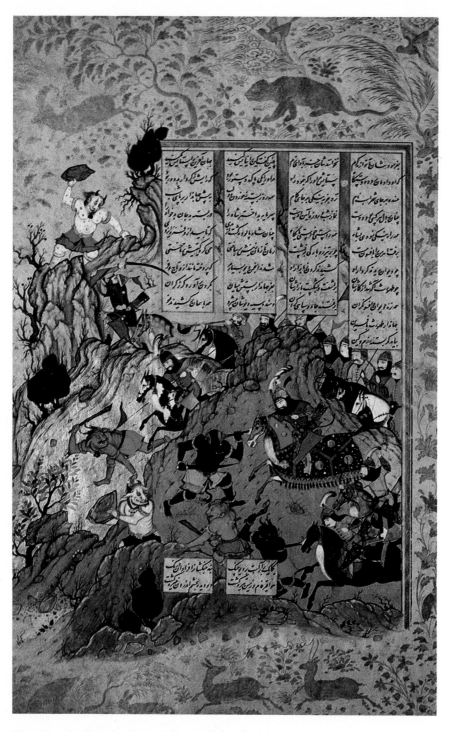

Plate 10. Attributed to RIZA. *Tahmuras fights the demons.* From the 1587–97 *Shahnamah*.

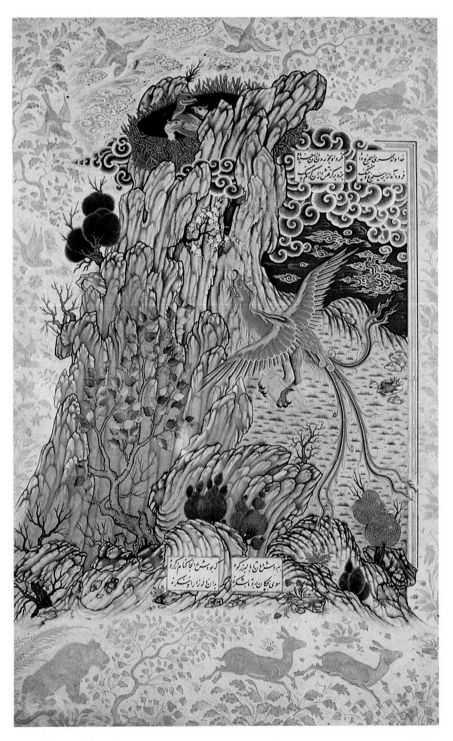

Plate 11. Attributed to SADIQI. *The simurgh carries Zal to her nest*. From the 1587–97 *Shahnamah*.

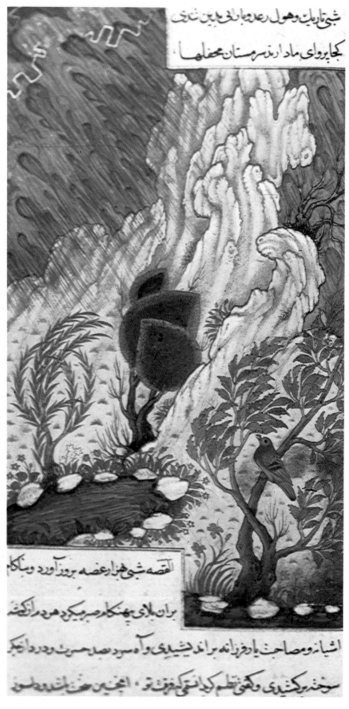

Plate 12. SADIQI. *A bird in a storm*. Folio 16a from the 1593 *Anvar-i Suhayli*.

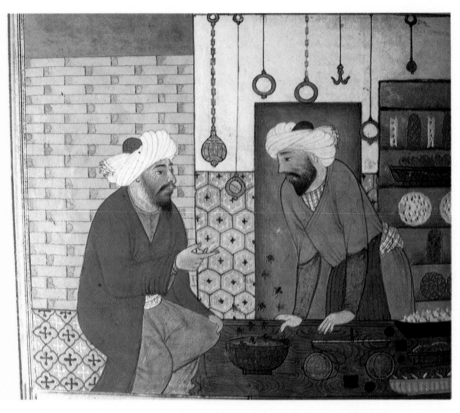

Plate 13. SADIQI. *Two men in a market*. Folio 265a from the 1593 *Anvar-i Suhayli*.

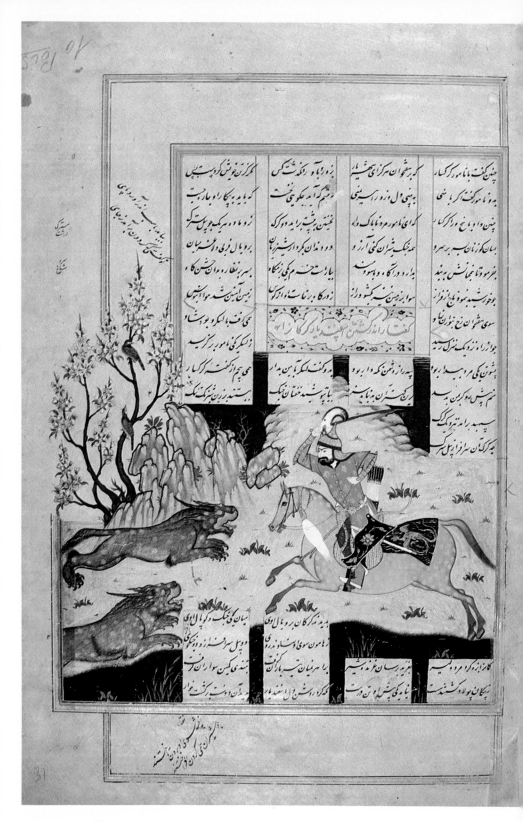

Plate 14. NAQDI. *Isfandiyar kills two kylins.* From the 1576–77 *Shahnamah*.

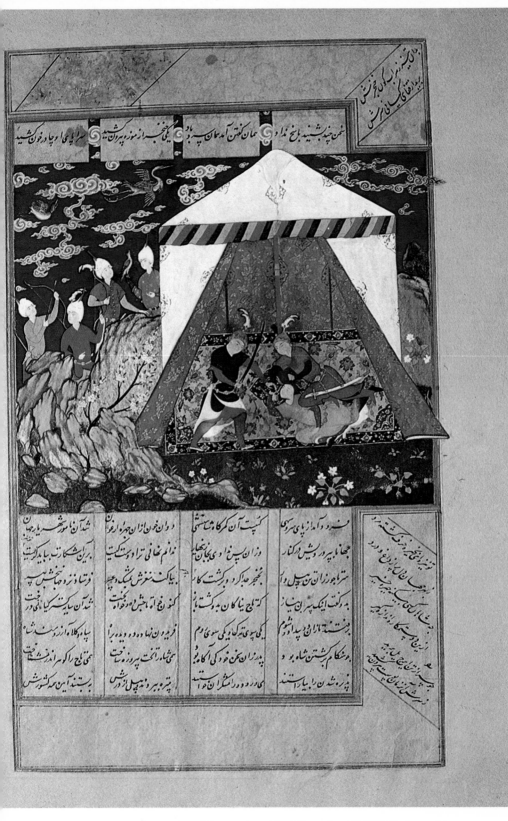

Plate 15. MURAD DAYLAMI. *The murder of Iraj.* From the 1576–77 *Shahnamah.*

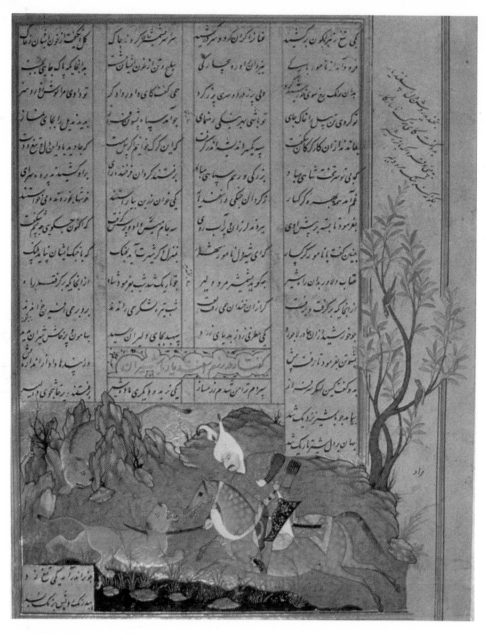

Plate 16. MURAD DAYLAMI. *Isfandiyar kills two lions.* From the 1576–77 *Shahnamah.*

his apparent wide contacts among both the Qizilbash nobles and the Tajik officials must have made him a uniquely well-connected figure at court. Is it possible that Sadiqi was the director of the *Shahnamah* project?

By virtue of his training he might well have been. He had been superbly schooled under both Mir San'i and Muzaffar 'Ali. Although it was more commonly the calligraphers who headed the production of individual manuscripts, some of the greatest Safavi manuscripts were directed by painters; both the Houghton *Shahnamah* and the British Museum *Khamsah* of Nizami were under the direction of painters. The only painter from the older generation who worked on the manuscript for Isma'il II was 'Ali Asghar, but by all appearances his role was a relatively minor one. Due to Muzaffar 'Ali's high standing and his great reputation, he may well have been initially appointed to head the project, and this may be the reason his two key students Siyavush and Sadiqi have such a large role in illustrating the manuscript. But Muzaffar 'Ali's death followed not long after Tahmasp's and precludes his having been able to complete the project as its director. It seems a distinct possibility that at this point Sadiqi, as one of Muzaffar 'Ali's two senior students, would have assumed the role of director.

What of Sadiqi's work as a painter in the manuscript? In most respects it is an extension of his work in the 1573 *Garshaspnamah,* as a detailed examination of three representative paintings indicates. The illustration of the conference of Pashang and Afrasiyab bears Sadiqi's name in the lower left corner (plate 4). The delicate pavilion throne to the right of center is balanced by a small cluster of courtiers at the lower left. In the background are a stiffly lyrical tree and a hovering bird. The multihued rocks range in color from a luminous lavender to a golden yellow and a pastel green. The rise of hill and rocks is gentle rather than precipitous. The mood, if not wholly in the mode of Muzaffar 'Ali's idylls, is at least changed from the almost tortured accents of the 1573 page.

But there is a disturbing quality in this picture. Contours seem unusually hard: those in the landscape are often outlined in thick black, while human contours are accented in a thin, brittle line. Figures face one another, but seem neither to look at nor talk with one another. The atmosphere is cold, almost chilling, and the composition is coolly calculated rather than felt. There is no human warmth, and the superficially charming natural notes—the birds in

the trees—are a token gesture toward a standard, almost requisite motif in Persian painting rather than a novel and warmly felt lyrical element. This is the painting of a well-trained and highly cerebral master.

A second miniature by his hand in Isma'il II's *Shahnamah* depicts Zal waiting stolidly below Rudabah's castle while the enticing princess talks to him from the roof (fig. 14). In the upper right is a landscape similar in style and effect to that in the previous painting, although Sadiqi has added in the upper left corner of this natural setting a gentle rocky outcropping with a pair of plump brown birds. The representation of architecture is conspicuously flat, and the striking advances in the depiction of architectural space which had been made under Bihzad and the early Safavi painters are almost wholly absent. The palace steps, entrance, walls, and recesses appear to be all on the same plane—a single colorful playing card with the princess and her handmaidens graciously ornamenting the top. This apparent disinclination to delineate visually convincing architectural forms is to remain one of the identifying characteristics of Sadiqi's work.[49]

The painter's art in this manuscript is clearly that of a relatively conservative artist, accomplished in the techniques of his respected master and securely moving within established traditions. But his own development is not untouched by those around him. He is an artist intensely affected by the milieu in which he works, and he readily assimilates the styles and characteristics of his artistic associates. This "eclectic" quality is especially evident in his drawings, which will be considered later, but in at least one miniature from the *Shahnamah* he closely approximates the work of his fellow student and long-time associate Siyavush.

The scene (plate 5) shows Faridun receiving the ambassador from Salm and Tur, the aging monarch's two jealous sons who are soon to murder their innocent and more favored younger brother Iraj. The roughly circular composition, as well as the highly individual figures gathered around the monarch's throne (fig. 15), make it clear that Sadiqi is emulating the manner of his gifted co-worker. Here the landscape in the upper left (fig. 16) is almost luxuriantly

49. It occurs again in another miniature from the 1576–77 *Shahnamah*. This miniature, in which Rustam is shown killing the white elephant, is in a private collection in Italy. (See *Sale Catalogue*, Sotheby & Co., London, December 7, 1971, lot 190A.)

Fig. 14. SADIQI. *Zal before Rudabah's castle*. From the 1576–77 *Shahnamah*.

Fig. 15. SADIQI. Detail of *Faridun receives the ambassador from Salm and Tur* (plate 5).

Fig. 16. SADIQI. Detail of *Faridun receives the ambassador from Salm and Tur* (plate 5).

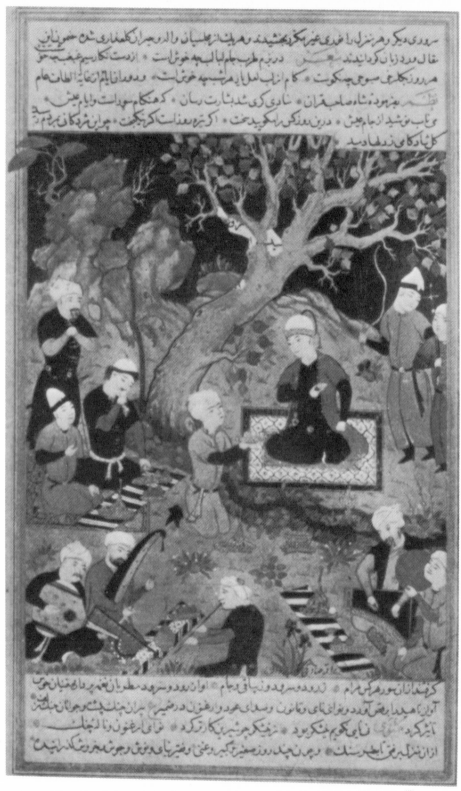

Fig. 17. SADIQI. *An outdoor entertainment*. From the 1579 *Habib al-Siyar*.

rendered, its colors harmonious rather than harsh, and its ambience
gentle and lyrical. The men gathered in a Siyavush-like order
around Faridun are varied and convincing individuals, and the
rather cold quality we noted in plate 4 is replaced by more melodi-
ous accents, such as the waving flowers beside the pool or the bend-
ing trees whose leaves are touched by the wind. Human beings
communicate, as they do not in Sadiqi's other pictures, and though
the painting has little of the psychological tension and anxieties of
Siyavush's representation of Piran's fateful meeting with Kamus and
the Khaqan of China, there is a sense of the text's significance: the
ambassador is bargaining for a better allotment of the world's re-
sources, whose choicest land, Iran, has been given to the youngest
son, Iraj.

In every respect this work is the most successful of Sadiqi's known
paintings for the 1576–77 *Shahnamah,* and one wonders how much
of its success is due to Sadiqi's "openness" to Siyavush's influence.
For, as we will see, the most successful drawing of his later years is
the one in which he is most strongly affected by the stylistic inno-
vations of Riza. Although he is an artist of talent, fine training, and
high capabilities, one suspects that he needed the "inducement" of a
more ingenious colleague (or rival) to rise above the almost hum-
drum patterns of his own less than personal style.

The miniatures he produced for the 1576–77 *Shahnamah* repre-
sent the last of Sadiqi's known work in royal employ for the next
ten years. Surely he, like Siyavush, must have hoped that the new
shah, Muhammad Khodabandah, would continue the work on the
unfinished *Shahnamah* and utilize the formidable talents of the ate-
lier which Isma'il II had assembled in so short a time. But he was
disappointed. Suffering both from weakness of ambition and from
the political turmoil around him, Shah Muhammad did not indulge
his predilection for painting, and Sadiqi left Qazvin for the Hamadan
court of Amir Khan, where he stayed two years. His next dated
work is in the 1579 *Habib al-Siyar,* and it is not a work of great
distinction. His depiction of an outdoor entertainment (fig. 17) is
technically accomplished but not on a level with his representation
Faridun receives the ambassador from Salm and Tur (plate 5). And
it was done for a Tajik patron, while Sadiqi aspired to royal favor.

According to our sources, he again left Qazvin in the same year
and wandered in search of patronage through much of Iran until
1587, when he may have accompanied the triumphant young Shah

'Abbas back to Qazvin. With no steady employment at a well-
equipped atelier during this period, Sadiqi evidently turned his
talents to drawing, thereby joining the many other painters, like
Siyavush, Mirza 'Ali, and Shaykh Muhammad, who had taken up
the draftsman's qalam, partly out of reawakened interest in drawing
and partly out of the lack of reliable patronage for the much more
expensive art of book illustration. Single drawings and miniatures
proliferated in the period from 1550 to 1600. Whatever the reasons
for this sudden appearance of single-page artworks, a new mode of
artistic expression was established which was to continue through-
out the seventeenth century, generally overshadowing the more tra-
ditional art of book painting.

Undoubtedly Sadiqi turned out dozens and perhaps hundreds of
single-page drawings and paintings during this period. What must
be his earliest known work of this sort is a tinted drawing of a seated
princess holding a tiny wine cup in her raised left hand and a light
pink cloth in her right (fig. 18).[50] Stylistically it must follow closely
after the 1576–77 Shahnamah, as a comparison of the princess and
King Pashang from plate 4 suggests. The delicate wrist at the end
of a tapering arm is repeated in both king and princess. So too is the
shape of the hand holding the fine cloth. In quality the delicately
lined drawing with its equally delicate, sensitive tints of blue and
light red is one of the artist's finest achievements.

Both these works share the same almost frigid atmosphere. The
air does not move around the princess: she seems frozen in a state
of exquisite perfection. There is none of the smoothly sensuous
ambience which we find in similar subjects of Mirza 'Ali in the same
period (fig. 19), nor is there any of the overt sexuality which has
been associated with Shaykh Muhammad (fig. 20). Sadiqi's work is
almost emotionless, and this drawing is conceived with a cool, clas-
sical mastery impelled by detached cerebration. Its superb calli-
graphic curves do not measure emotion.

Are these not the same characteristics that were apparent in the
first two paintings examined? Does the princess, like Pashang,
Afrasiyab, and Rudabah, not stare into an inner space, her eyes
meeting no one and her lips communicating nothing? Her double

50. The drawing is bordered with fine calligraphy, marbleized inner margins, and
superb gold-illuminated outer margins. Our only information about the calligrapher
—Mir Husayn al-Sahvi al-Tabrizi—is that he left Iran for India in the late sixteenth
century.

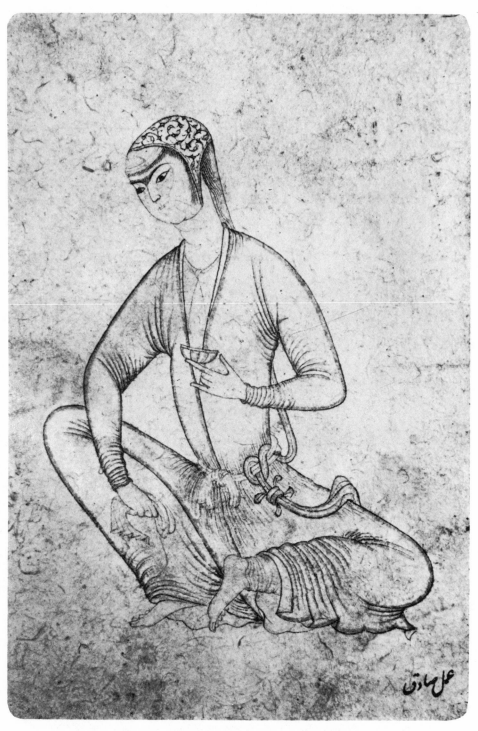

Fig. 18. SADIQI. *A seated princess*. Circa 1578.

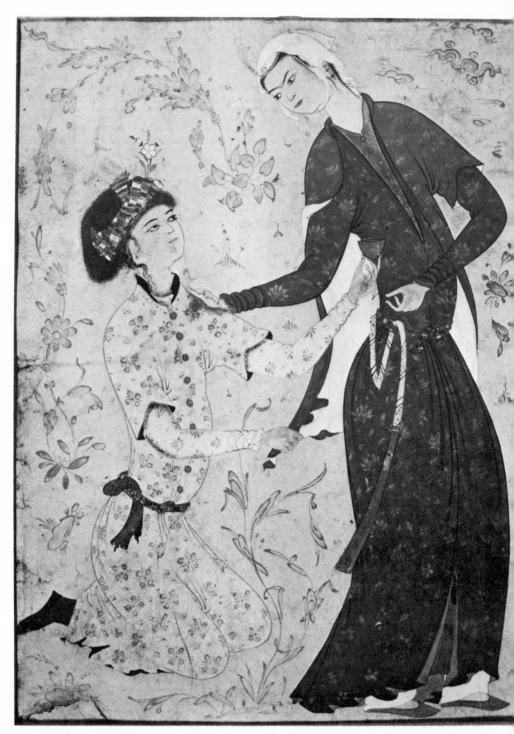

Fig. 19. Attributed to MIRZA 'ALI. *A young man offers wine to a young woman.* Circa 1575.

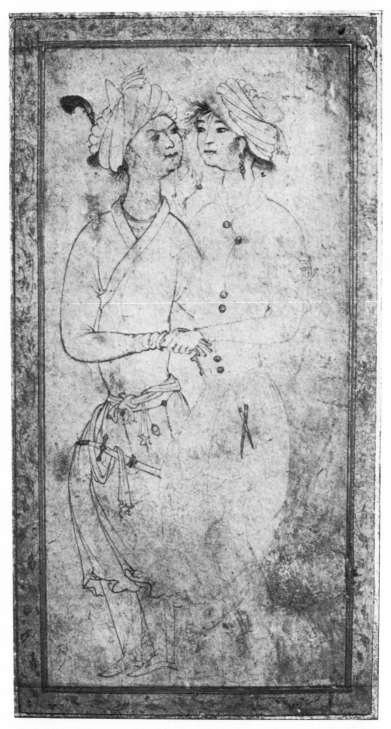

Fig. 20. Attributed to SHAYKH MUHAMMAD. *Two young men*. Circa 1575.

chin, her elongated neck, her tapering waist, all express the formal canons of a Qazvin beauty, but her beauty fascinates rather than attracts the viewer. It is the work of a virtuoso draftsman, and it helps explain why Sadiqi's color sense, in his early paintings at least, seems so weak. The classical distinction between sensual color and cerebral line which so fascinated Europe from the sixteenth through the nineteenth centuries seems neatly applicable to Sadiqi. One drawing would not be enough to make this case, but fortunately his firmly attributed oeuvre is larger. A great album in the Bibliothèque Nationale contains three drawings which must rank with the finest of his work.[51]

Our drawing of the seated princess must have been done about 1577–78, when Sadiqi had taken refuge at the Hamadan court of Amir Khan Mawsillu. A second drawing of a highly refined court woman in a blue cloak and a red dress was probably done only slightly later, about 1580 (fig. 21). She is another Qazvin beauty with tapering forearms, slender long neck, diminutive mouth, arching eyebrows, and narrow waist. Like the *Seated princess* (fig. 18) she is posed in a carefully studied posture of sophisticated elegance, her left hand with its attenuated flowers raised in a pointed conceit, gently echoing her own body's curve. Sadiqi's artistic debt is largely to Mirza 'Ali, one of the great masters of this narrow genre (fig. 19). But despite its sophisticated elegance, the drawing still exists in that cold intellectual atmosphere we have come to associate with Sadiqi. Like Poussin, Sadiqi is moved to make coolly rational statements of sensuous forms.

A second work from the Paris album expresses even more clearly the model of elegant refinement and idealized beauty that became the standard motif of painting in Isfahan some twenty years later (fig. 22). This young dandy is dressed in a red gown over a green undergarment. Around his waist is a purple sash. A delicate feather curls over his white turban, while he distantly sniffs a sprig of flowers almost the twin of the one held by the princess in figure 21. The more nervous calligraphic line, particularly in the turban and sash ends, implies a somewhat later date, closer to 1590 than the other two.

51. Bibliothèque Nationale, Paris, sups. pers. 1171. The album was very likely compiled about 1590, probably at 'Abbas's court and perhaps under the direction of Sadiqi himself. This artist's watchful eye over the creation of the album would explain why a disproportionate number of miniatures (9 out of 25) bear ascriptions to Sadiqi.

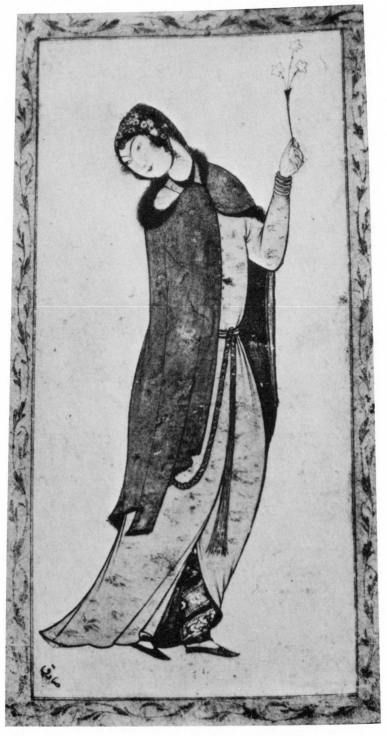

Fig. 21. SADIQI. *Young woman.* Circa 1580.

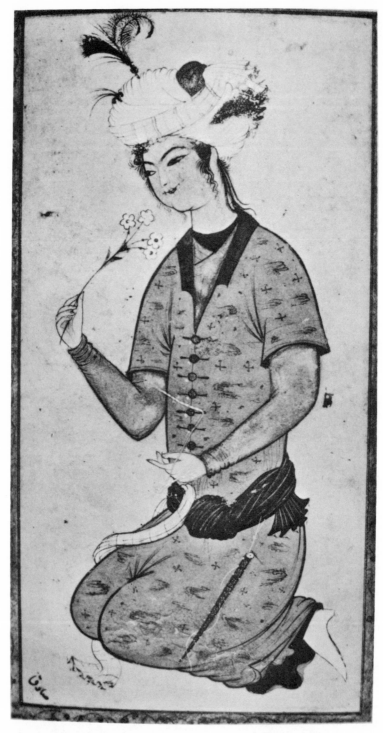

Fig. 22. SADIQI. *Seated young man with sprig of flowers*. Circa 1590.

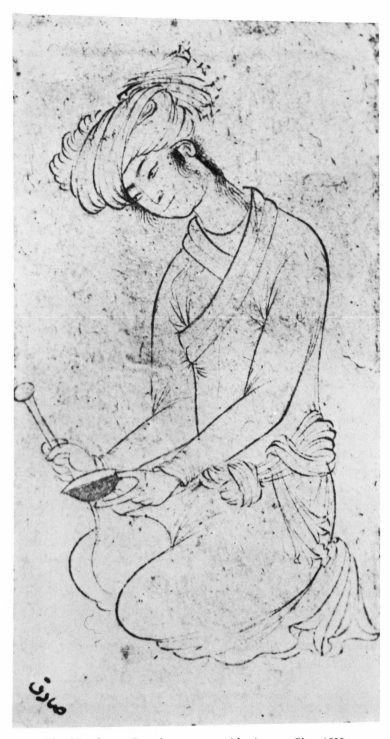

Fig. 23. SADIQI. *Seated young man with wine cup*. Circa 1590.

Its companion piece in the album is a similarly double-chinned youth kneeling to the left and holding a delicate gold wine cup in his left hand (fig. 23). While the cool atmosphere and distant detachment of the youth is much the same as that of the earlier seated princess, the quality of line has changed. The line of the seated princess is nervously explicit, gathering together at joints to show contours, at the waist to show attenuation, and at the ends of the sleeves to indicate the narrowness of the delicate wrists. But in the later drawing, line has become more suggestive and more implicit. The youth's form is more rounded than that of the princess, and the outlining curves are stronger, more rhythmic, the line tapering rapidly from thin to thick. Sadiqi's calligraphic pen reaches its virtuoso best in the turban and the sash, where the ink seems to set up high velocity curves and abrupt staccato stops.

But what is undoubtedly the masterpiece of this whole group of drawings and probably the finest surviving example of all Sadiqi's art is a small drawing in the Museum of Fine Arts, Boston (fig. 24). It is in this study of a seated man that Sadiqi's art for once seems to move out of its tensely rational scheme. Line flows, not only in the irrational thick and thin of the contours, where sometimes the tapering line disappears entirely (fig. 25), but also in the undulating, living rhythms of the cloth bunched under the man's legs. A clear sensuous love of line for line's sake is evident in the fluid ebb and flow of line in the drapery folds. Here Sadiqi's line finds its most complete expression. It is a writhing line, more sensuously expressive than any of Sadiqi's previous work. It animates the space around it so that the chilly ambience around the seated princess is replaced by a charged, electric atmosphere (fig. 26).

The drawing must belong near the end of Sadiqi's career, and it should be dated about 1595, along with two other drawings which can be securely attributed to his hand (figs. 27 and 28).[52] What caused the transition from his earlier "tight" style to this more "electric" style cannot be determined exactly. Part of the stylistic change is surely due to his increasing artistic experience and maturity. But there is another, more important factor at work that we will examine in the next chapter.

52. Neither drawing is signed, but their close parallels with the Boston drawings of the seated man leave no doubt that they are the work of Sadiqi about 1590–95.

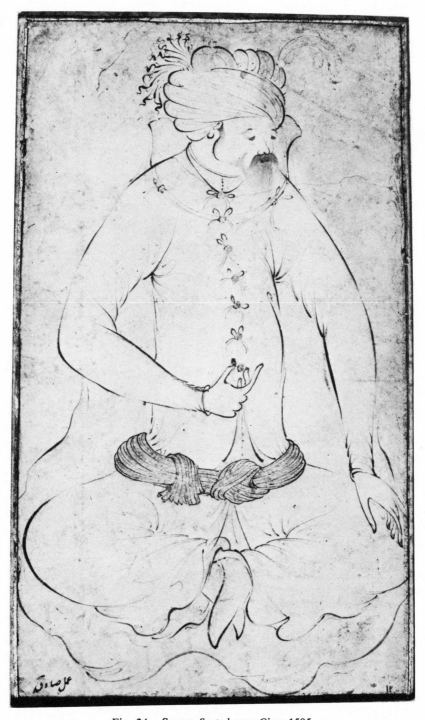

Fig. 24. SADIQI. *Seated man.* Circa 1595.

Fig. 25. SADIQI. Detail of *Seated man* (fig. 24).

Fig. 26. SADIQI. Detail of *Seated man* (fig. 24).

Fig. 27. Attributed to SADIQI. *Animal sketches.* Circa 1595.

Fig. 28. Attributed to SADIQI. *Man on horseback attacked by a dragon*. Circa 1595.

4. Sadiqi and Riza

A principal reason for Sadiqi's change to the "electric style" was his contact with a much younger artist, the celebrated Riza, a precocious genius whose early career coincided with the latter part of Sadiqi's life. Both Riza's works and contemporary literary accounts indicate that he joined the royal atelier soon after 'Abbas became shah in 1587. It was the period of Sadiqi's greatest good fortune. After years of vicissitudes and uncertain living, Sadiqi, fifty-four years old in 1587, had finally been restored to high favor at the royal court, indeed higher favor and greater honor than he had known even under Isma'il II. We can safely assume that from 1587 to 1597 Sadiqi was at the zenith of his personal powers, and, to judge from his last drawings, he was at the peak of his artistic capabilities as well.

There seems no doubt that Sadiqi and Riza knew each other.[1] Though the fifty-four-year-old director of the royal library and the much younger artist may not have been friends, they must have been acquainted with each other's work. The visual similarities between Sadiqi's late work and Riza's early work are clear evidence for that. But what is the nature of the relationship between the youthful genius and Sadiqi, the older and also richly talented practitioner of a more traditional art? Could Sadiqi's most brilliant drawing (fig. 24) have been a creation inspired by the younger man's innovations?

This would not have been the usual pattern. Though his prodigious talent was probably already apparent, the young Riza ought to have come into service at the royal court in order to be trained under the esteemed artist Sadiqi. This would easily explain the relationship between their styles. But Sadiqi was keenly aware of other talent. He was also unable to accept the worth of most of his peers and

1. Riza's name underwent three permutations, as E. Schroeder has cogently explained in *Persian Miniatures in the Fogg Museum of Art,* pp. 116–34. From its early form "Riza" about 1587–90, it changed to "Aqa Riza" about 1590–1600, and then to its final form "Riza-yi 'Abbasi" about 1600–35 when he was honored with the shah's name for his takhallus.

gave unstinting praise only to his deceased teachers or his patrons. He may not have seen in Riza a promising student but instead a threatening rival.

Riza's *Young man in a blue cloak* (plate 6) has been dated about 1587.[2] The subject—a refined youth elegantly dressed and graciously posed—is to become one of the stock motifs of seventeenth-century painting in Isfahan, though scarcely ever treated as brilliantly as in this picture. In Sadiqi's hands we can imagine that the outline would have been more dramatic and complex. Riza, however, works in terms of subtlety, gentle grace, and understated—though far from simple—harmonies. As a colorist he is superb, far advanced over the rather awkward Sadiqi we have observed in the 1573 *Garshaspnamah* and the 1576–77 *Shahnamah*. In figure 24 Sadiqi's line is taut, pulled to the limits of its strength; one senses enormous inner tension. Riza's figure is far more relaxed. The lines are simpler and, if anything, closer to nature than Sadiqi's: whereas Sadiqi's line becomes in places almost virtuoso "line for line's sake," Riza's stays close to its subject and is more economical. While Sadiqi's work is taut with control and a sense of enormous, sustained effort, Riza's is serene. If Riza has been studying under Sadiqi, he has learned his lessons swiftly and has already surpassed his master.

By and large Riza's figures are warm, breathing, and soft. A perfect match in refinement and elegance to the young man of plate 6 is the superb figure of a *Young woman in green* (plate 7), which must have been done at the same time.[3] Carrying a small fan decorated in delicate arabesque, she is a study in sinuous grace and languid sophistication, qualities which Sadiqi seeks to emulate in some of his works (fig. 23) but which the hard crispness of his line prevents.

Two somewhat later drawings by the youthful master can be used to summarize this comparison with Sadiqi (figs. 29 and 30). Both date about 1590–95 and are characterized by a frequent linear spatter, particularly at the ends of turbans and sashes. We find a superficially similar spatter on the turban ends of Sadiqi's *Seated*

2. This dating of the painting is generally accepted (Schroeder, *Persian Miniatures;* Stchoukine, *Les peintures des manuscrits de Shah 'Abbas I à la fin des Safavis,* p. 100; and A. Welch, *Shah 'Abbas and the Arts of Isfahan* [New York, 1973], no. 6).

3. The stylistic similarities are obvious. In addition, this miniature bears the same seal mark as plate 6.

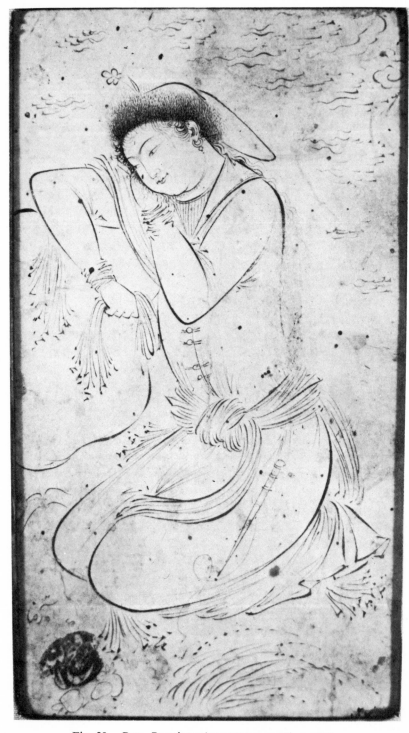

Fig. 29. RIZA. *Day-dreaming young man*. Circa 1590.

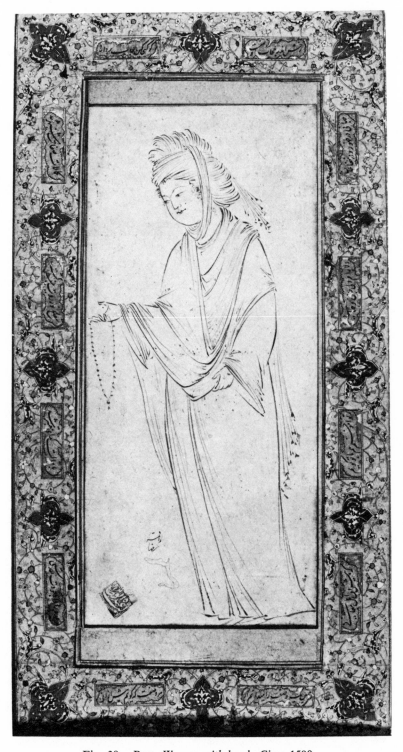

Fig. 30. RIZA. *Woman with beads*. Circa 1590.

man (fig. 24). But Riza's line is achieved through staccato brush-strokes, quick dabs of ink applied swiftly. In Sadiqi's work, however, the spatter turns into tight, painful coils, writhing snakelike forms. It is another expression of the basic difference we have noted before.

While Riza is able to create the sense of diaphanous silk in the voluminous sleeves of plate 7 and figure 30, Sadiqi cannot. Riza's folds truly suggest bunched cloth, but Sadiqi approximates them as abstract linear rhythms and sharply honed blades (fig. 25). The youth in Riza's drawing (fig. 29) is sensuously soft: his double chin and plump face bespeak the serenity of a happy baby, not of a mature young man. Sadiqi's youth (fig. 23), despite his apparently easy attitude, is anything but soft. His face is that of a young man, not a child, and its contours are almost brittle, sharply outlined in the classical linear hardness we associate with Sadiqi. Finally, through a masterful and unprecedented use of subtly modulated tones and stippling, Riza is able to suggest the play of light on surfaces far more believably than Sadiqi, or for that matter than any other Iranian artist of the period.

Two points are immediately obvious: first, the two artists were acquainted and knew each other's work; and second, the similarities in their styles are relatively superficial, though nonetheless significant. But before we go on in our analysis of the relationship between Sadiqi and Riza, we should examine what literary evidence there is about the younger artist.

Writing in 1596–97 Qazi Ahmad leaves the following account:

> The painter of beauty Aqa Riza is the son of Maylana 'Ali Asghar; it is fitting that the present age should be proud of his existence, for in the flower of his youth he brought the elegance of his brushwork, portraiture, and likeness to such a degree that, if Mani and Bihzad were living today, they would praise his hand and brush a hundred times a day. In this age he has no rival; master painters, skillful artists who live in our times regard him as perfect. He has snatched the ball of precedence from his forerunners and has yet days for perfecting himself; one must hope that he will prosper. He has been appointed to the court of Shah 'Abbas, the powerful monarch of the family of the most pure Imams. On one occasion he made such a por-

trait that this glorious monarch involuntarily expressed a thousand approvals and praises.[4]

Riza's career was not, however, as golden and serene as Qazi Ahmad envisaged it here, and ten years later in another version of his treatise he added what amounts to a footnote to the first account:

> [Aqa Riza] is [now] in the most honorable service of the felicitous shah, lord of the necks [of nations], whose service is supported by the celestial vault, Sultan Shah 'Abbas, may God make his reign eternal. But vicissitudes [of Fate] have totally altered Aqa Riza's nature. The company of hapless people and libertines is spoiling his disposition. He is addicted to watching wrestling and to acquiring competence and instruction in this profession.

It is a disappointing sequel to what had been a brilliant beginning in Riza's career. Nor did the artist reform. Writing a decade later, Iskandar Munshi tells a remarkably similar story:

> ['Ali Asghar's] son, Aqa Riza, became the marvel of the age in the art of painting and unequaled in portraying single figures, and his reputation has become firmly established in these days. In spite of the delicacy of his touch, he was so un-cultured that he constantly engaged in athletic practices and wrestling, and became infatuated with such habits. He avoided the society of men of talent and gave himself up to association with such low persons. At the present time he has a little repented of such idle frivolity, but pays very little attention to his art, and like Sadiqi Bek he has become ill-tempered, peev-ish, and unsociable. But the truth is there is a certain strain of independence in his character. In the service of his present Majesty, the Shadow of God, he has been the recipient of favors and kindnesses and consideration, but on account of his evil ways he has not taken warning and consequently he is always poor and in distress.[5]

The two accounts speak directly to our comparison of the two

4. Qazi Ahmad, *Calligraphers and Painters,* p. 192. Another version of Qazi Ahmad's treatise reads "that the monarch kissed his hand," a gesture which, con-sidering 'Abbas's temperamental, extrovert personality, sounds wholly believable.
5. Iskandar Munshi, *Tarikh-i,* p. 176; translation from Arnold, pp. 143–44.

artists. Not only had Riza become a celebrated and widely admired artist by 1596–97, he had also "snatched the ball of precedence from his forerunners." This may be a direct reference to Sadiqi, the painter discussed immediately before Riza in Qazi Ahmad's treatise. True, the author, using typically fulsome Persian praise, describes Sadiqi as "unequaled and unrivaled" in painting and portraiture, and then a few sentences later writes that "in this age [Riza] has no rival." Among the "master painters" and "skillful artists" who re-garded Riza as "perfect," Sadiqi must surely have numbered. And, as Qazi Ahmad poignantly indicates, Riza, "has yet days for per-fecting himself." At the same time we know that Sadiqi was nearing his mid-sixties. His career was drawing to a close, while Riza's was just beginning.

To determine the precise direction of influence, we need to look closely at a key manuscript on which both men worked, apparently the only time they collaborated. Unfortunately only a fragment re-mains of this once great *Shahnamah,* some sixteen illustrated folios as well as a superb illuminated frontispiece by Zayn al-'Abidin, one of the key painters in the 1573 *Garshaspnamah* and the 1576–77 *Shahnamah* for Isma'il II.[6]

The *Shahnamah* of which these sixteen folios are a slender rem-nant is undated, since the colophon—if there ever was one—has been lost. But the manuscript must have been begun not long after 'Abbas was crowned in Qazvin, and we can date it about 1587–97. As the newly appointed head of the royal library, Sadiqi was almost certainly the director of the vast collaborative effort required to create a manuscript of great size and quality. It is lamentable that so little remains of it.

Trained early to appreciate the qualities of the high-court style of Qazvin, 'Abbas must have been receptive to Sadiqi's work, and he probably saw in the notable painter a man who might rejuvenate the enfeebled art of the book in late sixteenth-century Iran. He may also have wanted to show his gratitude for the artist's early ad-herence to his cause. Sadiqi, castigated by Iskandar Munshi for his self-seeking, surely encouraged 'Abbas to see in him the great con-

6. Arberry, Robinson, Blochet, and Wilkinson, *The Chester Beatty Library, A Catalogue of the Persian Manuscripts and Miniatures,* vol. 3, ms. 277. The dating of this manuscript to the early years of 'Abbas's reign is also suggested by B. W. Robinson, in the above work and in his *Persian Miniature Painting,* no. 60; and by A. Welch, "Painting and Patronage under Shah 'Abbas I," pp. 473–77.

temporary master of classical painting, who possessed an impressive record of training and achievement and who embodied the sound principles of traditional art. 'Abbas, like his predecessors, was indulgent toward his artists, and he was rewarding the loyal Sadiqi for his fine talent and long training as an artist. The painter's character flaws, however, have been demonstrated already; to make him head of the library and director of a great artistic undertaking was a logical choice, but it was surely not a wise one.

Thus the long hiatus in Sadiqi's work as a manuscript painter came to an end soon after 1587. To his appointment as kitabdar there could not have been much artistic opposition: the *kitabkhanah* (library and workshop for manuscripts) had been woefully neglected under 'Abbas's inept father Muhammad Khodabandah, and apparently most of the talented staff Isma'il II had briefly assembled to work on his 1576–77 *Shahnamah* had been dispersed again throughout the country. It was probably a major part of Sadiqi's assignment to bring together again a great atelier of painters. This may be why artists such as Siyavush and Zayn al-'Abidin, who had been active with Sadiqi under Isma'il II and who have left no trace of any work which can be attributed to the patronage of Muhammad Khodabandah, reappear now under Shah 'Abbas. Logically, Sadiqi would have first tried to attract those artists whose work he knew, but it is also probable that a number of these artists in the meantime had either died, become firmly entrenched at provincial courts, or emigrated to India. New artists would have been needed to fill the inevitable gaps, and it is surely here that Riza ibn 'Ali Asghar entered the scene, perhaps actually at Sadiqi's behest.

Working under Sadiqi Bek could not have been easy. Whatever his gifts as an artist and a writer were, his talents did not encompass those of a conciliator and a manager. Hypercritical and supercilious, he must have been a harsh and sometimes unbearable head of the royal library. As director of the *Shahnamah* project, he was also almost certainly a very hard taskmaster, bearing down strongly on his subordinates in order to please the new shah.

Given this state of affairs and Sadiqi's difficult personality, let us turn to the great *Shahnamah* he was directing. It was the first of several manuscripts which the shah was to order and is, along with the 1614 *Shahnamah*,[7] the most impressive. Fourteen of the sixteen

7. In the Spencer Collection, New York Public Library. Published in E. Grube, *Muslim Miniature Painting*, and A. Welch, *Shah 'Abbas*, no. 14.

surviving miniatures were done between 1587–97. None is signed, and attributions must be based upon stylistic evidence and our knowledge of 'Abbas's atelier. Three are clearly the work of Sadiqi. Four others can be safely attributed to Riza. Seven were painted by a close follower of Riza. A final two pages were signed and added late in the seventeenth century by Muhammad Zaman.

Riza's four miniatures for the 1587–97 *Shahnamah* should be discussed first in detail. One of them depicts Rustam killing the white elephant (plate 8). The brilliantly decorated edifice in the upper right strives for an illusionistic representation of depth, although it is not wholly successful. The richly varied, rocky escarpment in the upper left swirls powerfully, first up, then to the left, then to the right. Concealed faces abound in its rough surfaces and edges: the whole natural "structure" is vitally alive. So too is the vibrant, brilliantly colored tree, its leaves in yellow, red, dark green, and light green and its trunk gently mottled in soft gray and white. The rich vegetation of the dark green lawn recalls the wilder flora of early Safavi painting, a resemblance no other late sixteenth-century painter is capable of achieving. Rustam's heavy mace falls with great force on the elephant's head (fig. 31). We feel its crushing force: the elephant's expression is dazed, his whole body stunned and collapsing under the enormous blow.

Besides capturing the sure confidence in Rustam's face and stance, as well as a quality of inner serenity which clearly recalls Riza's signed works of this same period (plate 6), the artist also conveys the helpless fear of the two servants fleeing headlong toward the right. It is a superb performance, on Riza's part as well as on Rustam's. The rich textures of the hero's clothing, the artist's instinctive inclination for soft, sensuous curves in the midst of a desperate duel, and the rather puffy face, compressed mouth, and elongated almond eyes are characteristics we have already noted in Riza's single-page drawings and paintings. This picture must have thrilled its patron.[8]

8. Sadiqi had earlier illustrated the same scene in the 1576–77 *Shahnamah*, and though it is a commonly represented story from the epic, the supposition is very possible that Riza was deliberately weighing his talent against Sadiqi's. Sadiqi's painting of the subject is a vastly inferior production. But, curiously, Riza's miniature assumes very nearly the same basic composition: the building on the right; the hero running from it to strike the elephant at the lower left; and in the upper left a tall tree and hilly landscape. Riza has even made use of the fleeing figures to the lower right, though where Sadiqi encumbered his painting with three running men and one decapitated victim, Riza has reduced his to a more effective twosome.

Fig. 31. Attributed to RIZA. Detail of *Rustam kills the white elephant* (plate 8).

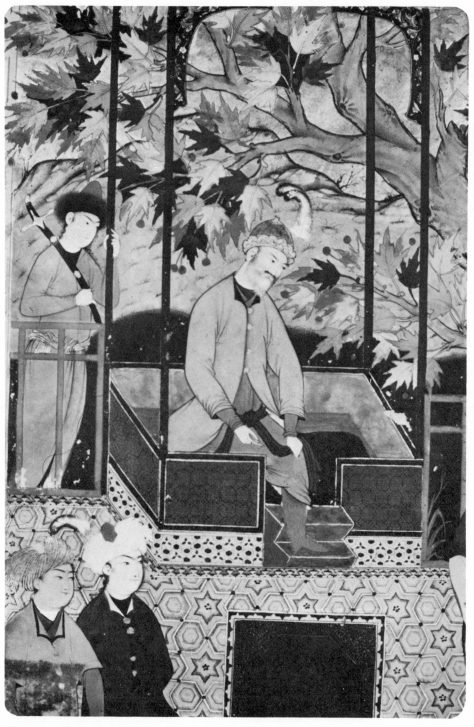

Fig. 32. Attributed to RIZA. Detail of *Faridun spurns the ambassador from Salm and Tur* (plate 9).

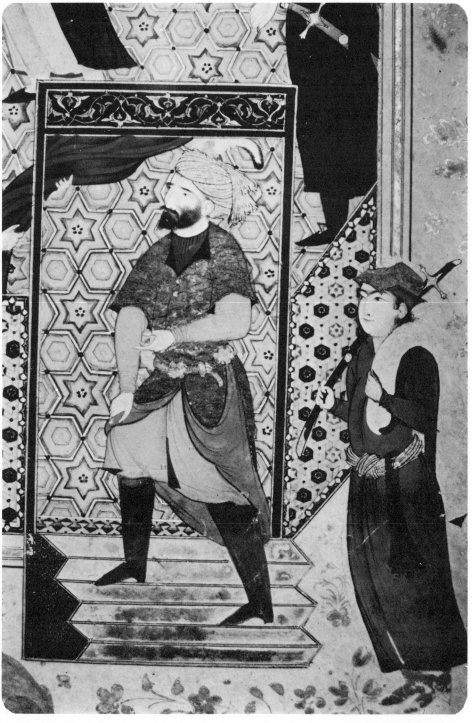

Fig. 33. Attributed to RIZA. Detail of *Faridun spurns the ambassador from Salm and Tur* (plate 9).

Riza is also a master of psychological drama. In his *Faridun spurns the ambassador from Salm and Tur* (plate 9), we see a tense court caught in a moment of nervous silence as the shah's vazir announces the arrival (or signals the departure) of the fratricides' envoy.[9] The old shah's piercing eyes are directed across the courtyard in a sharp diagonal from upper left to lower right (fig. 32). The vazir stands in an impressive curve, nearly identical to the mellifluous swoop of clothing of the young man in plate 6. Mediating, he is halfway between the incensed shah and the unsure ambassador. The envoy convinces us by his own uncertainty that he has not undertaken this mission willingly and that his sympathies do not rest with his own masters. He stands halfway up the steps, and we are not sure whether this basically honorable man is making his entrance or his exit (fig. 33). The richly tiled wall and the solid square composition exclude him from the court, while his beautiful attendant stands wholly outside, floating in the golden, animated space of the margins. In the upper right a grotesque mass of rock, resembling nothing so much as a sickly, decaying, parasitic growth, seems to symbolize the inner disease of the outside world, peopled by Faridun's two evil sons and their supporters. The rocks support no life: a single bush, blasted by the unhealthy atmosphere around it, scratches feebly at the sky. Things grow only near the court itself, near the aging shah who in his distant youth saved Iran from the horrors of Zahhak and who must now save it again from the horrors of his own two sons. The dark green lawn glows richly, verdantly, and from its healthy soil a massive tree, bursting with color and vital power, thrusts energetically toward the sky.

Is it too much for us to interpret this brilliant painting as a symbolic representation of the life the new shah, 'Abbas I, is restoring to an Iran likewise nearly destroyed by two brothers, Isma'il II and Muhammad Khodabandah? Aqa Mirak may well have been representing the young Shah Tahmasp as Khusraw on his throne in the British Museum *Khamsah* of Nizami (fig. 3), and another painter, perhaps Shaykh Muhammad, may have depicted his own sympathetic patron Ibrahim Mirza as the saintly Yusuf in folio *132r* of the

9. The meeting of Salm and Tur's ambassador with Faridun is also a scene illustrated by Sadiqi in Isma'il II's 1576–77 *Shahnamah,* and this second "competition" between the two artists make it seem extremely likely that Riza had studied the earlier version of the epic, which was surely still in the royal library, and was actively "tilting" against the work of his more celebrated and less gifted superior, Sadiqi.

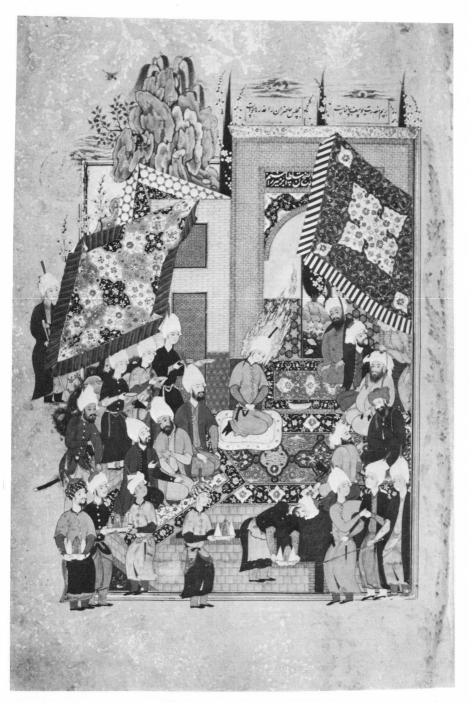

Fig. 34. Attributed to SHAYKH MUHAMMAD. *Yusuf and his brothers*. From the 1556–65 Freer
Haft Awrang.

Freer *Haft Awrang* of Jami (fig. 34). Although Firdawsi's story required that Faridun have a white beard, the obvious symbolism of Riza's great painting urges this contemporary political interpretation.

Plate 9 is clearly the work of a man of prodigious genius, and yet we know that he was still very young indeed. While Sadiqi came to his art late and, after enormous work and incredible trials, finally reached the official pinnacle of his profession, Riza seems to have come to it swiftly and easily, his superb natural gifts aided by the good fortune Sadiqi only periodically enjoyed.

Two final miniatures from this great *Shahnamah* sum up his qualities clearly. In the first (plate 10) Tahmuras fights the demons. In Riza's hands landscape becomes a living thing, writhing with inner earthy forces which threaten to break out completely in the lavender crags twisting in the upper left. The figures themselves— whether human or demon—are charged with muscular power and furious movement (fig. 35). Balanced by the four columns of text in the upper right, the composition rushes precipitously toward the lower and upper left. The modulations of light green and lavender burst into vibrant life by means of the glistening gold hill thrust between them. Both the action of nature and the action of battle are in violent ferment, exploding out of the frame into the margins.

The composition of *Faridun crosses the Ab-i Darya* (fig. 36) is less violent and more restrained than that of plate 10. Lacking the brutal power of *Rustam kills the white elephant* (plate 8) and less psychologically directed than *Faridun spurns the ambassador from Salm and Tur* (plate 9), it is still a sensitive masterpiece of color and design. The army in the lower right does not move easily through the water: we get a clear sense not only of the slow, hard passage of the horses and soldiers but also of the psychological states of several of the men. Faridun in front, his face an expression of energy and positive will, clenches his fists in determination while he gives his less than resolute army a "pep talk." Closest to him a warrior on a dappled horse strives to summon up his courage. A soldier in lavender looks more doubtful, obviously wanting to stay on safe, dry land. To the far right younger troops enthusiastically enter the water; they seem less cautious and less knowing than the two warriors closest to Faridun. The boat behind them floats convincingly in the rolling waves and is propelled forward by the dipping, pointed clouds. The tough captain in front evokes solid confidence; the

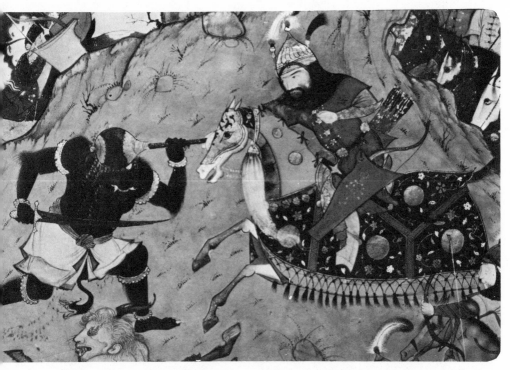

Fig. 35. Attributed to Riza. Detail of *Tahmuras fights the demons* (plate 10).

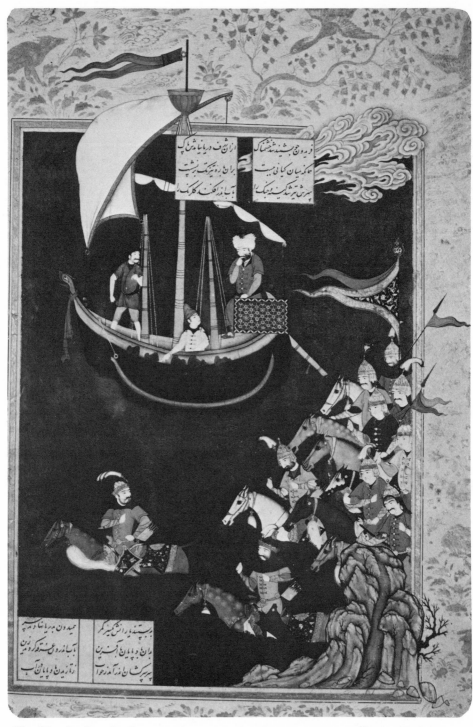

Fig. 36. Attributed to RIZA. *Faridun crosses the Ab-i Darya.* From the 1587–97 *Shahnamah.*

youth in yellow points reassuringly at the lifeboat beside the ship. Yet the noble passenger in the rear looks doubtful and concerned; the traditional gesture of astonishment (finger to lip) is effectively transformed into one of real anxiety. This is one of Riza's great gifts—the ability to invest traditional forms with new meaning.

Riza's contributions to the 1587–97 *Shahnamah* are on an exceptionally high level and bespeak a uniform style and approach to his art. But he is working in the company of Sadiqi, whose contributions to the *Shahnamah* we shall now examine. *Zal before Rudabah's castle* (fig. 37) shows the white-haired hero staring fixedly up at his beloved, while his attendant carries his sword. All three persons are depicted in traditional guise as ideal types of physical beauty, and in none of them do we find suggested the significant individualization and sense of psychological presence which is a part of Riza's art. Zal and his attendant seem to float over the courtyard's pavement, while Riza's characters in plate 9 firmly stand on solid ground. Nor in comparison with Riza's work is space here convincingly rendered: Rudabah's palace is a house of cards, its walls implying little solid structure, while the steps leading to the door are rendered in a meticulous detail which detracts rather than adds to the sense of logical space. In the upper right a rocky mass bends toward the left, its curve lacking the impelling thrust of the rocks in plate 8.

But there is one surprising feature. The figure of the youthful attendant in the lower right bears a striking resemblance to the young man in the lower right of Riza's rendering of *Faridun spurns the ambassador from Salm and Tur*. Despite the slightly different clothing colors, the youths' similarity suggests a relationship between Sadiqi and Riza which should be kept in mind.

Sadiqi's second miniature relies on a more complex composition. In *King Sarv, his daughters, and the three sons of Faridun* (fig. 38) the monarch sits with his three beloved daughters and gravely considers the merits of Faridun's sons who have come to his court as their suitors. In the lower left an attendant in yellow pushes back a curtain in order to enter the court. In the upper left a large tree spreads its branches over the court and toward a rocky hill in the upper right. The form and color of the figures so closely resemble Sadiqi's signed single pages that the painting can be attributed to him with complete confidence. Here too, as in figure 37, architectural representations are less than convincing, and the pale wall in the far right seems to have been added as an afterthought in order to

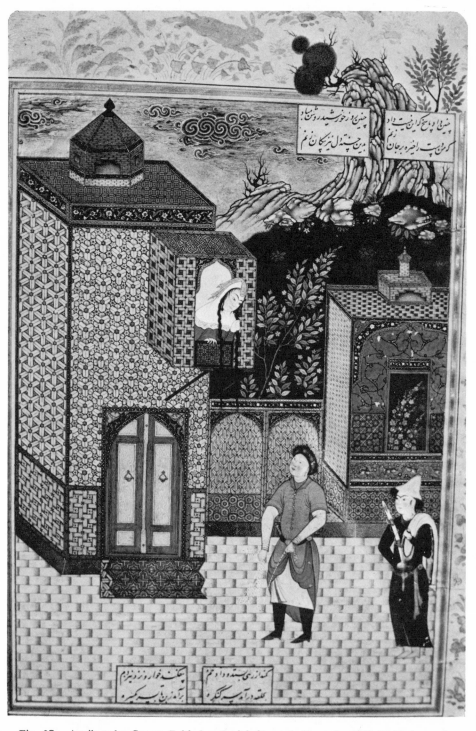

Fig. 37. Attributed to Sadiqi. *Zal before Rudabah's castle.* From the 1587–97 *Shahnamah.*

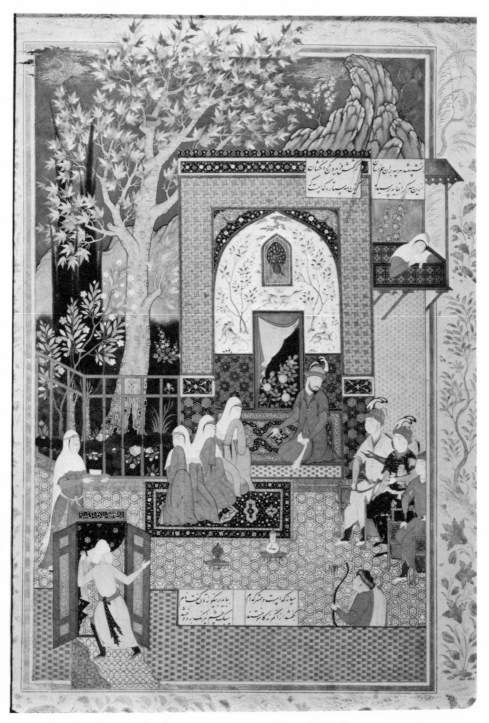

Fig. 38. Attributed to SADIQI. *King Sarv, his daughters, and the three sons of Faridun.* From the 1587–97 *Shahnamah*.

hold up the balcony from which a young woman lazily views the
scene below. Where Riza would have infused such a scene with the
psychological tension implicit in Firdawsi's rendition, Sadiqi deals
only with the outer forms and details. The great tree, whose span in
Riza's *Faridun* stretches and strains to shelter the aged king, is here
more comfortable and less vital.

What is clear from both these miniatures is that Sadiqi is a more
traditional master than Riza, and though the older artist is superbly
trained and endowed with considerable gifts, his work is in most
respects less innovative than Riza's. The two men were obviously
close associates in this great manuscript project, although the direc-
tion of influence appears to be the opposite of what we would expect
from a teacher–student relationship. For while figure 37 contained
only one element appropriated from Riza's *Faridun* page, Sadiqi's
King Sarv contains several. The latter page is very nearly a mirror
image of the composition of Riza's *Faridun,* even including the cur-
tain which is being drawn back in the lower corner, the red railing,
and the spreading tree, whose leaves break the frame. Technically
too there is a notable addition to Sadiqi's art, stippled grass, which
is used to great advantage by Riza.

It is clear from these two paintings that many of the features in
Sadiqi's contributions to the 1587–97 *Shahnamah* for Shah 'Abbas
are either borrowed from or strongly influenced by Riza. This ab-
sorptive quality is one of the characteristics of Sadiqi's career, for
we have seen it at work in the 1576–77 *Shahnamah*. It is a fortui-
tous quality, responsible for one of the finest pages in the earlier
Shahnamah, the illustration *Faridun receives the ambassador from
Salm and Tur* (plate 5), in which he was strongly influenced by his
colleague Siyavush. The impact of Riza's art is of even greater mo-
ment, and it is instrumental in shaping Sadiqi's finest painting, his
third contribution to the 1587–97 *Shahnamah*.

Sadiqi's rendering of *The simurgh carries Zal to her nest* (plate
11) is a tour de force of late sixteenth-century painting in Iran and
indicates, as we have seen before, that Sadiqi's talent is uneven—
sometimes sparse, more often polished and accomplished, and oc-
casionally overwhelming. The simurgh's colors are rich, subtly
colored and modulated. The vital, almost volcanic rock masses—
seeming to depict elemental natural forces—have a dynamic energy
far beyond anything in Sadiqi's earlier art (fig. 39). It is, in fact, one
of the greatest landscapes in all Iranian painting. Faces abound

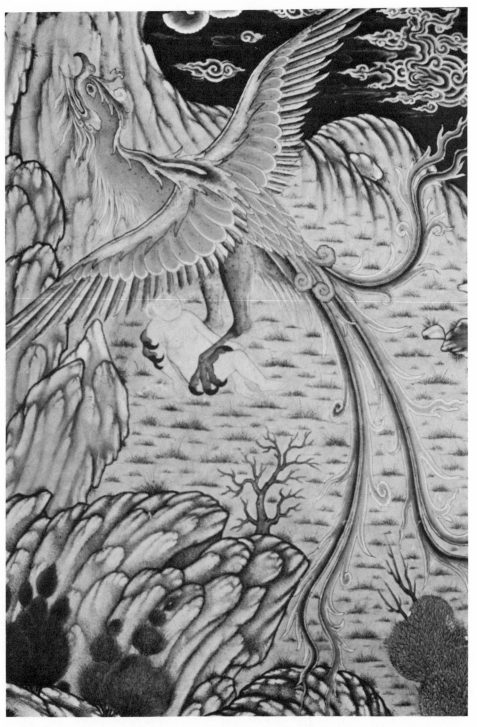

Fig. 39. Attributed to SADIQI. Detail of *The simurgh carries Zal to her nest* (plate 11).

in the rocks, resembling Sultan Muhammad's in the Houghton *Shah-namah,* and we can trace dozens of animals, humans of all types and emotional conditions, and fancifully ugly demons in the peaks and crags. The simurgh's face, as well as those of her brood, is keenly alive and active, and the brood's nest is a sensuous weave of sinuous, three-dimensional twigs, writhing and twisting together. The rocks themselves fade into thin washes as they merge with the margin, and this and their brilliantly stippled surfaces, which create vibrant effects of light and dark, suggest Riza's influence. The face of the child is a slightly younger version of the face in Sadiqi's *Zal before Ruda-bah's castle,* and the color scheme, rock forms, and clouds are more characteristic of Sadiqi than of Riza.

But this painting surpasses Sadiqi's others. The trees bulge into almost popping knots, like those in Riza's *Faridun* (plate 9). The color washes glow with a luminosity not apparent in Sadiqi's other work, while the rich and multicolored flora breathes life and growth. The painting is also a picture of the four seasons, for we find a blossoming tree, a mature summer shrub, an autumnal tree (fig. 40), and leafless wintry stumps. The simurgh is one of the principal symbols of knowledge and mystical awareness in Persian poetry, and the vital harmonies of the colors in her body are a rich component of the page's visual splendor. But Sadiqi's painting is not simply an illustration of one of the *Shahnamah's* most moving episodes: it is also a profound, pantheistic vision of a charged nature whose forces infuse the simurgh's world with enormous energy.

The manuscript's fourteen sixteenth-century pages imply a specific relationship of the three painters. Responsible for four pages, Riza is the innovative spirit in the work. His unnamed follower, who painted seven miniatures, is simply a technically competent imitator (fig. 41). Sadiqi, the master of three pages, uses his gifts unevenly, two pages being fine but not outstanding, and one page, *The simurgh carries Zal to her nest,* surpassing all his previous work and in a class with Riza's best. Still, in all his pages here he is strongly and vitally affected by the art of his young associate, Riza, and it is this kind of artistic relationship which is most fruitful for his work.

Perhaps in this project for Shah 'Abbas Sadiqi had not expected an artistic challenge, paticularly from a youth such as Riza, trained in the high Qazvin manner by his father, 'Ali Asghar. But Riza was endowed with remarkable inventiveness, profound spirit, and an

Fig. 40. Attributed to SADIQI. Detail of *The simurgh carries Zal to her nest* (plate 11.)

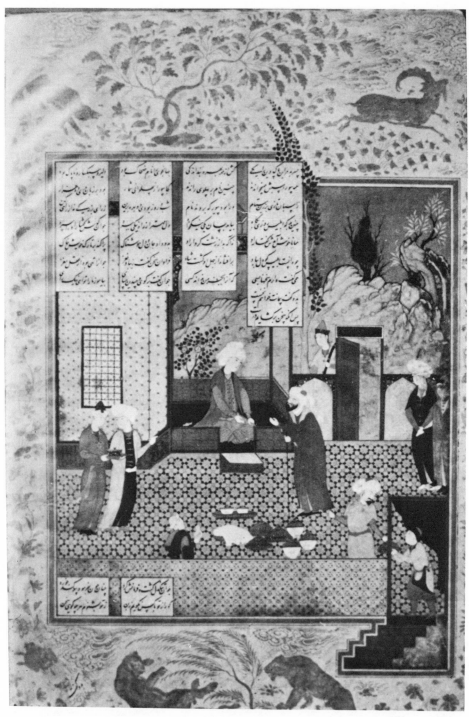

Fig. 41. Anonymous follower of Riza. *Jandal before Sarv*. From the 1587–97 *Shahnamah*.

enormous share of native genius, and Sadiqi was confronted with the work of a more radical spirit whose art by all accounts found immediate favor with the young shah. Being gifted and receptive to outside influences, Sadiqi tried to adapt himself to the new mode and often succeeded, occasionally with astonishing brilliance. But the younger artist was the more vital as well as the more progressive talent. This situation could not have been much to Sadiqi's liking, and we can reasonably assume that his already generally intolerant attitudes toward others were honed to razor sharpness by the maddening abilities of the younger man who was destined to become the great innovative spirit of later Safivi painting. It was Riza, not Sadiqi, who was to shape the styles of painting in the seventeenth century.

But Sadiqi was still head of the royal library and was to remain in that position until 1596–97. Although we suspect that Sadiqi resented Riza, we cannot prove it, and even if Riza was a threat to Sadiqi's ego, he was no threat to his position. From the vantage point of this position Sadiqi produced what was to be one of his most impressive works of art, his manuscript of the *Anvar-i Suhayli*. Dated precisely 8 November 1593 (13 Safar, 1002) it was probably under way during the final period of the creation of the 1587–97 *Shahnamah*.[10] One would expect it to have been commissioned by the shah, who was ambitious to create a great atelier and a great library of illustrated manuscripts, but it was not. Head of the library and at the peak of his personal power and wealth, Sadiqi commissioned his own manuscript!

One presumes he did it out of a mixture of enormous pride and overflowing energy. In any case, in the entire history of the Turko-Iranian book no painter had ever ordered his own manuscript, and when Sadiqi did just that, usurping the patron role of monarchs, princes, noblemen, eminent officials, and wealthy merchants, he did not do it in a halfhearted manner. Indeed, little in his entire life was done halfheartedly.

The book's 363 folios of good naskhi calligraphy include 107 miniatures, all painted by Sadiqi,[11] and the whole volume is bound

10. The manuscript is in the collection of the Marquess of Bute. I am indebted to B. W. Robinson for first drawing my attention to it. The same scholar published it in *Oriental Art* 18, no. 1 (Spring, 1972).

11. None of these illustrations is signed, but details of figures, as well as composition and color scheme, conform to Sadiqi's style, and this evidence, coupled with that of the colophon, make it clear that Sadiqi is solely responsible for the manuscript's illustrations.

in a fine green-and-red lacquer of contemporary date. The manuscript is complete and in perfect condition, its pages supple, and its colophon preserved:

> Copied by ibn Na'im Muhammad al-Husayni al-Tabrizi (May forgiveness come to him) on the 13th of month. It is well and victoriously completed in Safar of the year 1002 H.
>
> It is written as it is ordered by the rare man of the time, the second Mani and the Bihzad of the age, Sadiqi Musavvir.

Sadiqi enjoyed being in the enviable position of a renowned painter and head of the library of the vigorous young shah. In his own mind he was still "the rare man of the time, the second Mani, and the Bihzad of the age," despite the unnerving proximity of Riza.

About the scribe, a competent though not very gifted calligrapher, we know nothing beyond his name. In keeping with his usual practice of ignoring colleagues and associates unless he can slander them, Sadiqi does not mention him in the *Majma' al-Khawass.*

One hundred and seven miniatures is a staggering undertaking for a single painter, no matter how thoroughly trained and gifted. The paintings were executed quickly. There is no labored building up of textures and no intricate detail work. Figures and faces are repetitive, and color is thin, almost too thin. Although the illustrations bear the mark of haste, they are all of fine quality, and a few of them are among the finest work of Sadiqi's long career. We can study only a portion in detail, but they will at least give us some idea of the range and scope of the illustrations, as well as of an often startling subject matter and a richer color sense than in his earlier work.

In folio *10a* a king sits conversing with a hermit in a cave (fig. 42). The simple palette of the figures harks back to the master's work in the 1576–77 *Shahnamah.* The drawing of the king has the same precise, rather cold appearance as the drawing of the seated princess (fig. 18), although the king is not equal to her in quality. A more impressive figure, the hermit sits in a gently modulated dark interior, its dim light throwing an aura around him. The rocks are colored with a thin wash of richer tonality and greater variation than in Sadiqi's earlier work, and the hard surfaces are peopled with a few grotesques, a new element in his work. Both "innovations" are surely borrowed from Riza.

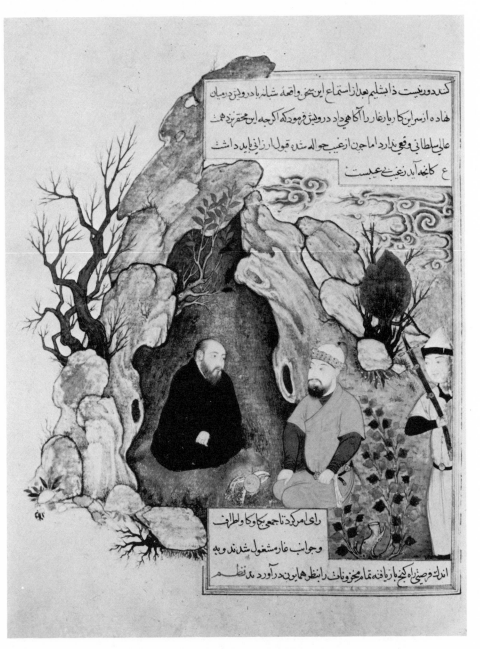

Fig. 42. SADIQI. *A king visits a hermit.* Folio 10a from the 1593 *Anvar-i Suhayli.*

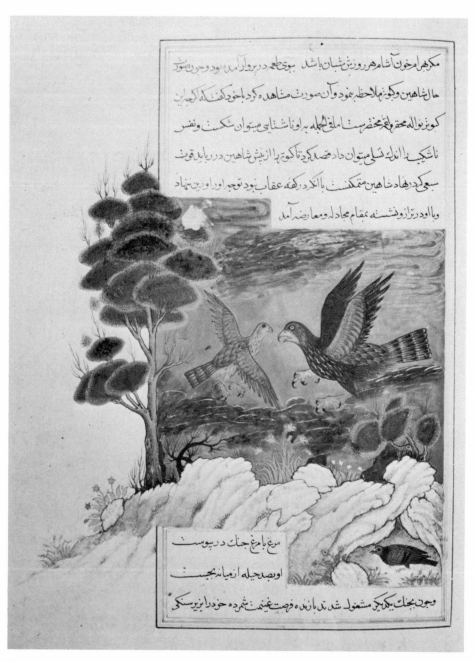

Fig. 43. SADIQI. *Two birds fighting*. Folio 17a from the 1593 *Anvar-i Suhayli*.

Folio *16a* is more dramatic (plate 12). A violent storm rages over an oasis. Lightning flashes and thunder cracks, while leaves and branches turn in the fierce wind. Only the unperturbed blue bird in the lower right retains the composure of the usual idyllic prettifications which typify not only Sadiqi's early work but most Iranian painting. At close range the painting is less satisfying: the lavender rocky pile is peopled with "puppet" faces whose lack of animation only detracts from the power of the natural scene. Landscape reacts only feebly to the storm: the leaves of the bird's tree turn but do not whip; the pale brown escarpment above curves awkwardly against the storm. Though there is no similar depiction of a storm in Riza's known work and though this unusual subject may be something we can credit to Sadiqi's inventiveness, we can imagine what the scene would have become in Riza's hands.

In folio *17a* (fig. 43) two fighting birds are frozen in midair against a deep blue sky with clouds. But there is no action, no sense of movement—two qualities Sadiqi was never able to capture.

In folio *38a* (fig. 44) the pale tones, the setting, and the drawing of the animals hark back to the great early fifteenth-century *Kalila wa Dimna,* a manuscript Sadiqi may very well have known.[12] It seems likely that Sadiqi was quite aware of 'Abbas's developing predilection for Timurid models in his official architecture and manuscript painting.[13] Did he perhaps commission the *Anvar-i Suhayli* in the first place in order to please the shah and to prove to him the range of talent at the artist's command?

In folio *28b* (fig. 45) the unpleasantly pointed rocks seem to have been borrowed from Shiraz conventions.[14] The crowned monarch is a familiar Sadiqi type, though here he has the long mustaches which 'Abbas sported and made fashionable. His accompanying youths are less familiar in their bulky turbans, a change of fashion encouraged by 'Abbas and appearing also in what we assume to be Riza's nearly contemporary miniature of the *Young man in a blue cloak* (plate 6).

12. This manuscript in the Gulistan Library in Tehran is published in Binyon, Wilkinson, and Gray, *Persian Miniature Painting,* no. 44, as well as in many of the other accessible studies of Iranian painting.

13. For a discussion of 'Abbas's Timurid archaicizing see A. Welch, *Shah 'Abbas,* p. 65, and "Painting and Patronage under Shah 'Abbas," pp. 481–91.

14. E.g., the Shirazi 1560 *Shahnamah* in the India Office Library, London, pers. ms. 133, published in I. Stchoukine, *Les peintures des manuscrits Safavis de 1502–1587,* pls. 44–48.

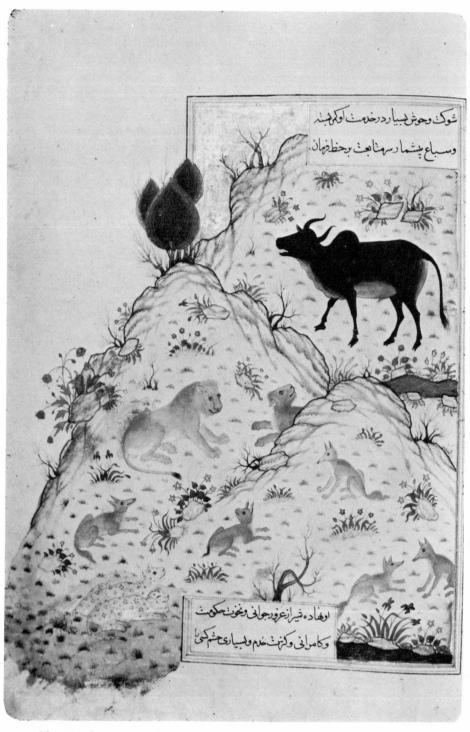

Fig. 44. SADIQI. *Animals in a landscape.* Folio 38a from the 1593 *Anvar-i Suhayli.*

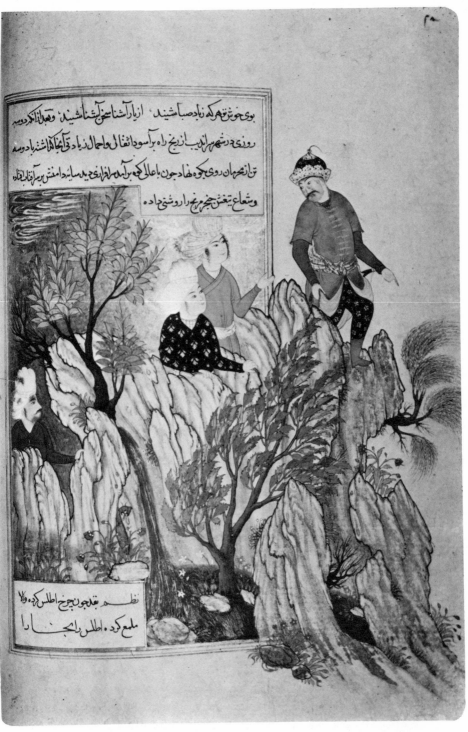

Fig. 45. SADIQI. *A king in the mountains.* Folio 28b from the 1593 *Anvar-i Suhayli.*

Some of the natural exuberance we have found so strong in Riza's work is echoed in one of the *Anvar-i Suhayli's* most successful illustrations, folio *20b* (fig. 46). Here a tree's branches swoop in a dramatic curve, though blown by a wind that obeys no natural logic. Riza's did.

Sadiqi's talent for architectural realism was never great, and in folio *52a* (fig. 47) this deficiency is most disturbingly apparent. It is simply beyond his powers to represent the complex interior convincingly.

If we compare the youth dressed in blue who is holding his master's sword in folio *309a* (fig. 48) with Riza's similar figure in *Faridun spurns the ambassador from Salm and Tur* (fig. 33), we see how far removed Sadiqi's stiff, less flowing art is from Riza's svelte new ideal types.

This is not to be too hard on Sadiqi. He can be a marvelous draftsman (fig. 24) and a highly original painter at times. In folio *55b* (fig. 49) he achieves a startling pictorial effect with the pink-and-gray stork ascending from a burning tree into a dark-blue night sky. The simurgh in folio *85a* (fig. 50), though not the same unique species as the one created by Sadiqi in figure 39, is still a beast of strong decorative power, and the intense black line of his neck recalls Sadiqi's masterful drawing of the *Seated man* (fig. 24). The dragon in folio *227b* (fig. 51) similarly seems to have crawled from a gold-illuminated margin into the miniature: his lumpy, twisting body is a close cousin of the dragon in Sadiqi's nearly contemporary drawing (fig. 28). The painter's palette can be rich and harmonious; the subtly modulated browns, golds, and greens of folio *40b* (fig. 52) create the artist's warmest painting, glowing with comfortable colors a far remove from the icy precision of his earlier work (plate 4). His use of thin wash can be impressive too, as in folio *313a* (fig. 53), where the pale lavender is gently brushed off into the margin in the lower left.

But of the book's many miniatures there are three that rank very high among Sadiqi's work, not so much because of great technical achievements but because of the subject matter portrayed. In folio *83b* (fig. 54) he illustrates the familiar story of the tortoise and the ducks. It is Sadiqi's first venture into a "genre" scene, and he depicts a village bustling with ordinary life: the donkey feeds at the right while a hen and her chicks peck at the ground and a rooster crows. Smoke streams out of the roof of one of the carefully depicted hum-

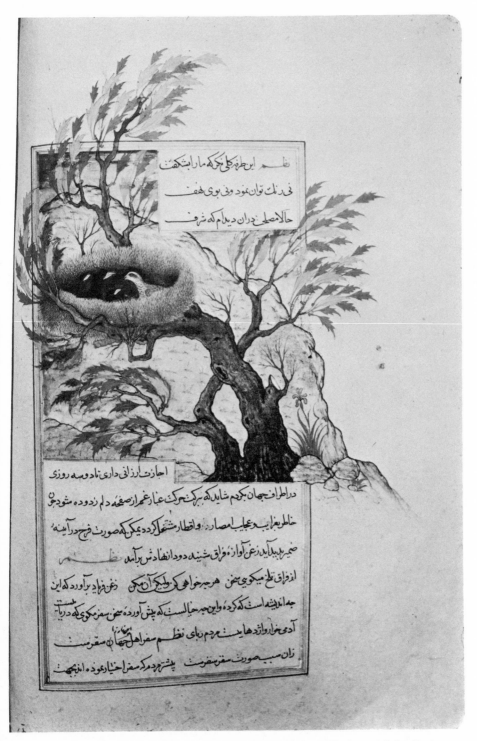

Fig. 46. SADIQI. *Birds in a nest*. Folio 20b from the 1593 *Anvar-i Suhayli*.

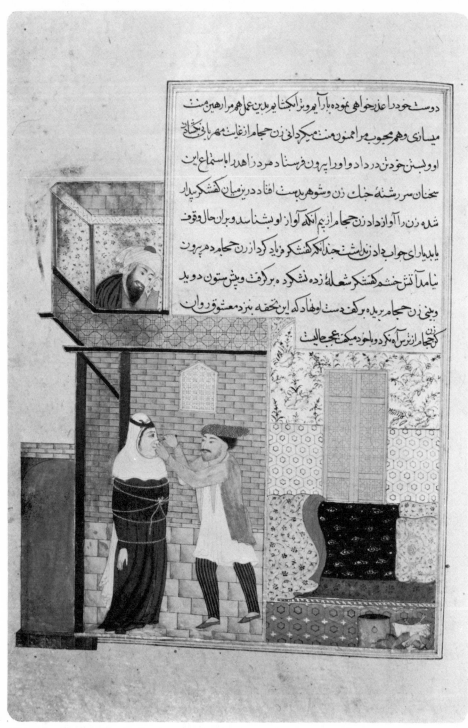

Fig. 47. SADIQI. *The husband cuts off his wife's nose.* Folio 52a from the 1593 *Anvar-i Suhayli.*

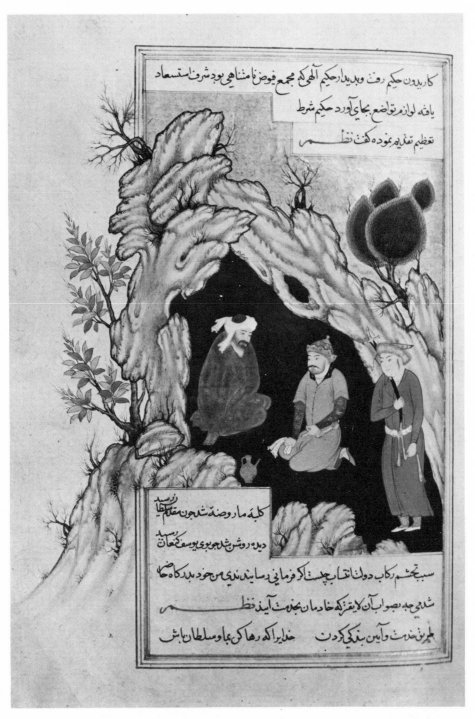

Fig. 48. SADIQI. *A king visits a hermit*. Folio 309a from the 1593 *Anvar-i Suhayli*.

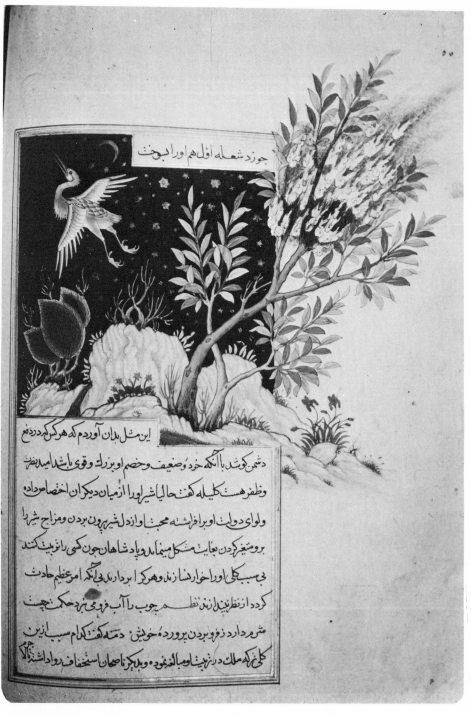

Fig. 49. SADIQI. *A stork in a night sky.* Folio 55b from the 1593 *Anvar-i Suhayli.*

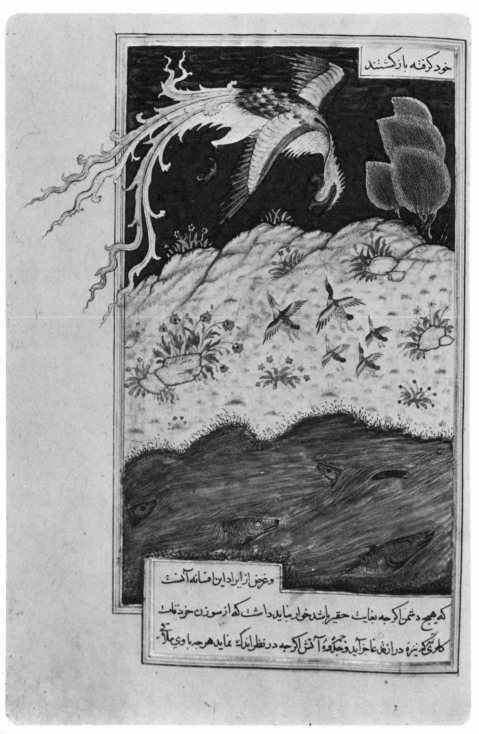

Fig. 50. SADIQI. *A simurgh*. Folio 85a from the 1593 *Anvar-i Suhayli*.

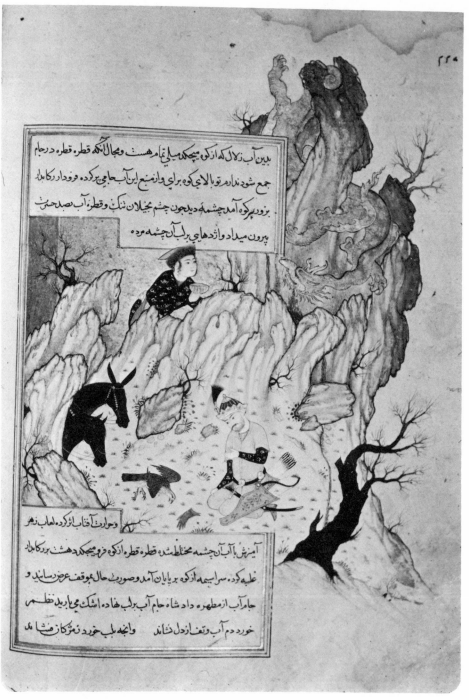

Fig. 51. SADIQI. *A dragon in the mountains.* Folio 227b from the 1593 *Anvar-i Suhayli.*

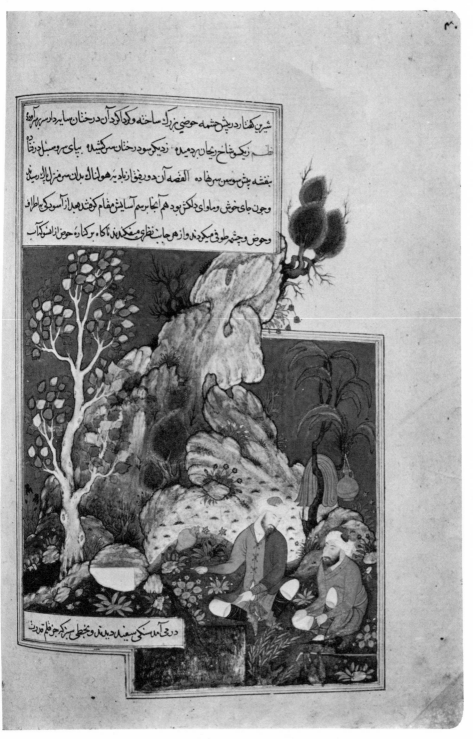

Fig. 52. SADIQI. *Two men by a stream.* Folio 40b from the 1593 *Anvar-i Suhayli.*

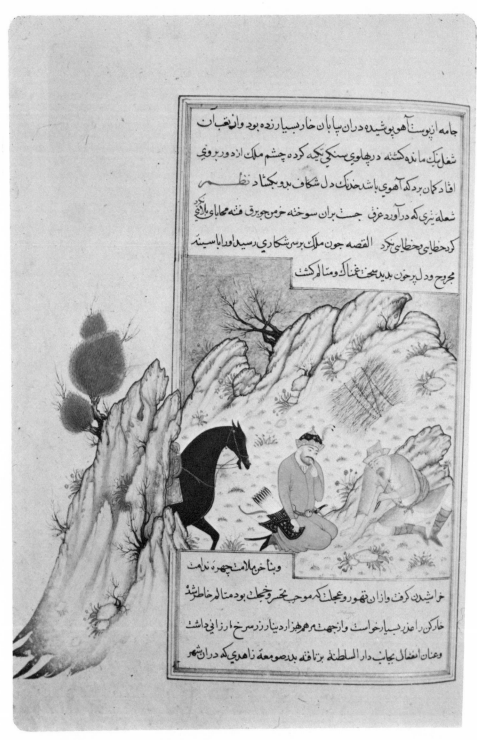

Fig. 53. SADIQI. *A king with a wounded woodcutter*. Folio 313a from the 1593 *Anvar-i Suhayli*.

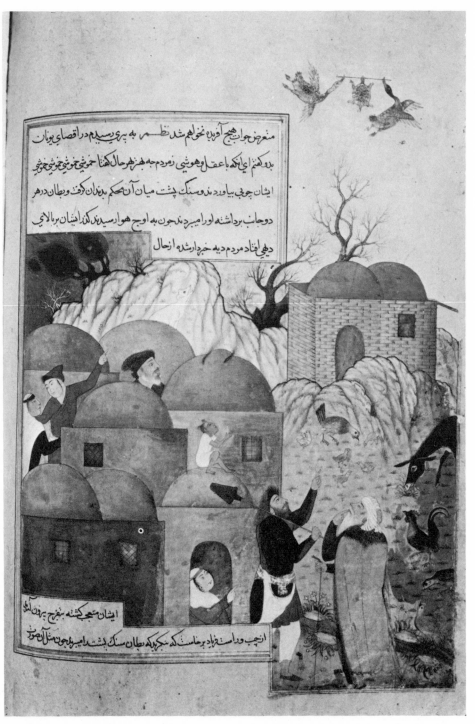

Fig. 54. SADIQI. *The tortoise and the ducks.* Folio 83b from the 1593 *Anvar-i Suhayli.*

ble dwellings. On another roof a little boy squats staring in aston-
ishment at the animals flying overhead. On still another roof a dog
reminiscent of one in Mir Sayyid 'Ali's great "cityscape" barks
furiously at the strange apparition above.[15]

In folio 22a (fig. 55) we view a humble interior in which a woman
sits spinning thread. With an eye more sympathetic than we would
have expected, Sadiqi supplies us with the details of her simple life:
the oil lamp shedding light in the wall niche, the pot cooking over
the fire, the large mixing bowl, the simple peasant rugs on which
she sits. It is one of the humblest interiors ever represented in Ira-
nian painting, and its matter-of-fact representation makes it also
one of the most informative.

Folio 265a (plate 13) is another example of Sadiqi's discomfit-
ing two-dimensional architecture, but it is also one of the most
naturalistic market scenes in Iranian painting, again bringing to
mind details from Mir Sayyid 'Ali's work. Hooks and rings of vari-
ous sizes hang from the ceiling. On the shelves at the right is ar-
ranged a careful display of sweets. While the two men haggle over
the price to be paid, unpleasant large flies hover and dip into the
bowl of sweets between them. That Sadiqi is the only Persian painter
who has ever included flies in his work may not be the most earth-
shaking distinction, but, considered along with the two previous
illustrations, it does indicate that Sadiqi, trained by one of the most
courtly of all the high-court artists, still knew and appreciated the
qualities of humbler existence. It also shows that the naturalistic
elements so long considered to have been one of the major innova-
tions of Mughal painting appear in Iranian painting at about the
same time. Sadiqi painted in this genre–naturalistic vein only once
—in this *Anvar-i Suhayli* which he commissioned for himself and in
which, we presume, he was subject to no taste but his own.

The manuscript is the artist's last known, dated, and firmly as-
cribed work. Although it may have been undertaken by the painter
in order to sell it at a profit, either in the bazaar or to an apprecia-
tive client in Iran or India, this does not seem likely. Sadiqi was not
in need of money. He received what we assume was a good salary
from the treasury, and as kitabdar he also had the opportunity to
increase his income considerably through wise purchasing and wiser
accounting in the acquisition of supplies for the royal workshop, as

15. Fogg Art Museum. Published in A. U. Pope and P. Ackerman, *A Survey of
Persian Art*, pls. 908/B and 909/B.

well as through the occasional theft of a manuscript. He was expected to pad his accounts, and earlier painters had made good use of this privilege. Whereas single drawings and paintings involved small expenditure and little risk and must have brought in a good profit, a large, costly book would have been a risky undertaking even for a man of Sadiqi's position unless he had a ready customer. And if this were the case, we would expect the colophon to bear the customer's name rather than Sadiqi's.

But Sadiqi is a man of "firsts" in the Iranian art world. Although several Iranian painters were also poets of note, Sadiqi has left behind a larger corpus of literary work, composed in both Chaghatay Turkish and Persian, than any of them. He is the only painter who felt the need to write biographies of his contemporaries including not just painters but also poets, calligraphers, princes, officials, friends, and enemies. He is the only artist whose *Assembly of Worthies (Majma' al-Khawass)* joyfully includes so many who are patently unworthy. No other painter saw fit to compose an Iranian equivalent of the Florentine painter Cennino Cennini's 1437 *Craftsman's Handbook,* and as a result Sadiqi's *Qanun al-Suvar* is a unique document in Iranian art history. And there is compelling evidence that Sadiqi was the first, and apparently only, Iranian artist to commission his own manuscript.

There seems to exist a basic division in Sadiqi's life work. His art up to about 1580 clearly reflected the main currents of the Qazvin style, significantly affected, of course, by his own particular approach. After about 1587 his work, whether in drawing or painting, came strongly under the influence of Riza, an influence so strong that at times we might speak of dominance.

During this period when Sadiqi was in his ascendancy Riza was not inactive, although his principal work seems to have been single-page drawings and paintings rather than illustrations for manuscripts. Only one manuscript can, in fact, be reliably attributed to Riza's hand during this period, and this is a copy of the *Qisas al-Anbiya (Annals of the Prophets)*[16] which is undated but must have been completed about 1595. The colophon provides no information concerning its patronage, and it may not have been done for Shah 'Abbas himself. Just one page bears Riza's name,

16. In the Bibliothèque Nationale, Paris. Published in B. Gray, *Persian Painting,* p. 162 and E. Blochet, *Les peintures des manuscrits orientaux de la Bibliothèque Nationale* (Paris, 1914–20), pl. 54.

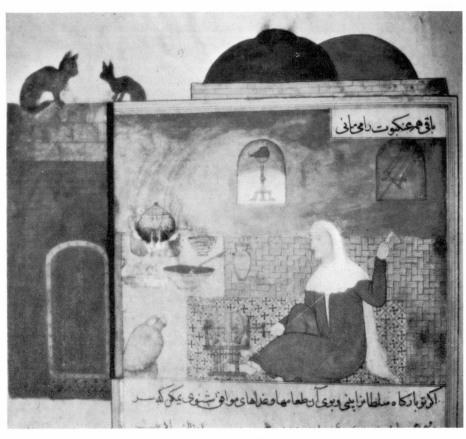

Fig. 55. SADIQI. *A woman weaving.* Folio 22a from the 1593 *Anvar-i Suhayli.*

although the manuscript's other illustrated pages share the same svelte, elegant line characteristic of the artist at this period in his career. But despite the manuscript's relatively high quality, it does not compare with the superb single-page images examined earlier, and it is clear that with the important exception of the 1587–97 *Shahnamah* for Shah 'Abbas I, his finest work was done in the medium of single pages rather than precious books.

Riza's presence continued to haunt Sadiqi's work for the rest of his life. Two drawings, both dating about 1600, confirm this point. One (fig. 56), a remarkable drawing that can be confidently attributed to Riza, reveals a *qarrad,* a wandering entertainer, whose trained monkey, perched high on his right shoulder, would delight crowds with his antics, dances, and imitations of comic human types. But though animal–human couples of this sort were a frequent sight in sixteenth-century Iran,[17] this duo has been depicted with rare perception. The ancient, overworked nag (one of the most poignant symbols in Iranian mystical poetry of human existence weighed down and broken under the weight of its own mortality) trudges with glazed eyes through an arid landscape. Once a stallion, its genitals now sag, its shanks collapse, and its bones protrude from the remnants of its flesh. The line, while vividly descriptive, almost belies this state of chronic exhaustion: its tapering thickness and sensuous turns capture the drooping, withered beauty of decay, while the high-velocity curve of the saddlecloth circling below the neck implies the purer state which the body is seeking. Astride the staggering horse, the trainer is a picture of consummate complacency, his body still young, strong, and well fed, and his face with its beady eyes, cauliflower ear, and unkempt hair, implying steady ignorance of the realities the horse reveals. Riding lightly on his shoulder, the monkey is strangely humanoid, its feet, hands, thighs, and body like those of its master, whose physiognomy is, in fact, more simian, for the animal's face is endowed with keen perceptions and otherwordly knowledge. And is the bird struggling in the qarrad's hand (and clearly destined to be his next meal) a symbol of the soul, striving to be free?

The drawing is one of the richest blends in all Iranian art, a tour

17. Muhammadi has left several fine drawings of animal entertainments. See R. Ettinghausen, "The Dance with Zoomorphic Masks and Other Forms of Entertainment Seen in Islamic Art," in *Arabic and Islamic Studies in Honor of Hamilton A. R. Gibb,* ed. George Makdisi (Leiden, 1965), pp. 211–24.

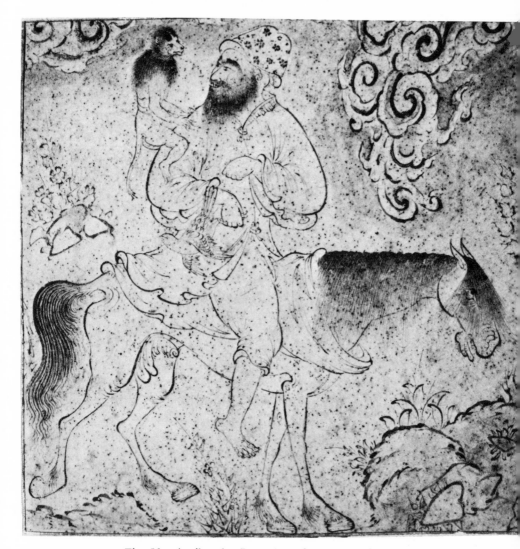

Fig. 56. Attributed to RIZA. *A monkey-trainer*. Circa 1595.

de force bringing together satire, superb description, sharp wit, and an almost overpowering awareness of mystical truths.

Compared with this drawing, Sadiqi's contemporary piece (fig. 57)[18] is a highly competent work of art in a traditional vein. It too pursues, at least on the surface, a religious message, for the seated man is a dervish who has put down his cap while he rests under a tree in which two birds sing. It is one of the stock images of late sixteenth- and seventeenth-century art, its linear treatment revealing the strong influence of Riza's technique. Despite the overt devotional content, there is no hint of the mystical profundity of Riza's drawing. The fundamental unity of figure 56 is absent: the birds are a lyrical footnote, and nature is a convenient backdrop, a stage-set for a scene of little real action. Vegetation, birds, rocks, and dervish all owe their technical rendering to Riza's innovations. Here in what is one of his last known works of art, Sadiqi has borrowed the bare surface, but not the depth, of Riza's art.

This second division in Sadiqi's oeuvre is less clear and is necessarily advanced with some hesitation. There seems to exist in his art a separation between the work he did for his royal patrons and the work he did as a private artist. The illustrations for the three royal manuscripts on which he worked—the 1573 *Garshaspnamah,* the 1576–77 *Shahnamah,* and the 1587–97 *Shahnamah*—are all technically accomplished and in many cases fine. But with the notable exception of his great *Simurgh* page (plate 11) for the 1587–97 *Shahnamah,* they are neither innovative nor imaginative. His drawings, however (and none of them bears an inscription citing a royal patron, as do two of Siyavush's most important drawings) are, despite their hard cerebral quality, masterful works, superior to his usual illustration of royal books. From this evidence alone we might conclude that he was a better draftsman than a painter. This is only half true. For some of Sadiqi's paintings in the 1593 *Anvar-i Suhayli* are exciting and reveal his strong color sense, as well as his predilection for highly unusual subject matter and for an occasional naturalism rare in Iranian painting.

It is possible that we can draw a distinction between his formally

18. This drawing is published as the cover photograph of *Hunar u Mardom,* new series, no. 51 (Tehran, 1966). It bears the artist's name in the lower right; the date has been rubbed out. An additional drawing must also date to the early years of the seventeenth century. This rendering of a lion tamer is not signed but can be confidently attributed to Sadiqi's hand. It has been reproduced and discussed in A. Welch, *Shah Abbas,* no. 3.

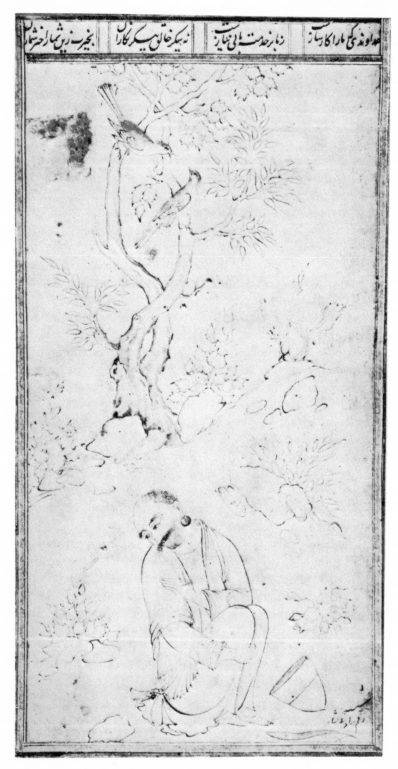

Fig. 57. SADIQI. *Man in a landscape*. Circa 1600.

commissioned works and his uncommissioned works, since apparently the drawings, as well as the *Anvar-i Suhayli,* belong in this latter category. Was Sadiqi an artist rare among Safavi painters— one who did not thrive under active, interested patronage but who worked better when left to his own devices? Much of Sadiqi's most brilliant and original work was achieved when he was most independent, which may be evidence that the fruitful system of royal patronage that had created so many masterpieces of Iranian art was no longer as effective as it once had been.

Another major artist lends support to this hypothesis. The great Riza himself did not function well under royal patronage but balked and struggled against it, even going so far as to dissociate himself from the cultured milieu in which the shah no doubt wished him to circulate. Thus to the urbane, polished, and sycophantic Iskandar Munshi the "certain strain of independence" in Riza's character was definitely not an asset, for it clearly offended the otherwise appreciative and indulgent Shah 'Abbas. This new independence from royal patronage is part of an evolving ethos that, along with changing economic conditions and changing tastes, was one of the principal reasons for the relative decline of manuscript painting in the seventeenth century and the ascendency of single drawings and miniatures.

"Ill-tempered, peevish, and unsociable," Riza and Sadiqi are amazingly similar in character. Although the latter seems to have produced little, if any, art after about 1600, Riza continued to work with great energy: his oeuvre from then until his death in 1635 is of enormous proportions and frequently striking originality.

5. Personalities and Patronage

From this examination of Siyavush, Sadiqi, and Riza it has become increasingly apparent that the role of the patron is of crucial importance in determining both the scope and the quality of Iranian painting in the late sixteenth century. It is a period in which patronage is extremely diffuse, including that of not only the great imperial figures such as Shah Tahmasp and Shah 'Abbas I, but also of princes of the royal house, high aristocrats, leading bureaucrats, provincial noblemen, and possibly even wealthy merchants. It is a period marked by the gradual decline in importance of the precious manuscript and the increasing importance of the single page, whether painting or drawing or calligraphy. As a result an art form which had been previously restricted by cost and tradition to a relatively narrow social elite had become far more accessible to a wider public.

Until now we have approached the question of patronage largely from the viewpoint of the lives and works of the three most important painters of the period. But we must also regard it in terms of the patrons, the men who supplied the funds and frequently the overall direction for these great manuscripts and some of the single-page works.

Ibrahim Mirza

Ibrahim, the son of Tahmasp's favorite and only loyal brother Bahram, who had been a noted patron in his own right, was born in 1543/44 (950). At the time of his uncle Tahmasp's "personality crisis" he was still a very young child, presumably being carefully educated in the refined culture of the Safavi court. He would have studied painting, perhaps with an accomplished, favored master such as Muzaffar 'Ali, and calligraphy, perhaps at first with Rustam 'Ali, his father's leading scribe, and then later with Mawlana Malik Daylami. According to Qazi Ahmad, who grew up in Prince Ibrahim's service, his virtues and accomplishments were beyond description: he was thoroughly versed in Koranic studies, theology, and philosophy; he had studied history, mathematics, music, and as-

tronomy. He was an artist, "one of the recognized calligraphers in Iran," and a composer. He was brave, manly, without equal in polo and archery, a skilled shot with a musket, a fine chess player, an accomplished chef, and a gifted craftsman able to turn his hand at almost any handicraft. "No occupation, trade, or art escaped his attention," and he had masterfully assimiliated the instruction which had been part of princely education in Iran since the eleventh century, if not before.[1]

In 1556/57 (964) he was appointed *hakim* (governor) of Mashhad and *nazir* (superintendent) of the shrine of the Imam Riza. In the same year, with the shah's permission and presumably with his encouragement as well, he undertook the patronage of the Freer Gallery's *Haft Awrang* of Jami, a monumental task which was to occupy him for the next nine years. Though Ibrahim could not draw on quite the same resources as had his uncle thirty years earlier when he began the Houghton *Shahnamah,* he still assembled a most impressive atelier. The scribes and the painters were among the most gifted artists of his day.

The manuscript's progress was not smooth. Although the shah must have approved of the project and did support it by letting the still remaining court artists such as Aqa Mirak and Muzaffar 'Ali work on its illustrations, he could become suddenly hostile and peevish and withdraw the vital services of a crucial artist such as the calligrapher Malik Daylami.

Originally begun in Mashhad, the manuscript had to be continued in Sabzavar and Qa'in during the years 1563–66 (970–73), when the prince was transferred to these minor posts by his unpredictable and perhaps spiteful uncle. These three years could not have been pleasant, and it must have slowed the work on the *Haft Awrang.* Did not Ibrahim (whose pen name was Jahi) complain bitterly about it himself?

> Jahi! Perhaps with the blessings of the martyr of Tus
> Your feet will get out of the mud of Sabzavar.

But judging from one verse at least, the prince tried hard to keep his equanimity:

> Do not groan at the cruelty, Jahi; impatience is wrong.
> God may return clemency to the heart of our sovereign.[2]

1. Qazi Ahmad, *Calligraphers and Painters,* pp. 155–56.
2. Ibid., p. 157.

Even if conditions were sometimes difficult, nine years for the production of a superb manuscript was not an extraordinarily long time. But where had the *Haft Awrang* painters and calligraphers come from? By whom had they been trained, and how did they fare under Ibrahim's patronage?

At least one of the scribes Ibrahim Mirza "inherited" from his father. Rustam 'Ali, the nephew of the great late fifteenth- and early sixteenth-century painter Bihzad, had been with Bahram Mirza during that prince's governorship in Hamadan from 1545 to 1549, and on Bahram's death in that year he almost certainly transferred his service to the young prince. By the time he went to Mashhad with Ibrahim he was an old man. A famed calligrapher for many years, he must have been one of the prince's familiar associates. He died in Ibrahim's service in Mashhad in 1562/63 (970). His entire professional experience was spent in this one family's employ.[3]

His son Muhibb 'Ali therefore came naturally under Ibrahim's aegis. As Rustam 'Ali's son and Bihzad's grandnephew he already had much in his favor, and training, coupled with great natural talent, ensured him success. His cousin Muzaffar 'Ali, also a grandnephew of Bihzad, is known to have been a member of Ibrahim's atelier and must surely have been one of the leading painters for the manuscript. "Dynastic" efforts like this one were not at all uncommon, and the complex familial interrelationships among the artists of the Safavi period indicate that marriages between artistic families were sought after, possibly as a means of transmitting genetic abilities, perhaps too as a way of establishing a de facto guild.[4] Related artists undoubtedly helped each other secure posi-

3. Ibid. p. 147.

4. Only a very brief list of some of the dynastic arrangements among leading Safavi artists will give a fair idea of how extensive they must have been: Muzaffar 'Ali, Bihzad's nephew, was the son of Haydar 'Ali a fine painter of the early Safavi period. Mirza 'Ali, one of the likely painters of the *Haft Awrang*, was the son of Sultan Muhammad, himself the son of the painter Sultan Mahmud. The son of Sultan Muhammad's daughter was Zayn al-'Abidin, a calligrapher, illuminator, and painter who was one of the important artistic figures of the late sixteenth century. Mir Sayyid 'Ali, one of the painters of the Houghton *Shahnamah* and the British Museum *Khamsah*, was the son of the great early Safavi master Mir Musavvir. Riza, the leading painter of the late sixteenth and early seventeenth centuries, was the son of 'Ali Asghar, a member of Ibrahim Mirza's atelier in Mashhad and a painter under Isma'il II. The calligrapher Mawlana Ibrahim, who took refuge in Istanbul in 1577/78 (984) was the son of Malik Daylami, one of the scribes of the

tions at court, and it is probably not due to talent or chance alone that three of the major artists of the *Haft Awrang* were related.

Both position and patronage were frequently hereditary. A prince would naturally look to the offspring of his scribes and painters for new talent, and they in turn could expect that he would endeavor to employ them. Shah Tahmasp had employed at least two of his father's chief painters, Mir Musavvir and Sultan Muhammad, and Ibrahim Mirza became the patron of most of his uncle's unsupported painters and scribes. In 1576/77 (984) Isma'il II in turn took over some of the talents assembled by his cousin Ibrahim. But despite the hereditary nature of much patronage, there was always room for new talent from outside. Neither Siyavush nor Sadiqi was connected by birth with one of the great artistic families, yet both managed to rise to positions of great status and considerable power within the imperial ateliers.

An artist's relationship with his patron was not clearly defined. Some artists, such as Aqa Mirak, were intimates of the sovereign and filled the dual role of boon companion and artist. 'Abd al-'Aziz, among others, apparently understood his patron's temperament so well that he could take almost unheard-of liberties with impunity. But some such as Mir Sayyid Ahmad and Hakim Rukna might be swiftly punished for small or nonexistent offenses. Thus we do not know how great Muhibb 'Ali's political transgression was, or whether he incurred the displeasure of Ibrahim Mirza or Shah Tahmasp, when Qazi Ahmad reports that "not content with his duties, he was trying to acquire influence upon his lord."[5] He was recalled to Qazvin in 1565, the year of the *Haft Awrang's* completion and the year in which his function as director of Ibrahim's atelier was presumably no longer as crucial as it once had been. He remained in Qazvin until he died.

Shah Mahmud Nishapuri, a third master of the great manuscript, was apparently one of those cast off when Shah Tahmasp lost interest in the arts at midcentury. But did the shah actually dismiss his

Freer *Haft Awrang*. 'Abd al-Hadi Qazvini, another calligrapher of note, was Mawlana Malik Daylami's brother-in-law and pupil. And Mawlana Malik himself was the son of the famous calligrapher Shahra-Mir Qazvini. Shah Mahmud Nishapuri, one of the greatest scribes of the sixteenth century, was the nephew and pupil of Mawlana 'Abdi, a calligrapher. And Shaykh Muhammad, one of the leading painters of the sixteenth century, was the son of the calligrapher Shaykh Kamal Sabzavari.

5. Qazi Ahmad, p. 147.

artists, as Qazi Ahmad says, or did he simply stop paying them, a ploy he favored as a means of filling the royal coffers?[6]

Whatever the case, Shah Mahmud had to "obtain leave" to retire to Mashhad. Although there was an enormous amount of artistic mobility during this period with artists traveling to India and to the outer reaches of the Safavi empire in search of patronage, at least some of those who worked for the shah seem to have been bound to him until formally released.

That an artist of his caliber should be released at all is surprising. He had been the sole scribe of the British Museum's *Khamsah* of Nizami. But shortly after that manuscript's completion in 1543 he did leave for Mashhad. According to Qazi Ahmad, he was something of a recluse, had no relatives, and never married. How he lived during the next twenty years in Mashhad is a mystery. "From no source had he any pension or grants of lands, and he received no patronage from anyone." It is astonishing that a scribe of his merit who had just completed a monumental task like the entire 1539–43 *Khamsah* should be so summarily dismissed.[7]

During his years in Mashhad he was not, however, idle, and he must have earned his income from a variety of jobs. He had some students, Qazi Ahmad among them. He was also "engaged in writing inscriptions and samples of calligraphy," which presumably were either on commission or sold by the scribe himself. He may too have received orders for decorating buildings with inscriptions, a common occupation for calligraphers. In addition, he was at work on several manuscripts, three of which have fortunately survived.[8] But in view of what Qazi Ahmad says, it would seem that he had no fixed income and that even his writing for the *Haft Awrang* was "piecework." In terms of financial rewards his life was no easier than that of Mir Sayyid Ahmad.

The other leading calligrapher of the Freer manuscript, Mawlana Malik Daylami, was a favorite of Shah Tahmasp. At first on the staff of Tahmasp's grand vazir, Qazi-yi Jahan, he was assigned,

6. On coming to the throne in 1576 Isma'il II discovered that the royal *qurchis* (guards) had not been paid for fourteen years. (See W. Hinz, "Schah Esma'il II, Ein Beitrag zur Geschichte der Safaviden," in *Mitteilungen des Seminars für Orientalische Sprachen,* 1933, pp. 19–100.)

7. Qazi Ahmad, p. 135–38.

8. A 1551 *Bustan* of Sa'di (Chester Beatty Library, no. 221); a 1552 *Khamsah* of Amir Khusraw Dehlevi (Bibliothèque Nationale, Paris, sup. pers. 1149); and the 1556 *Subhat al-Abrar* portion of the Freer *Haft Awrang*.

probably after that official's dismissal in 1550, to the workshop of
Ibrahim Mirza. When Ibrahim Mirza was in Mashhad, the shah
allowed Mawlana Malik to join him there, where he wrote two parts
of the *Haft Awrang*.[9] But as soon as he had finished the *Silsilat al-
Zahhab*, the shah ordered him back to Qazvin to decorate with in-
scriptions the newly completed royal palace, the Dawlatkhanah, as
well as the Sa'adatabad gardens and the Chehel Sotun palace. When
his work there was finished, Ibrahim wanted him back in Mashhad,
perhaps to do further work on the *Haft Awrang*. But "despite the
constant representations which His Highness the Mirza made to the
exalted throne," the shah would not let him return. It may be that
the shah had more tasks planned for the scribe in Qazvin, but from
Qazi Ahmad's short account it does not seem as if Mawlana Malik
was involved in anything essential for the few years remaining be-
fore his death in 1561/62 (969).[10]

We know little about the other two calligraphers of the *Haft Aw-
rang*, and what we do know sheds scant light on the question of
patronage. 'Ayshi ibn 'Oshrati came to Mashhad to work on the
Jami project, perhaps after the shah's refusal to release Malik Day-
lami, and was well treated by the prince. Muhammad Khandan had
had an impressive training, for he had been a pupil of Mir 'Ali,
Ibrahim Mirza's ideal calligrapher and the scribe whom the prince
emulated and avidly collected. Muhammad Khandan's work for the
Haft Awrang is undated, but we know of two other manuscripts by
his hand: an undated *Diwan* of Shahi and a 1564 *Subhat al-Abrar*,
presumably produced for Ibrahim Mirza in Mashhad while the
Freer manuscript was still in progress.[11]

It must have been a pleasure to work under the young prince. He
was himself gifted in all the arts he supported, and since "by nature
he was of pleasant disposition and inclined to gaiety and joy," and
since he possessed impressive financial resources, it is little wonder

9. Jami's *Haft Awrang* consists of seven mathnawi poems of considerable length:
Silsilat al-Zahhab (*Chain of Gold*); *Salaman wa Absal* (*Salaman and Absal*); *Tuhfat
al-Ahrar* (*Gift of the Noble*); *Subhat al-Abrar* (*Rosary of the Pious*); *Yusuf u
Zulaykha* (*Yusuf and Zulaykha*); *Layla wa Majnun* (*Layla and Majnun*); and
Khiradnama-i Sikandari (*Book of Wisdom of Iskandar*).

10. Qazi Ahmad, p. 144.

11. Ibid., pp. 153–55. Shahi was a leading poet at the court of the great early
Timurid prince, Baysunghur (1397–1433) in Herat. The *Subhat al-Abrar* is one of
the mathnawis of Jami's *Haft Awrang*. The Shahi manuscript is in the Bibliothèque
Nationale, Paris, sup. pers. 1962, while the *Subhat al-Abrar* has been published in
I. Stchoukine, *Les peintures des manuscrits Safavis de 1502–1587*, ms. no. 169.

that "no sultan or khaqan possessed a more flourishing kitabkhanah than that powerful prince." He knew how to teach and how to encourage: "Masters of all kinds of arts becoming pupils under him seemed to receive from him and acquire visible confidence [in their profession]."[12] It was like the golden age of patronage that Tahmasp had initiated in 1522. But whereas the shah's cultural flowering had lasted more than twenty years, the prince's survived for only ten.

But what of the painters whom Ibrahim brought together in Mashhad for the *Haft Awrang* project?[13]

The elder master of the group was Aqa Mirak, the boon companion of Tahmasp as a youth and a painter in the Houghton *Shahnamah,* the British Museum *Khamsah,* and the Freer *Haft Awrang.* He was a contemporary of Sultan Muhammad, who had died soon after 1543, and of Mir Musavvir, who had followed his son Mir Sayyid 'Ali to India about 1545.

Two other artists were also Tahmasp's men, though of the second generation. Mirza 'Ali was Sultan Muhammad's son, as well as his pupil and had worked with his father on the Houghton *Shahnamah* and the British Museum *Khamsah.* He was an established master with a high reputation and was a "natural" for Ibrahim to pick. So too was Muzaffar 'Ali, the son of Haydar 'Ali, one of Tahmasp's first-generation artists. Muzaffar 'Ali's career had paralleled that of Mirza 'Ali, and the two men had long been associates.

Two unnamed artists "graduated" from the Houghton *Shahnamah* to the Freer *Haft Awrang.* Neither worked on the great *Khamsah.*

The last of the six painters was Shaykh Muhammad, not a new figure in Iranian court art but the only real "promotion' Ibrahim made. The other five artists were established painters with high reputations. It would have been surprising if Ibrahim had not selected them. But Shaykh Muhammad was something of an oddity with a highly unusual style. Ibrahim's careful and very conscious choice of Shaykh Muhammad as a major painter (to him have been attributed seven of the manuscript's twenty-eight miniatures) must

12. Qazi Ahmad, pp. 158–60.
13. The following cursory discussion of the painters involved in the illustration of the Freer *Haft Awrang* is based upon S. C. Welch's attributions and analysis in *A King's Book of Kings* (New York, 1972), and in his forthcoming study (with M. B. Dickson), "The Houghton *Shahnamah*." I am extremely grateful to this scholar for his generosity in putting his manuscript of the latter work at my disposal.

have reflected his own stylistic proclivities. It is equally likely that
the patron's choice strongly influenced the other leading painters of
the manuscript, for both Muzaffar 'Ali and Mirza 'Ali veered to-
ward Shaykh Muhammad's style. As a result, Ibrahim's patronage
was, for the time at least, a crucial factor in Iranian painting.

The *Haft Awrang* was a watershed manuscript. For the rest of
the century we find no new manuscripts illustrated by Aqa Mirak,
Mirza 'Ali, or Shaykh Muhammad. Muzaffar 'Ali painted a single
miniature in the 1573 *Garshaspnamah,* but this illustration was his
last work in a major manuscript, and he died three years later.
Though Mirza 'Ali and Shaykh Muhammad continued to paint for
most of the remainder of the century, they worked on single-page
minatures and drawings rather than on manuscripts. The older two
generations who had been trained under Tahmasp and who had
earned their laurels on the Houghton *Shahnamah* were passing
away. A new generation, for the most part trained by them, re-
placed these artists, and new styles of painting and of patronage
emerged.

Ibrahim's place in these further changes is unclear. His great *Haft
Awrang* was completed in 1565. Presumably the manuscript re-
mained with him in Mashhad along with the other works he had
acquired. "Some three thousand volumes and treatises were col-
lected in the library of that light of every eye," writes Qazi Ahmad.
In 1568 (976) Ibrahim was recalled to Qazvin and remained there
until his death nine years later. What post he held under Tahmasp is
not known. It is also not clear what became of his library and ate-
lier. Did he bring his books, painters, and scribes back with him to
the capital? Did they remain under his control, or did they become
part of the royal library? The latter hypothesis is possible, for in his
later years the shah seems to have mellowed and regained some of
his earlier interest in painting.[14]

14. Several manuscripts of very fine quality were produced between 1565 and
1576, very possibly either by Ibrahim's or Tahmasp's atelier: (a) The c. 1565 *Subhat
al-Abrar* of Jami (Gulbenkian Collection, no. 126). (b) The 1568 (976) *Three Poems*
of Hilali (Gulbenkian, no. 127). (c) The 1568/69 (976) *'Aja'ib al-Makhluqat* (Top-
kapi Palace Museum, H. 403). (d) The 1569/70 (977) *Silsilat al-Zahhab* of Jami
(Gulistan Library). (e) The c. 1570 *Khamsah* of Nizami (Topkapi, H. 777. (f) A c.
1570 *Shahnamah* fragment of four miniatures (reproduced in Colnaghi, nos. 18 i–iv).
(g) The 1570/71 (978) *Haft Awrang* of Jami (Topkapi, H. 1483). (h) The 1573 (981)
Garshaspnamah (British Museum, Or. 12985). (i) The 1574/75 (982) *Khamsah* of
Nizami (Topkapi, R. 884).
Four other manuscripts in a closely related style may belong together as the

Although Ibrahim was a daring man and would go out of his way to encourage and protect artists whom he admired, it does not seem likely that he could have supported a large kitabkhanah in the capital city without the shah's acquiescence. During the nine years of his residence in Qazvin from 1568 to 1577 there is no single work approaching in quality the 1556–65 *Haft Awrang*. And even though the 1573 *Garshaspnamah* was written "at Qazvin" by Mir 'Imad, only one of its paintings (by the aged Muzaffar 'Ali) is of truly superb quality. If the prince was still a patron of the arts, it is clear that he was less interested and less involved than before.

Our chronicles tell us nothing of the prince during the eight years between his return to the capital and the death of Shah Tahmasp. And this gap is not filled by Sadiqi's sympathetic, but generalized comments:

> He was the chosen one of the children of Bahram Mirza. He was a fine conversationalist and had a fine temperament and keen understanding, and he was a jester. His unusual songs are famous. There were few arts or crafts in which he did not have some knowledge whether in practice or in theory. He greatly delighted in jests, so much so that he became proverbial for this among people. Because he could not control his tongue, he was killed in the time of Shah Isma'il II.[15]

Ibrahim's murder in 1577 was a great blow to the future of Iranian painting, and we can only speculate what works might have been produced by his atelier had the gifted prince not died so young. But we do know what happened to the artists in his and the royal employ. They passed directly into the service of the paranoid monarch who had murdered Ibrahim.

Isma'il II (r. 1576–77)

This third monarch of the Safavi line came to the throne after nineteen years of prison life, and his reign was an almost unparal-

work of a subroyal, though highly skilled, atelier in Qazvin: (j) The 1572–81 (979–989) *Khamsah* of Nizami (Morgan Library, Ms. 836). (k) The 1572 (979) *Haft Paykar* of Nizami (Fitzwilliam Museum, Ms. 18–1948). (l) The c. 1572 *Khamsah* of Nizami (Bodleian Library, Ms. Ouseley 316). (m) The 1576 (983) *Diwan* of Bana'i (Beatty Library, Ms. 243).

15. Sadiqi Bek, *Majma'*, pp. 25–26. Subsequent citations of page numbers in the text of this chapter are to this work.

led disaster for the Iranian state. Born in 1533, he had early showed prowess as a military leader, and at midcentury, while Tahmasp followed a scorched-earch policy against invading Ottoman armies, Isma'il Mirza led the Qizilbash troops in a series of daring assaults on the Turks. While the Ottoman sultan Sulayman was engaged in his Hungarian campaigns from 1549 to 1552, Tahmasp's second son, not yet twenty years old, raided eastern Anatolia, Georgia, and the Caucasus. When Sulayman responded in 1552 by sending an immense army under Iskandar Pasha to attack Iran, Isma'il and his troops inflicted an astounding defeat on them outside Erzerum. During the following years he attacked and harassed Ottoman armies with continuing success and became the unquestioned leader of the Qizilbash and the great popular hero of the day. He was acclaimed as the image of his (namesake) grandfather, the great warrior Isma'il I who had founded the Safavi dynasty in 1501.[16]

The Peace of Amasiya in 1555 ended the conflict with the Ottomans and was to preserve peace for over twenty years. Tahmasp combined official rejoicings with the marriage of his hero son, showered him with honors and gifts, and bestowed upon him the coveted governorship of Khorasan, until then held by Isma'il's older brother, the unassuming and unadventurous Muhammad Khodabandah. But Isma'il was evidently not grateful enough, and the peace sat hard upon him. He must have felt that a great opportunity to defeat the Ottomans had been lost. In Khorasan he began conspiring with Qizilbash amirs to form an army to march against the Turks. For Tahmasp this action was clearly threatening, and in 1556 Isma'il was recalled from his post, denounced in no uncertain terms by his enemies at court, and without being allowed to speak with his father, was taken to the fortress prison of Qahqahah, where he was to remain incarcerated for the next nineteen years. He was bitter and also full of remorse, as one of his poems written during this period indicates:

> That day when your business was only laughing [*qahqahah*]
> The course of the kingdom encountered adversity through your advice.
> And now in this Qahqahah you must be content with weeping,
> Since that loud laughing [*qahqahah*] resulted in this Qahqahah.
> [p. 12]

16. For a lively and thorough study of Isma'il's life and reign see Hinz, "Schah Esma'il II."

Much of his pain he tried to ease with increasingly heavy doses of *faluniya,* a potent mixture of opium, hashish, and other narcotics of which his father was also fond. Surely he was conscious of his own abilities now being wasted. Time after time he had beaten the Turks in battle; he had the charisma to unite both Qizilbash and Tajik behind him and heal the rift behind the two language groups. The prince was also talented, well educated, and a sincere lover of the arts. Sadiqi records one of his poems written under the pen name 'Adeli:

> The circling heaven never makes us happy by union (with the beloved).
> It only helps our ignorant rivals.
> It never conveys to them our desires.
> It does nothing for the success of the unsuccessful.

<div align="right">[p. 12]</div>

During Isma'il nineteen-year incarceration in Qahqahah his adherents remained faithful, and Sadiqi indicates that there were powerful forces at work to secure his release and perhaps overthrow Tahmasp:

> Before he came to the kingship, he accomplished many things fearlessly, but the late shah incarcerated him in the fortress of Qahqahah for the space of twenty-one years for the sake of public opinion. The notables and the amirs wrote letters to him and sent messengers, but it never occurred to him to disobey the orders of the late shah.[17] [p. 8]

When Tahmasp died in 1576, the Qizilbash split almost evenly into supporters of Isma'il and of his younger half brother Haydar. The struggle for power was brief. Tahmasp's daughter Pari Khan Khanum, a brilliant figure at the Safavi court and an adept intriguer, won Haydar's trust and then betrayed him to Isma'il's supporters. The young prince was murdered, and many of his adherents executed, while Isma'il's supporters celebrated their victory by terrorizing the Tajik population of Qazvin.

On 24 May 1576 Isma'il II entered the capital city in triumph. Though initially the forty-three-year-old monarch displayed leniency toward his defeated opponents and showed promise of initiating favorable policies, his rule soon turned into an unparalleled reign

17. Sadiqi, writing many years after the event, mistakenly lengthens Isma'il's term of imprisonment by two years.

of terror. A broken man, physically decayed and mentally unhinged by years of drug abuse, he systematically extirpated real or imagined enemies at home, including brothers, cousins, and other relatives, until he had finally reduced the Safavi royal family to only his elder brother Muhammad Khodabandah and the latter's immediate family, including the young boy 'Abbas. The monarch also attacked prominent aristocrats, Tajik notables, Sufis, and Shi'a religious officials. Isma'il seems to have had strong Sunni proclivities, and during his brief reign he almost undermined the Shi'a convictions which were a vital support of the Safavi state. His vicious and largely unwarranted actions against his own family, as well as against the feudal and religious structure to the empire, strongly imply that he was not merely trying to secure his own position as shah but also attempting to destroy the fragile state his father had so painstakingly preserved.

Still, the new shah's reputation for ferocity had a few good effects: "In the beginning of his reign his severity so terrified the people that although for a space of more than two years no governors were dispatched to the border regions, no one had the courage to rebel" (pp. 8–9).

Near the end of his rule he withdrew into his palace, which he had massively fortified, and increasingly devoted himself to drugs and pleasure. Hostility and fear grew so strong among the Qizilbash aristocrats and the leading Tajik notables that they apparently cooperated in engineering his assassination. The king was poisoned and died on 25 November 1577.

In his brief year-and-a-half reign the half mad shah had shaken and nearly toppled every pillar of the Safavi social order. The system so painfully constructed by Isma'il I and Tahmasp was on the verge of collapse. Had Isma'il II alternative forms in mind, as did his nephew 'Abbas I, this one-man upheaval might have served a purpose. But as it was, his death left Iran terribly weakened and prey to all the same divisive forces as before. His ironic death was as bitter as his life, which, so full of promise when he reached manhood, had been a tragedy of enormous proportions.

Isma'il II's political career was rocky, unsavory, and of short duration. But what of his patronage? Could this man, the murderer of a round dozen of his close relatives, have been a patron of the arts?

He was, and had his life not been cut short he might have been a great one. The royal atelier, dispersed once by Tahmasp in the

1540s and perhaps again when Ibrahim Mirza returned from Mashhad in 1568, was scarcely at full strength when Isma'il ascended the throne in 1576. It was evidently one of the new shah's major concerns to restore it to its former glory.

He had the gifts to do it too. Certainly his education must have been similar to that of his father and his cousin Ibrahim. Sadiqi's comments, quoted earlier, leave us the impression of a highly cultivated and properly sophisticated shah. Despite his famous cruelties, he was a man of gifts. Did this king aspire to become a patron to rank with his own father and with his gentle cousin Ibrahim, whom he was soon to destroy?

In 1573 the British Museum *Garshaspnamah* had been completed. Muzaffar 'Ali, the aging genius who had illustrated so many of the great Safavi books, had painted and signed the first miniature. Sadiqi Bek, his pupil and the source of so much of our information about the period, had signed another. So too had Zayn al-'Abidin, Sultan Muhammad's grandson. These painters were the core of the studio which Isma'il II found when he became shah, although Muzaffar 'Ali was to die very soon afterward. But the shah was ambitious, and he gathered together many more calligraphers and painters, several of them coming from Ibrahim Mirza's Mashhad atelier. Isma'il was an enthusiastic connoisseur and an energetic patron, for he brought together in Qazvin some of the finest painters Iran possessed.

The manuscript to emerge from this new studio was the now dispersed *Shahnamah* of 1576–77. Its calligraphers were first-rate masters whose names are unfortunately not known. But we do know the painters who illustrated the manuscript: Siyavush, Sadiqi Bek, Zayn al-'Abidin, Naqdi Bek, Murad Daylami, 'Ali Asghar, Mihrab, Burji, and probably 'Abdullah Shirazi. These men, however, were not the only painters in the refurbished royal atelier. Iskandar Munshi tells us that Khwajah Nasir ibn 'Abd al-Jabbar, the Gilani artist who served under Khan Ahmad, was appointed to Isma'il's library staff. So too was Shaykh Muhammad, the singular genius who likely worked on the Freer *Haft Awrang*. Mirza Muhammad Isfahani, a student of 'Abd al-'Aziz, joined the library, as did the malevolent Hasan Baghdadi. Siyavush's brother Farrukh Bek was also associated with the library, although it is not entirely clear on what basis.[18]

18. Iskandar Munshi, *Tarikh-i*, pp. 176–77, translation from Arnold, *Painting in Islam*, p. 143; Sadiqi Bek, *Majma'*, pp. 257–58.

Isma'il II did not turn his attention solely to painters. According to Sadiqi, he was close to the poet Mirza Muhammad Munshi. The calligrapher Mawlana Muhammad Husayn, a pupil of Mir Sayyid Ahmad and a student who had "perfected his writing to the point of equaling the masters,"[19] served under him as an official architectural calligrapher, a post previously occupied by Malik Daylami.

And the great master and teacher of calligraphy Mir Sayyid Ahmad, who had been so rudely treated by Tahmasp, was brought back to Qazvin from Mashhad with every sort of glory by the new monarch and given a lodging over the gate of the Sa'adatabad gardens.

Isma'il II's reign was too short to accomplish more. He assembled a considerable atelier, certainly the finest since Ibrahim Mirza's, and undertook the production of an important *Shahnamah*. For a turbulent reign of a year and a half this was a large achievement. History has justly condemned the paranoid ruler for his needless cruelties, but it must respect his energetic and talented efforts as a patron.

Muhammad Khodabandah (r. 1577–1587)

This dismal shah possessed neither the monstrous faults of his younger brother Isma'il II nor his larger virtues. He was a weak, belittled man, fond of family and pleasant living, neither a great shah nor a great patron.

At the time of his accession Shah Muhammad Khodabandah was forty-five years old. Born in 1531 (938), he was the eldest son of Shah Tahmasp. He was said to be well proportioned, and his face was not unattractive. By the time he became shah, his hair was already white, although he dyed his beard.[20]

He was a favorite of his father. In 1535/36 (942) he was named nominal governor of Khorasan, thereby replacing Bahram Mirza, and the province's *amir al-'umara'* was appointed his regent and

19. Mirza Muhammad: Sadiqi Bek, *Majma'*, p. 46. Qazi Ahmad, p. 97, confirms this information, adding that Mirza Muhammad became Isma'il II's companion and chief scribe. He continued in high office under Shah Muhammad Khodabandah, was the companion of the heir apparent Prince Hamzah, but was executed under Shah 'Abbas I. Muhammad Husayn: Qazi Ahmad, p. 165.

20. Much of the historical evidence for this account is derived from H. R. Roemer's *Der Niedergang Irans nach dem Tode Isma'ils des Grausamen*.

lalah.[21] His education must have followed the normal course for royal princes, and we can reasonably assume that he was trained in government, war, etiquette, and the arts. To some of his instruction he took well, but his later life attests that in government and war he had no special interests.

He was briefly removed from his high post in Khorasan in 1556, apparently not because of any insubordination but because the shah wished to advance his more capable brother Isma'il. Six months later Muhammad was reinstated, and at about the same time his eyesight began to fail. He became rapidly blind, and when he finally ascended Iran's throne in 1578, he could only distinguish between light and dark. Ordinarily, this disability would have barred him from becoming shah. Indeed, upon Tahmasp's death he had not even been seriously considered a candidate. But after Isma'il II's short murderous rule Muhammad Khodabandah was the only surviving adult Safavi, and his physical state promised the battered amirs a weak shah who would not act against their interests.

This proved to be the case. During his education in Herat the prince had distinguished himself by his gentleness, wisdom, understanding, and generosity. He was much concerned with the welfare of others, but evidently in a languid and nonconstructive way. He was averse to worry or melancholy, and his nature tended more toward jests, amusements, and light pastimes.

A poet, like his predecessors, the new shah wrote under the pen name "Fahmi," but his poetry follows the typical innocuous patterns of verse prevalent at the Safavi court:

> When the line of his eyebrow showed itself in the clear wine,
> It was like the crescent moon of the 'Id reflected in the water.[22]

He had not, however, had an easy life. His dismissal from the governorship of Khorasan in 1556 was a rude blow, despite the fact that he was restored to the position six months later. He must have had a talent for survival, for he had evidently aided in disgracing Isma'il in 1556 yet still managed to survive the latter's eighteen months of rule twenty years later. Perhaps he had expected to be

21. The *amir al-'umara'* (prince of princes) was the chief military authority of a region and often functioned as its virtual ruler. The position of *lalah* (tutor or mentor) was prestigious. The lalah was not simply responsible for the education of the young prince under his care but was also his guardian.

22. The 'Id is the exuberant festival at the end of Ramazan, the month of fasting in Islam.

named shah in 1576 following his father's death. If so, he must have been bitterly offended by Isma'il's high-handed treatment of him. During the whole year and a half that his brother occupied the throne Muhammad Khodabandah was kept a virtual prisoner in Shiraz. He must have daily expected the arrival of the shah's assassins. Had they not already killed his eldest son Hasan in Tehran? Indeed, it is surprising that Muhammad Khodabandah ascended the throne as he did—a gentle, essentially harmless family man, pious, scholarly, and not embittered.

Muhammad Khodabandah had no military exploits to his credit. He was as little skilled in government as in strategy. Unable to delegate authority responsibly, he let others usurp it from him. Although endowed with critical perception about poetry and perhaps too about painting, he was inept in statecraft and soon lost the respect and support of those who had placed him on the throne. Passionately devoted to his four surviving sons and to his wife Khayr al-Nasa' Begum, he spent most of his time in the harem and sometimes wrote poetry.

> This evening my beloved, in spite of the wishes of others,
> Has given me permission to take part in her feast.
> O morning, do not kill the lamp of our pleasure.
> Please, hold back your breath tonight.
>
> pp. [9–11]

Unwilling to rule, the new shah let his wife run the government. Though Queen Khayr al-Nasa' Begum had political abilities of a high order and the decisive character that her husband signally lacked, she was unable to control herself well, and her lack of diplomatic forbearance rapidly offended the Qizilbash amirs who were already chaffing under a woman's leadership. During the next year and a half the queen invariably propelled herself toward the points of greatest friction. In Qazvin she disregarded the advice of the amirs and impugned their honor, and by her importunate demands for the return of Prince 'Abbas from his necessary post in Khorasan, she succeeded in driving otherwise loyal aristocrats into reluctant insurgence against the royal authority. In the summer of 1579 the threatening situation reached a head. A conspiracy of amirs and leading officials plotted the queen's assassination, and when, even then, she refused to give up any authority, she was strangled to death by her supposed subjects.

The terrible deed seems to have broken whatever will the shah had left. He had deeply loved and respected the queen and had relied completely on her guidance. Without her he was even less than a figurehead. Though he was to rule for eight more years, the real royal power during that time rested mostly with Prince Hamzah, his eldest son and a capable, ambitious young man. But the central government's power was now weaker than it had ever been during the previous eighty years of Safavi rule, and the threatening sedition in Khorasan continued until in the spring of 1581 the province's governor, 'Ali Quli Khan Shamlu, assumed the role of "kingmaker." Leading the unenthusiastic ten-year-old prince 'Abbas to the throne in Herat, he and the assembled Khorasani amirs declared the boy shah of Iran.

It was still six years before 'Abbas would be crowned king in Qazvin, and the six years were filled with attack and counterattack, sedition and betrayal. Considering the unstable and unhappy temper of the times it seems amazing that any kind of artistic activity could continue in the capital of Qazvin, where Muhammad Khodabandah still nominally ruled and nominally dispensed royal patronage.

The picture is at best confusing. Two of our principal sources speak well of the shah, though in general terms. Riza Quli Khan writes: "He had some knowledge of all the current sciences, and was incomparable in understanding and judgment, virtue and discernment, bounty and generosity, and expression and eloquence."[23]

To this heavy praise Sadiqi adds: "He was a ruler [who was] the master of munificence and magnanimity. In the arts of painting, in the laws of poetry, and in the technical language of music he was very skillful and knowledgeable." Yet, despite these typically exaggerated words of praise, the evidence that we possess of a court atelier under his reign is meager. There are no manuscripts dedicated to him, nor are there any which we can safely ascribe to his patronage. Iskandar Munshi, speaking of the painter Siyavush, refers not to the shah's patronage but rather to that of Prince Hamzah, the heir apparent. Despite Sadiqi's generalized laudation, history seems to indicate instead that the painter was disheartened by the low state of patronage during Muhammad Khodabandah's reign. Other evidence is scarcely more encouraging.

The fine calligrapher Khwajah Ikhtiyar carried on the shah's cor-

23. E. G. Browne, *A Literary History of Persia*, 4: 102–03.

respondence. Another scribe, Khwajah Malik Muhammad Haravi, was the secretary of his *divan-i mamalik* (department of state affairs), but "during the war with the Tekkelu Turkmans, being a friend of that tribe, he disappeared without a trace." Qazi Ahmad tells us that the calligrapher Mirza Ahmad was killed during the shah's siege of Turbat-i Zava in the winter in 1582 (990) and that another scribe, Qazi 'Abdullah of Khoy, died in Sabzavar during the return of the royal army from Herat at the end of 1583.[24]

But this is all our sources tell us. There were a few notable manuscripts finished at Qazvin during these ten years,[25] and it is possible that Sadiqi's words are true and that Muhammad Khodabandah was a patron whose largesse we do not appreciate, whose connoisseurship we do not know, and whose commissioned works have vanished. It is equally possible that this handful of manuscripts was the result of the patronage of his talented son Hamzah.

Royal Princes and Princesses

At the royal court in Qazvin were there others, besides these kings and Ibrahim Mirza, who supported the arts? The information is scant but implies an affirmative answer.

In the early part of Tahmasp's reign we know that both Sam Mirza and Bahram Mirza, brothers of the king, were noted patrons. Sadiqi's praise of the latter prince in particular is full:

> [Bahram Mirza] was a peerless prince, and his speech was pleasant. His discourse was sweet, and his poems ornate. He was an eloquent and sagacious speaker; he loved poetry and was a friend of poets and an appreciator of poets. It was as if his princeliness were a miracle brought down in the form of that royal personage or as if it were a standard elevated high in his name. He encouraged many wise and skilled men and distinguished them among their contemporaries. [p. 22]

Of the Safavi princes it is clear that only Bahram and his son Ibrahim were patrons on somewhat the same level as Tahmasp. Both father and son had the rare gift of helping others gain self-esteem.

Of the many other Safavi princes we know little beyond the record

24. All four scribes are mentioned in Qazi Ahmad, pp. 91–96.

25. Two of the finest are the following: the 1582 (990) *Diwan* of Ibrahim Mirza, published in G. Marteau and H. Vever, *Miniatures Persanes,* figs. 122 & 124; and the 1586 (994) *Shahnamah* (British Museum Add. 27302).

of their political activities. A few hints contained in the sources in-
dicate that they may also have been patrons, but in no case can we
cite specific manuscripts that came from their ateliers.

Ibrahim's brother, Badi' al-Zaman, for instance, "was intelligent
and quick-witted and generous and munificent" (p. 27), and in his
position as governor of Sistan from 1558 to 1577 he may have
commanded resources sufficient to make him a patron of note. His
brother Husayn in Qandahar could also have attracted artists, but
there again no mention of them occurs in the sources.

Tahmasp's son Haydar (1555–76) had been carefully educated at
court by Royal Chancellor Ma'sum Bek Safavi and the latter's son,
and one must assume that this education included the usual training
in the arts.[26] But his activity, as far as it is recorded, is limited to the
political jockeying for favor and position which eventually led to
his death in his brief contest for power with Isma'il II. The only hint
we get of a possible interest in art on the prince's part is from a
single sentence in Iskandar Munshi's *History (Tarikh-i),* where we
read that the painter Khwajah Nasir ibn 'Abd al-Jabbar, who had
been trained by his father at Khan Ahmad's court in Gilan, "was
especially associated and connected with Husayn Bek Yuzbashi,
who was an officer of Sultan Haydar."[27]

Muhammad Khodabandah's eldest son Hasan, who ruled in
Mazandaran from 1558 until his murder by Isma'il II in 1577, was
a poet and had "a reputation for generosity" (pp. 26–27), but
whether this liberality extended to painters and calligraphers is not
known.

Hamzah Mirza, Muhammad Khodabandah's heir after Hasan's
death, is a more attractive figure, not only for his courageous defense
of his rights against the insurgent Qizilbash but also for his success-
ful attacks on the Ottomans. He had the leading role in government
during the last five years of his father's "rule" and had the use of
the royal seal. But what of his possible patronage? Sadiqi reports that
the poet Mawlana Turkman was a confidant of the prince (pp. 129–
30) and that the less noted poet Mir Muhammad Aywaghali was one
of his guards, or *qurchis* (p. 126).

26. Part of his training apparently also came from Mir Muhammad Mu'min
Astarabadi: "His excellency the Mir is a learned searcher after knowledge and was
both the teacher and the favorite of Sultan Haydar Mirza" (Sadiqi Bek, *Majma',*
p. 78).

27. Iskandar Munshi, *Tarikh-i,* pp. 175–76; translation from Arnold, *Painting
in Islam,* p. 143.

In a previously quoted passage Iskandar Munshi refers to the prince as the patron of Siyavush and his brother, Farrukh Bek, both of whom were admitted to Hamzah's confidential circle. Consequently we may conclude that the heir apparent to the Safavi throne enjoyed the company of painters and that at least some of the artists brought together by Isma'il II were retained during the reign of his successor.

One of the most intriguing figures of all is Abu'l-Ma'sum Mirza, a descendant of some of the greatest Mawsillu Turkman amirs and the son of the maternal uncle of Shah Muhammad Khodabandah. As the shah's cousin, he must have had easy access to the court, and Qazi Ahmad indicates that he made good use of his privileges in order to become more skilled in the arts:

> He has good taste in portraiture and in artistic design. He spends all his time on art and work; not for a moment does he slacken in this. He is incomparable in painting, carving, restoration of books, gold sprinkling, bookbinding, making cardboard, engraving seals, carving tables and spoons, dissolving lapis lazuli, and other small artistry. He spent a long time with beardless youths until his hair turned gray. All his noble time he has spent on art and now is engaged in that same occupation. [He died in 1596 (1005) and was buried at the sanctuary of Qum.] He was not devoid of high aspirations and the feeling of the transcience of this world. In his company there were always some clever and gifted men as well as poor and hapless people who profited by the open table of his liberality.[28]

Although his period of activity was the second half of the sixteenth century, there is no mention of this second Ibrahim Mirza in either Iskandar Munshi or Sadiqi. Nor does the Ottoman chronicler 'Ali speak of him. We have no works signed with that name, no manuscripts dedicated to him, and no other references to him. We can only speculate, and we have few grounds for that. He is an appealing figure in Qazi Ahmad's lengthy account, and he undoubtedly exerted significant influence in the royal atelier. As the son of Tahmasp's brother-in-law, the cousin of Shah Isma'il II and Shah Muhammad Khodabandah, and the second cousin of Shah 'Abbas I, he lived through four different reigns and must have stayed diligently apolit-

28. Qazi Ahmad, pp. 190–91. The Mawsillu Turkmans originally came from the area of Mosul in present-day Iraq.

ical, for he survived the terror months of Isma'il II and did not compromise himself with either Muhammad Khodabandah or the more suspicious Shah 'Abbas. When Ibrahim Mirza was murdered in 1577, it may have been he who filled part of the patronage gap, if there was one. His cousin Isma'il II filled the rest. How many of our painters knew him personally and worked for him and how many benefited by his advice or were indebted to him for assistance at court are questions that cannot at present be answered. This prince who may have had great influence remains a mysterious figure.

The male members of the Safavi line were not the only patrons of note, and some of the remarkable women who figure in sixteenth-century Iranian history also had a part in furthering the arts. Of the three leading female personalities in this period one especially, Shah Tahmasp's sister Sultanum Khanum, was a well-known and highly effective patron.[29] The princess's date of birth is not known. She was a great favorite of Tahmasp and his brother Bahram, and it seems likely that all three were the children of the same mother. She partook of the fine education which her brothers enjoyed, for Qazi Ahmad reports that Dust Muhammad himself taught her calligraphy.[30] And when the shah dismissed all his scribes in the 1540s, he kept Dust Muhammad at court for some time, perhaps at her instigation.

Her authority was wide. When the defeated Mughal emperor Humayun took refuge with Tahmasp in 1544, the shah, having at first received him warmly, gradually became hostile, until he eventually threatened to burn alive both him and his companions unless they converted to Shi'ism. The intemperate shah was not deflected from his course until both Sultanum Khanum and Qazi-yi Jahan presented compelling arguments to him. She and the grand vazir, together with the court physician Nur al-Din, appear to have formed a circle of moderation at court which was influential with the mercurial monarch. Since both she and Qazi-yi Jahan were patrons

29. We have already briefly discussed the careers and eventual rivalry of two other princesses, Pari Khan Khanum and Khayr al-Nasa' Begum. Neither was a patron on a large scale. The calligrapher Majd al-Din Ibrahim was Pari Khan Khanum's vazir, according to Qazi Ahmad, but it would be only normal for a highly competent scribe to be attached to a politically active royal figure. In 1570 Zayn al-'Abidin 'Ali dedicated his *Takmilat al-Akhbar* to the princess, a dedication perhaps more due to the fact that she was a favorite daughter of Shah Tahmasp than that she was an important patron in her own right.

30. Qazi Ahmad, p. 147. The princess's given name was Mihin-Banu.

in their own right, it seems also possible that they affected the shah's artistic policies as well.

Sultanum Khanum was the shah's favorite sister. He often let her accompany the royal hunts and was pleased to have her standing next to him. But he was also fiercely jealous and dangerously over-protective. At the age of eighteen she had a young admirer. Exactly what transpired is not known, but the shah had the youth burned alive.

She remained unmarried and became a favorite maiden aunt to younger members of the family. She was recognized and famed as a leading patron of calligraphy. In the Bahram Mirza album in Istanbul there are two fine nasta'liq calligraphies, both richly illuminated and signed in gold on a deep blue background: "Sultanum, daughter of Isma'il al-Husayni al-Safavi."[31]

In 1554/55 (961–62) she established a *waqf* (charitable endowment) in the name of the Fourteen Innocents.[32] She endowed it with her considerable properties in Shirvan, Arasbar, Tabriz, Qazvin, Rayy, Garmrud, Isfahan, and Astarabad, and the shah himself was named overseer of the waqf. The princess died in 1561/62 (962).[33]

Tajik and Qizilbash Patrons

But what of other, nonroyal patrons? The information here is even scantier. Some Tajik officials at the Safavi court must have been patrons. We know that Qazi-yi Jahan, Shah Tahmasp's grand vazir until 1550, exerted wide influence in the arts as well as in government, but there is no single work of art which can be reliably attributed to his patronage. We know too that the scribe Malik Daylami was in the royal camp on the staff of the vazir, although high officials of all sorts employed calligraphers, and more in the capacity of scribes than of fine artists. Thus, while the vazir may have had much to do with some of the masterpieces of Safavi painting in the first half of the sixteenth century, we have no undisputed evidence to prove it.

The only Tajik official whose commissioned manuscript has sur-

31. Topkapi Palace Museum, H. 2154.

32. The Fourteen Innocents (Chahardah Ma'sum) denotes the key figures for most Shi'as in Safavi Iran: the Prophet Muhammad, his daughter Fatima, and the first twelve Imams.

33. K. M. Röhrborn, *Provinzen und Zentralgewalt Persiens*, p. 116.

vived was one 'Ali Khan, the munshi of Shah Muhammad Khoda-
bandah's general secretariat. His book, a *Khamsah* of Nizami in the
Morgan Library,[34] was written by several adequate, though not es-
pecially gifted calligraphers and illustrated by three or four painters
who worked competently in the current court style of Qazvin. The
book contains three dates on three separate colophons—1572 (976),
1580 (987), and 1581 (988)—and the colophon of the *Iskandar-
namah* contains the additional information that this particular part
of the *Khamsah* was written in Qazvin by Khalilullah ibn 'Ali al-
Darab Astarabadi. Neither the patron nor this scribe is otherwise
known. Since the book was begun in 1572, the patron 'Ali Khan
must already have occupied a high official position under Shah Tah-
masp, and he held on to it through the turbulent years of Isma'il II
and Muhammad Khodabandah.[35]

Among the Qizilbash nobility there seem to have been more
patrons. Yusuf Khan ibn Quli Bek Afshar, a rash and short-lived
governor of Kirman, employed the poet Hamti Isfahani in his
library (p. 242). The famous Isfahan family of the Nur Kamals
invited the calligrapher Mawlana Ad-Ham of Yazd to come from
Khorasan "to embellish their houses in Isfahan."[36] He was gener-
ously rewarded.

The high-born Qizilbash youth Muhammad Bek Khalifat al-
Kholafayi had a vital interest in the arts:[37]

> He is the eldest son of Kholafa. Truly he is a good, worthy,
> and even-tempered youth. He works in the art of painting,
> which is the hardest of all the arts, to such great effect that he
> does not need anyone [to help him]. He writes a good nasta'liq
> and plays the five-stringed tanbur well. Truly he is a very gifted

34. For reproductions of four of this manuscript's forty-nine illustrations see E.
Grube, *The Classical Style in Islamic Painting*, pls. 78.1–78.4.

35. The colophon of the fine *Sifat al-'Ashiqin* of Hilali in the collection of Edwin
Binney, 3d (see Grube, *Classical Style*, no. 79; E. Binney, *Persian and Indian Minia-
tures from the Collection of Edwin Binney, 3d, circulated by the Smithsonian Insti-
tution Travelling Exhibition Service*, Washington, D.C., 1966, frontispiece; and
Colnaghi, nos. 24 i–iii) states that the book was ordered by Salim al-Anami, who
is otherwise unknown. Although produced for a nonroyal patron, the book is of
very high quality and may be an additional product of Tajik patronage.

36. Röhrborn, *Provinzen und Zentralgewalt Persiens*, p. 100; Qazi Ahmad, p.
133.

37. Khalifat al-Kholafayi was the title given to the governor of Baghdad by Shah
Isma'il I.

youth. Among his peers he is illustrious for his bravery and generosity. Although, in accord with the habit of fate, he sometimes has experienced misfortunes, he has so much modesty and dignity that he has not been touched by these things. He never fails to send whatever in his house his friends might need. God willing, under the aegis of the shah's favor he will attain his desires. [p. 73]

Husayn Kahn Shamlu, the unfortunate father of the Khorasan rebel amir 'Ali Quli Khan, was a leading political figure and governor of Qum under Muhammad Khodabandah. When he went to Herat in 1578 at the behest of Queen Khayr al-Nasa' to try to bring his straying son back into obedience to the royal court, he took his favorite painter Habibullah of Savah with him.[38] 'Ali Quli Khan's seven-year-old royal ward, Prince 'Abbas, was pleased with the painter and unceremoniously appropriated him. Despite his youth, 'Abbas was already keenly aware of artistic quality. The unhappy Husayn Khan returned to Qazvin without his painter, without his son's submission, and without Prince 'Abbas, the principal object of his expedition.

Ismi Khan Shamlu, a powerful Qizilbash noble under Muhammad Khodabandah, is known to have employed the esteemed calligrapher Muhammad Amin 'Aqili in his library,[39] while another Qizilbash noble, Muhammad Khan Sharaf al-Din Oghli Tekkelu, ordered Aqa Hasan Naqqash Haravi to ornament "with painting

38. The painter was very highly regarded by Qazi Ahmad (p. 191): "For the skill of his hands he was one at whom men point their fingers and with regard to art he became a ravisher of the souls of his contemporaries. Every day he makes further progress. . . . Now he is in the capital, Isfahan, employed by the court department as a painter." His erstwhile patron, Husayn Khan, was also a patron of calligraphy. One page of calligraphy from his library is in a private collection in Cambridge, Mass. Written in a delicate nasta'liq skillfully composed in different panels, it contains excellent Sabk-i Hindi poetry by some of the leading masters of this literary genre—Fayzi, Zamiri, Abdu'l-Razzak, and others.

According to the colophon of a *Shahnamah* recently sold in New York, Husayn Khan was also a patron of manuscripts: "The copy of this unique work has been completed at the court of Herat. . . . at the order of Husayn Khan Shamlu." It is dated 1599 (1008). None of its forty-four miniatures is signed, but they can be divided into two stylistic groups: the first is clearly derived from the Qazvin court style; the second reflects the influence of Riza and the emerging Isfahan style (*Sale Catalogue*, Sotheby Parke Bernet, Inc., New York, 2 May 1975).

39. Qazi Ahmad, pp. 170–71. The scribe was a favorite of Prince Hamzah and "had the title of 'master of the Sword and the Pen.'" After Hamzah's murder in 1586 he retired and lived as a dervish, although he still practiced calligraphy.

the inside of the holy tomb of the Imam 'Ali Riza."[40] And, according to Sadiqi, 'Ali Quli Khan, 'Abbas's lalah in Khorasan, had a library directed by the gifted poet and calligrapher Yulquli Bek Shamlu.[41]

But these scattered reports are secondary to those we obtain from Qazi Ahmad about the patronage of Farhad Khan, the great general of 'Abbas's early reign. From the fact that Qazi Ahmad with overflowing praise dedicates his treatise to him, as well as to the shah, we can get some idea of Farhad Khan's power and probable generosity. The great Safavi calligrapher Mir 'Imad "worked in the library of Farhad Khan Qaramanlu in Simnan." Later Qazi Ahmad mentions that Mawlana Sultan Husayn Tuni also write in the general's library. And even 'Ali Riza Tabrizi, the most highly regarded of the Safavi calligraphers at the end of the sixteenth century, worked for the khan:

> For two years he was the companion and fellow traveler of the Khan of the Time in Khorasan and Mazandaran, and now he is in attendance at the court of the Shah of the World, the shadow of the Almighty, in the capital, Qazvin.[42]

But Farhad could not keep him. Qazi Ahmad does not mince words. "Shah 'Abbas took him from the khan. . . ." Like Husayn Khan Shamlu, Farhad Khan lost a skilled and favored artist to the ambitious monarch. It seems that a lesser patron could never be sure of keeping his staff. A shah could order an artist delivered up to him as easily as he could a courtesan.

Qazi Ahmad's praise indicates that he himself either was or wished to be beholden to the khan:

> On the day of liberality he is a mine of generosity,
> A cloud of gifts on the sky of kindness. . . .

40. Röhrborn, *Provinzen und Zentralgewalt Persiens,* p. 43, and Qazi Ahmad, p. 187. For some time the Tekkelu nobleman was Muhammad Khodabandah's lalah in Herat.

41. Sadiqi Bek, *Majma',* p. 107. In fact, in Istanbul there survives a probable portrait of 'Ali Quli Khan, the renegade Shamlu leader, inscribed with his name and elaborately ascribed to the artist "Muhammadi Musavvir at Herat in 992 [1584]," a notation which indicates that this painter and draftsman (whose uneven oeuvre is considered in A. Welch, "Painting and Patronage under Shah 'Abbas") worked in Herat under 'Ali Quli Khan himself in the years immediately preceding 'Abbas's accession in Qazvin in 1587. (Topkapi Palace Museum, H. 2155, fol. 20b.)

42. Qazi Ahmad, p. 168, 170–72.

The hand of his liberality is an April cloud,
Equal to the lowly and the high . . .

When he stretches his hand of kindness out of his pocket,
Hatim-Tayy pulls his hand back into his sleeve.
Hatim is the beggar at his assemblies,
His company is the meeting place of the virtuous.[43]

The shah's execution of his too rapidly rising lieutenant in 1598/
99 (1007) must have been a blow to the arts. But it enabled the
vigorous monarch not only to govern more freely but also to pursue
more energetically his own ambitious patronage of the arts.

Provincial Patrons

The remarkable unity which the Safavis fostered in the religious,
social, and political life of Iran was reflected in the arts as well.
Thus, in comparison with the preceding Timurid period, Safavi art
is relatively meager in provincial styles. True, the indomitable Shiraz
painters in the south were still active and relatively independent, but
even they by the middle of the sixteenth century began to veer closer
to the metropolitan court style.[44]

For all their hostility to the Safavis in the sixteenth century the
Uzbeks in the northeast had a reputation for generosity as patrons,
and it is clear that some Safavi painters served under them. For
example, Shaykh Zadah, after painting for several years under Shah
Tahmasp, emigrated to Bukhara, the Uzbek capital, shortly after
1527 in search of more appreciative patrons.[45] Qazi Ahmad's
teacher of calligraphy Mir Sayyid Ahmad worked in the library of
'Abd al-'Aziz Khan, the son of 'Ubayd Khan Uzbek.[46] Although
the Safavi chronicles almost invariably regard the Uzbeks as un-
civilized barbarians, Sadiqi Bek did not consider them in this light.
Of 'Ubayd Khan Uzbek he writes:

43. Ibid., pp. 47–48. The pre-Islamic Arab poet Hatim Tayy is traditionally re-
garded as the perfect model of generosity.

44. See G. D. Guest, *Shiraz Painting in the Sixteenth Century*, for a study of
this style. The contemporary Khorasan style in the northeast (identified and dis-
cussed by B. W. Robinson in his *Descriptive Catalogue of the Persian Paintings in
the Bodleian Library*, p. 152, and in his *Persian Miniature Painting*, p. 110) was a
short-lived phenomenon whose relationship to the main court tradition is not yet
entirely clear.

45. See S. C. Welch, *A King's Book of Kings*, pp. 56–60.

46. Qazi Ahmad, p. 139.

He was a ruler of very good taste, a poet by temper, and good-natured. Among the Uzbeks there was no one like him in bravery. He fought with the late Shah [Tahmasp] and was defeated, but he gave many proofs of his own courage and martial valor. He is well-gifted in the forms of poetry. [pp. 15–16]

'Abdullah Khan Uzbek (1556–98) is described in the same source as "the bravest of the sultans and the most generous of the great Uzbek khans."[47] And Sadiqi must have known another Uzbek leader, Ghazi Garay Khan, personally:

From the time of Janghiz until now such a youth has not sat on the throne of the sultanate. Truly no one has been seen who, like him, embodies all the attributes of perfection. The courage which he (like Rustam-i Dastan and Sam-i Nariman) evinced at the time of his captivity in the hands of the Qizilbash army needs no description or explanation. In giving and in generosity Hatim [Tayy] does not reach the level of apprenticeship to him. He has skill in the art of music and is acquainted with the types of musical instruments. Even if my pen were able to write for years, it would not complete the description of his praiseworthy attributes. [pp. 19–20]

It is evident that painters, poets, and calligraphers must have turned to this rich source of patronage. But unfortunately, except for Shaykh Zadah earlier in the century, we know the name of no painter who left the Safavi for the Uzbek court.

Northern Iran was a rich source of patronage too, although not to be compared with Tahmasp's patronage in his youth or of Ibrahim Mirza's in Mashhad. But Gilan and Mazandaran rank high in Sadiqi's estimation, and he traveled there himself in search of good receptions.

Of its rulers the most generous was apparently Khan Ahmad. He had a checkered career, for his entire life was spent striving to keep the Safavi state at bay and to preserve his territory's traditional independence. The bare facts of his political life are indicative of his precarious position. He ruled Gilan from 1536 to 1567 but in that year was deposed by Shah Tahmasp and brought to the royal court in Qazvin, where he remained a virtual prisoner for the next

47. Sadiqi Bek, *Majma'*, p. 16. See F. R. Martin, *The Miniature Paintings and Painters of Persia, India, and Turkey*, pl. 149, for a c. 1570 portrait of this ruler.

ten years, while his son Mahmud Khan ruled as a puppet king in the Safavi behalf. In 1577 Isma'il II restored Khan Ahmad to his throne. Why he took this risky step is not clear. Perhaps the resourceful khan had worked his way into the esteem and trust of the new shah; perhaps he had aroused enough Qizilbash support so that he could compel the shah to restore him. He ruled until 1592, causing Shah Muhammad Khodabandah and his successor Shah 'Abbas no end of trouble, and left his throne only when 'Abbas invaded Gilan with devastating force. The khan then fled to Istanbul where he died.

While Khan Ahmad ruled in Gilan, he was an important patron. From Iskandar Munshi we know that he supported the painter 'Abd al-Jabbar and his son Khwajah Nasir. 'Abd al-Jabbar came from an Astarabadi family. After becoming skilled in the writing of nasta'liq and in painting,

> he went for a time to Gilan and attached himself to the officials and courtiers of Khan Ahmad of Gilan; after the rebellion in that province and the arrest of Khan Ahmad, he went to the capital, Qazvin, and stopped there for a time, but though he had established there an atelier for painters, he wasted the greater part of his time in the company of amirs and nobles and consequently accomplished little.[48]

His son Khwajah Nasir must have served originally with Khan Ahmad too, but later

> was especially associated and connected with Husayn Bek Yuzbashi, who was an officer of Sultan Haydar. In the reign of Isma'il Mirza he became attached to the service of the library. In the time of Sultan Muhammad [Khodabandah], when Khan Ahmad was appointed to the government of Gilan, he again took service with him and followed his flag.[49]

These two painters were not the only artists serving under the Gilani ruler. Sadiqi's description of his court, which has already been quoted in our discussion of the painter, and his several references to others who were favored with Khan Ahmad's attention, make it seem most likely that Sadiqi served for a time under him too. The artistic entourage at the Gilani court was large, and the

48. Iskandar Munshi, *Tarikh-i*, p. 175; translation from Arnold, *Painting in Islam*, pp. 142–43.
49. Ibid., pp. 175–76; translation from Arnold, p. 143.

shifting social system of the time and the aristocratic bent toward manual crafts, which we have already observed with regard to Abu'l-Ma'sum Mirza and Ibrahim Mirza, are also evident in Sadiqi's account of one Mawlana Ghani Lahiji: "Although he is one of the nobles in his own country, he is employed as a coppersmith. At the command of Khan Ahmad Padshah he composed a ghazal in his presence" (pp. 238–39).

But there are neither manuscripts nor single-page works of art which can be firmly attributed to Khan Ahmad's Gilani patronage, and despite the intriguing evidence left us by literary history, we are as yet unable to reconstruct the visual history of his reign.

Shah 'Abbas I (r. 1587–1629)

The last of the sixteenth-century's royal patrons must, like his predecessors, have been provided with a proper princely education, similar to the training which the first Mughal emperor Babur described in his *Memoirs:* a king's son not only learned the military skills requisite for survival, he also was taught to write poetry, paint, appreciate and perhaps execute fine calligraphy, and maybe even turn his hand at some of the more sophisticated crafts. Certainly this was the kind of thorough, aristocratic instruction which Tahmasp and his brothers were given, and evidently Tahmasp as shah saw to it that his own sons, grandsons, and nephews enjoyed the same benefits of patrician upbringing. If 'Abbas took to many aspects of it less eagerly than his grandfather, that was apparently due more to the young prince's character than to Tahmasp's negligence.[50] Although 'Abbas, born in 1571 or 1572 (979 or 980), was sent off to Herat as governor of Khorasan before he was two years old, Tahmasp seems to have taken careful steps for his education. He appointed the Ustajlu noble Shahquli Sultan Yagan as 'Abbas's lalah and as the de facto governor of Khorasan. Earlier, this same noble had served as the lalah of Tahmasp's eldest son Muhammad Khodabandah, when he had been similarly sent to Herat as the representative of royal authority.[51]

In 1576 Shahquli Sultan was murdered on the order of Shah Isma'il II. 'Ali Quli Khan Shamlu, sent to replace him and to execute

50. For a more detailed study of 'Abbas's character and the arts he fostered in the seventeenth century see A. Welch, *Shah 'Abbas and the Arts of Isfahan.*

51. Röhrborn, *Provinzen und Zentralgewalt Persiens,* p. 43.

the young Prince, resisted the royal order until after the paranoid shah's death and then installed himself as a nearly independent ruler in Khorasan. The ambitious Shamlu noble is known to have had a sizable library of which the poet Yulquli Bek Shamlu was the director. Sadiqi knew him and appreciated his talent, as we have seen in a passage quoted earlier.

If we can believe Qazi Ahmad, 'Abbas's education in the arts of the book was very effective, for by the age of seven his aesthetic sense was so defined that he could compel the visiting royal emissary from Qazvin, Husayn Khan Shamlu, to yield to him his favorite painter, Habibullah of Savah.

It is an astonishing account. At a seemingly tender age 'Abbas was already so fascinated by painting and was such an educated connoisseur that he could appropriate the favored artist of one of Iran's chief amirs! The prince's interest certainly continued, although we unfortunately know nothing of his later activities as patron of the arts in Herat.

In 1581 'Abbas was crowned shah in Herat by an unstable coalition of Qizilbash amirs under the irresolute leadership of the young prince's lalah, 'Ali Quli Khan. This overt revolt, capping years of steadily brewing sedition in Khorasan, finally drove the lethargic Qazvin government to strong action. Pressed hard by a royal army, 'Ali Quli relented and recognized the central authority: 'Abbas the "king" had been unmade as swiftly and expediently as he had been made.

The political situation was no more stable in Khorasan than in central Iran. In a skillful combination of military strategy and political treachery one of 'Ali Quli Khan's underlings, Murshid Quli Khan Ustajlu, captured the young prince 'Abbas whose presence with him at least partly legitimized his own claims for control of Khorasan. For the six years from 1581 to 1587 'Abbas was the pawn of this second aspiring strongman.

The situation in the west meanwhile became more and more hopeless. A vicious civil war broke out between rival Qizilbash clans in early 1583 and threatened to destroy what remained of royal authority in Qazvin. In the following year a strong Ottoman army invaded Iran in order to take advantage of the unstable conditions. But the vigorous and promising young heir Hamzah defeated the Ottomans and successfully quelled a dangerous Qizilbash rebellion. The prince had great political potential, and for two years he tried to rescue Iran

from internal dissension. His career was cut short. Near the end of 1586 he was assassinated by his barber.

Near anarchy reigned in Iran, and the time was ripe for a strongman. The Khorasan conspirator Murshid Quli Khan marched west with his followers and with his captive prince 'Abbas. Their passage through Iran turned into a triumphal procession. City after city opened its gates to the new shah, and by the time they reached Qazvin it was clear that Muhammad Khodabandah was no longer shah.

A brief reign of terror over the dissident Qizilbash established 'Abbas as shah with Murshid Quli Khan playing the role of regent with essentially unlimited powers. But neither he nor the other amirs had reckoned with the sixteen-year-old king's determination to be his own master. Within a few months of his coronation he succeeded in having Murshid Quli Khan murdered and then instituted a systematic purge which decimated the Qizilbash and terrified them into submission.

Following a policy compounded of military campaigns, treachery, and murder, 'Abbas succeeded within the next four years in firmly securing his authority over all Iran's provinces. Once in clear control, he determined to alter radically the previous "system" of decentralized, feudal government whose effectiveness had depended upon Qizilbash good will and the monarch's own determination. In 1581 he appointed as vazir a gifted nobleman, Hatim Bek Ordubadi, and for the next nineteen years of his life this honest, energetic man instituted the reforms Iran so desperately needed. An able, effective, central bureaucracy was created which enforced royal authority over all the far-flung provinces of the Safavi empire. The earlier collection of revenue through confiscation and tribute was replaced by a regular system of taxation. Provincial power was severely restricted, and hereditary feudal lands were appropriated by the monarch, who dispensed them as fiefs to loyal subordinates, many of whom did not belong to the old aristocracy and all of whom held their lands solely at the king's pleasure.

New men rose to power. Farhad Khan successfully led most of 'Abbas's early military campaigns, and his star rose to dizzying heights until 1597, when the shah, apparently wary of this man whose power had become second only to his own, executed him for alleged cowardice in battle. His replacement was Allahvardi Khan, a Georgian Christian by birth who had been advanced from the governorship of Fars to become head of the shah's personal body-

guard. It was obviously no longer necessary to be one of the Qizil-bash in order to hold high office.

The shah's confidence was high. He exchanged friendly embassies with the Mughals in 1596 and 1597 and was anxious to stay on good terms with them. In the northeast the Uzbeks, who had been raiding deep into Khorasan for years, made motions of suing for peace. And when an Ottoman embassy appeared in Qazvin in 1597 with peremptory demands, 'Abbas shaved the ambassador's beard and sent him packing.

As a sign of his new strength, the shah transferred his capital from Qazvin to Isfahan. It was a symbolic as well as a strategic move. Isfahan was in the center of the Iranian plateau, far from the Turk-ish-speaking northwest where the Safavis had originated. The city's language was Persian, not Turkish, and its people were largely Tajiks, not Azarbayjanis. It had a fine climate and a bustling com-merce which made it the richest city in the empire. Symbolically it stood for the new importance of the Tajik majority in Iran and of the newly reorganized and powerful central government.

Beginning in 1600, Allahvardi Khan, relying to some extent on the advice of his English "adviser" Robert Sherley, thoroughly re-formed the military system. The shah's personal bodyguard, known as the *ghulams,* was increased to the size of a private army of 10,000 men, almost entirely drawn from Georgian converts to Islam who owed their new positions solely to the shah's favor. A permanent standing army was formed as well, so that the monarch no longer had to depend upon uncertain feudal levies. Supported too by the royal treasury rather than by the amirs, the new army consisted of soldiers from all levels of Safavi society: Tajiks, Qizilbash, and Georgians functioned together, firmly united under the shah's con-trol and unquestionably loyal to him. Coupled with the crucial re-forms in the administration and the shah's more evenly distributed taxation policy, the military gave the Safavi dynasty a new lease on life.

The founding of the capital at Isfahan was a new step in the country's history. So too was the revitalization of Iran under a cen-tralized, rather than feudal, system and under an autocrat whose personal genius and capable bureaucracy ensured a stability Iran had not known for forty years. These changes mark a clear break with previous patterns of Safavi history. They also mark the emergence of new art styles whose history is beyond the scope of this book.

But what of 'Abbas's role as patron of the arts during this turbu-

lent and formative period from 1587 to 1600, when he accomplished such radical reforms of Iran's body politic. How were the arts affected, and did this king, who adopted so different a political stance from his predecessors, also assume a different role as patron?

One of 'Abbas's first acts upon formally assuming power in Qazvin in 1587 was to begin the reconstruction of the manuscript atelier which his father had neglected. Sadiqi Bek was appointed director of the royal book-making establishment and was almost certainly given instructions to assemble an artistic staff worthy of the shah's high ambitions.

Sadiqi, who has left us valuable literary evidence about the period, went about his assignment with dispatch, and the first major manuscript to be produced by this refurbished atelier was the great 1587–97 *Shahnamah,* whose fourteen remaining sixteenth-century miniatures are striking proof that a highly talented and highly trained atelier had been assembled in a very short time.

To judge from this brilliant manuscript, we would expect the development of late Qazvin and early Isfahan painting to have continued to move in the direction of greater fluidity, more daring use of color, more mellifluous line, and increasingly lyrical and idealized content. This was, in fact, what happened, but curiously, not solely under the impetus of 'Abbas's patronage. It was a measure of the breakdown of the traditional role of the monarch as supreme patron and arbiter of aesthetic taste that this should have been so. While the idyllic Isfahan style developed consistently out of late Qazvin painting and at least partly under the influence of nonroyal patrons, the monarch himself for a time made a considerable effort to steer Iranian painting in a wholly different direction—toward a studied revival of Timurid forms.

In the first manuscript that documents the revival's existence, the 1593 *Diwan* of Hafiz in the Bodleian Library,[52] the four excellent miniatures clearly reflect classical Timurid painting of the Bihzadian type at the court of Sultan Husayn Bayqara in Herat at the end of the fifteenth century. Although the landscape rocks in folio *11b* indicate the hand of a Qazvin master, the composition and figures are deceptively close to Bihzadian types. Folio *55b* was painted by another artist, less skilled at imitating Herati painting; though the long-necked figures are unmistakably Qazvini in origin, the setting and composition are carefully modeled after Bihzad. The whole

52. MS Elliott 163, published by B. W. Robinson, *A Descriptive Catalogue,* pp. 147–48 and pls. 34 (fol. 11b) and 35 (fol. 55b).

manuscript's illustration is a concentrated and concerted effort to re-create a century-old style of painting.

Why this rather abrupt change of taste took place is not entirely clear. The manuscript was almost certainly produced by the royal atelier, and presumably it reflects the monarch's own aesthetic inclinations. Perhaps the new forms, strikingly altered from the brilliant work of Sadiqi and Riza in the 1587–97 *Shahnamah*, were partially due to the influence of Hatim Bek Ordubadi, 'Abbas's grand vazir. Like Shah Tahmasp's vazir Qazi-yi Jahan fifty years before, Hatim Bek had an enormous influence upon his king, but, as in the earlier instance, we cannot be sure how far this influence extended into aesthetic taste and policy.

We must also consider the very distinct possibility that 'Abbas's political ambitions had a direct effect upon his art patronage and that this shift in taste does not simply reflect a new aesthetic direction. After 1591, when he had firmly established his own control over the Qizilbash amirs and other dissident elements inside Iran, the king vigorously set about to expand the much diminished Safavi territory. He was, as he often said, intent upon recovering his patrimony, and he viewed with intense anger the systematic encroachments upon the original Safavi realm of his grandfather, Shah Isma'il I, by both the Uzbeks in the east and the Ottomans in the west. At its height the empire of the first Safavi had been only slightly smaller than the Timurid domain under Shah Rukh 1405–44). By the mid-1590's, when 'Abbas began to provoke war with the Ottomans, it became apparent that the young king was determined not only to recover his patrimony but also to make his Iran as extensive as that of Shah Rukh. It was a conscious and eventually successful attempt to restore Iran to a peak period of power and stability, and in 'Abbas's sudden, ambitious reforms of the country's government and social structure we can also read an attempt —again a successful one—to re-create the efficient administration and generation of peace that had existed under Timur's great son.

If this is so, then the deliberate Timurid revival in the arts is not due to a curiously anachronistic Zeitgeist in the air but rather to the shah's conscious, calculated politics. One wonders how his own personal, rather than political, taste inclined. If the 1587–97 *Shahnamah* is adequate evidence, his personal aesthetics moved in the mainstream of Iranian art, at least in the early part of his reign when he was still in his teens. But as a mature, able, energetic, and confident monarch in the last years of the sixteenth century, his real,

deep-seated aesthetic predilections are less easily fathomed. He is a monarch whose life style, politics, patronage, and ambitions are so intricately interwoven that it is impossible to distinguish whether the Timurid revival he instituted was a largely political move or a mirroring of his own real aesthetic desires.

One manuscript—the 1593 *Diwan* of Hafiz—would not be enough to prove the existence of a Timurid revival. Fortunately there are others. About 1600 the shah ordered that a copy of Farid al-Din 'Attar's *Mantiq al-Tayr*,[53] which was in the royal library and which contained four miniatures perhaps by Bihzad himself, be expanded by the addition of four contemporary miniatures. But the paintings, including one by the monarch's early favorite, Habibullah of Savah, are not contemporary in the sense of the new Isfahan style then evolving in the hands of Riza and his associates. Instead, they are a conscious re-statement of Bihzadian and pre-Bihzadian forms. That Habibullah, whom 'Abbas had known since he himself was a young prince in Herat, should be associated with the manuscript's refurbishing is evidence of the shah's own keen interest in reviving Timurid styles. For Habibullah was a gifted painter in the prevailing Isfahan manner,[54] and we cannot interpret his signed Timurid-type miniature in the manuscript as evidence of his own personal inclination toward archaistic forms. Nor can the individual direction of the artist explain the similar Timurid tendencies of the other major painter of the manuscript's miniatures. What we are seeing is undeniably 'Abbas's determined patronage at work. He must have been very proud of the final refurbished manuscript, for in 1609 he gave it in waqf to the family shrine in Ardabil.

But the outstanding example of this Timurid revival is the magnificent 1614 *Shahnamah* copied and illustrated for Shah 'Abbas in Isfahan.[55] Its forty-four miniatures are detailed re-statements of Timurid painting. A good many, in fact, are close, brilliant copies of the 1430 *Shahnamah* presently in the Gulistan Library in Tehran, while others may be variations on them or on other Timurid miniatures which have not survived.

Conscious or self-conscious revivals of previous art styles are

53. The Metropolitan Museum of Art, 63.210.11, published in M. Lukens and E. Grube, "The Language of the Birds," *Bulletin of the Metropolitan Museum of Art* (May 1967). All eight miniatures are pictured.

54. E.g., see A. Sakisian, *La miniature persane*, pl. 103.

55. See chapter 4, n. 7.

rarely as effective as innovative, original work. Certainly 'Abbas's manuscript patronage, determined and deliberate as it seems to have been, pales beside the example of Shah Tahmasp. With the sole, though very impressive, exception of the 1587–97 *Shahnamah* fragment in the Beatty Library, his manuscripts have little of the brilliant vitality of the Houghton *Shahnamah* of 1522–45, the British Museum *Khamsah* of 1539–43, or Ibrahim Mirza's great 1556–65 *Haft Awrang*. It makes us wonder whether painting was an effective vehicle for 'Abbas's archaistic art politics. Certainly architecture was, although the vitality of Safavi architecture is due not so much to its derivative qualities as to its brilliant reworking of Timurid structures beneath Safavi surfaces. This does not seem to be the case in painting. In the 1614 *Shahnamah* there is dazzling surface but little sense of vital strength beneath it. In only one manuscript produced under 'Abbas's patronage do we find both technical brilliance and great creative strength, and that is, of course, in the pages illustrated by Sadiqi and Riza in the 1587–97 Beatty *Shahnamah* fragment.

Architecture may well be a more viable means for expressing a ruler's or a government's convictions. It certainly seems to have been so for Shah 'Abbas I. But it is also probable that the great tradition of manuscript patronage which had existed in Iran since the days of Rashid al-Din in the early fourteenth century was drawing to a close. For from about 1550 we find a voluminous production of single-page drawings and paintings which reaches its peak in the seventeenth century. And although the shahs unquestionably were patrons of this relatively new art form, it was also open to the patronage of lesser men. Generally inexpensive and highly portable, single pages could circulate widely, could be sold in bazaars (perhaps by merchant "art dealers" specializing in them), and could be easily collected for inclusion in albums (*muraqqa'*) whose creation was regarded as a high art form in itself. These trends in patronage, already clearly evident at the end of the sixteenth century, became key factors in determining both the art forms and the aesthetic taste of seventeenth-century Iran.

Self-employed Artists

Artists did not depend solely upon salaried positions under their patrons. They also associated in ateliers under their own direction.

Iskandar Munshi reports in a previously quoted passage that the painter and calligrapher 'Abd al-Jabbar came to Qazvin after the 1567 arrest of his Gilani patron Khan Ahmad and established there an atelier for painters. To be sure, it was not notably successful. The painter, like so many of his fellows, had easy access to the highest levels of society and consequently "wasted" most of his time in the company of members of the nobility, as Iskandar Munshi indicates disapprovingly. Still, the artist's act of establishing an atelier does not occasion surprise on this chronicler's part, and it was presumably not an uncommon practice to set up such organizations outside the royal purview.

There were other opportunities as well for the artist. The proliferation of single-page paintings and drawings in the Safavi period indicates that additional forms of patronage were evolving. While it is possible that some of these single pages were commissioned, others were undoubtedly the result of the artist's own initiative. A fine miniature or drawing may have been given to a ruler or potential patron in much the same way a new poem or panegyric was. The poet Muhtasham gave Shah Tahmasp a eulogy in praise of the holy Imams; so too Mirza 'Ali may have presented him with one of his splendid miniatures of graceful page-boys. Artists must have produced miniatures and drawings like these in the hopes of gaining a salaried position or a single, impressive gift. Fine surviving calligraphies strongly imply that calligraphers followed the same practice.[56] Perhaps Shah Mahmud Nishapuri was doing this in Mashhad, when he existed without "any pension or grants of land, and he received no patronage from anyone." It seems likely that the "samples of calligraphy" he was writing were intended for sale or as gifts that he hoped would be reciprocated in cash. This hypothesis would explain in part the enormous number of single-page paintings, drawings, and calligraphies that were produced from 1550 on into the seventeenth century.

It is also likely that single-page miniatures and drawings were sold in the bazaars, probably by merchant "art dealers" specializing in them. What may be the only literary evidence for this marketplace art trade occurs in an anecdote by the Safavi poet Mulla Ghururi, who apparently knew Sadiqi Bek quite well:

I wrote a qasidah in praise of Sadiqi and went to recite it in

56. E.g., see A. Welch, *Shah 'Abbas,* nos. 1, 5, 15, and 16.

a coffee house. The qasidah had not yet come to an end, when [Sadiqi] seized it from me and said, "I don't have the patience to listen to more than this!" Getting up after a moment, he tossed down five tomans bound in a cloth, along with two pieces of paper on which he had executed black-line drawings. He gave them to me and said: "Merchants buy each page of my work for three tomans. They take them to Hindustan. Don't sell them any cheaper!" Then he excused himself several times and went out.[57]

Certainly the shahs were not the only customers. Royal princes, provincial lords, Qizilbash nobles, Tajik bureaucrats, and wealthy merchants all competed for these pages. And, as the mulla's story indicates, there was an active and lucrative market for drawings and miniatures outside Iran in India. An artist of good reputation could obviously do quite well selling his work privately: three tomans a page was a large amount of money.

The pages were bought singly but probably later included in albums. Muraqqa'-making was a highly regarded Safavi art, and though some albums, like the Bahram Mirza album, were devoted in large part to admired works of the previous century, others, like the equally impressive Shah Tahmasp album, contained primarily contemporary works, and miniatures may well have been painted specifically for inclusion in it.[58] Muraqqa'-making was a careful, noble art; there was nothing haphazard in the juxtaposition of miniatures and calligraphies, and the exact harmonies and sophisticated design of a splendid muraqqa', like the Shah Tahmasp album, are a stunning achievement.

One artist in particular was self-employed in another sense. Sadiqi Bek, our frequently mentioned poet–painter–courtier, was highly nonconformist. He was not entirely satisfied with the usual modes of patronage, and he had worked on both commissioned manuscripts and single-page miniatures and drawings in abundance. Apparently affluent enough to be reasonably independent near the end of the

57. This invaluable account, recorded in the 1702/03 (1114) tazkirat of Mirza Tahir Nasirabadi (British Museum Add. 7087) is from A. R. Khayyampur's introduction to Sadiqi Bek, *Majma'*, p. v.

Calligraphy was similarly bought and sold by art dealers. Qazi Ahmad (p. 165) records that Mir Mu'izz al-Din Muhammad "raised the mastery of writing to the uppermost rung of the ladder. He wrote excellently in large and small hand." Merchants particularly exported his writings to India.

58. Both albums are in the Topkapi Palace Museum, H. 2153 and H. 2161.

sixteenth century, he commissioned his own manuscript, the 1593 (1002) *Anvar-i Suhayli*. The book's 107 illustrations, many of them in an unusual and original style, often deal with equally unusual subjects. They were all painted by Sadiqi himself. Most likely this irascible, opinionated man, who had difficulty getting along with many of his contemporaries, was fed up with working for others and having his own ideas about painting influenced or distorted by his patrons'. Here in his own book he was free to be literally his own master, and the manuscript, unique in its mode of patronage, is one of the most significant in the history of sixteenth-century Iranian art.

6. Patrons and Artists

A historical survey of the period from 1576 to 1598 can be divided into two parts. In the first part, from 1576 to 1587, the power of the Safavi monarchy is measurably weakened to the advantage of the Qizilbash clans. The centralized administration which had begun to develop under Shah Tahmasp is undermined, while the centrifugal tendencies of the feudal system are accentuated. In his brief eighteen-month reign Shah Isma'il attempts to pursue his father's earlier policy of centralization but is himself too psychologically disturbed to succeed. Instead, he brings the Safavi royal house to the brink of extinction. Muhammad Khodabandah's ten-year reign is a total reversal of the tendencies toward centralization: he becomes virtually a puppet of the feudal Qizilbash factions.

In the second part, from 1587 to 1598, the reign of his son and successor 'Abbas initially appears to turn in the same direction, but by 1591 this monarch is not only firmly in control of his government but is also actively suppressing the Qizilbash. His early reign is characterized by a near revolution from above in the country's social and governmental system: the Qizilbash are reduced to the level of obedient courtiers and servitors of the monarch; the administration is centralized under an able bureaucracy residing in the capital; a large and effective standing army is created; regular and reasonably equitable taxation is instituted; religious orthodoxy is rigorously encouraged within the Muslim population, while a diplomatic and politic tolerance is observed toward Armenian and foreign Christians. In a move symbolic of all these changes the royal capital is transferred from Qazvin to Isfahan in 1598. The net result is that what had been a disunited and feudal country is converted within the space of ten years to a unified nation-state under an enlightened despot after the manner of Peter the Great, Charles V, and Louis XIV.

Patronage in late sixteenth-century Iran under these monarchs does not present a clear, uniform picture, either in terms of the notable patrons or the notable artists. Patronage could be an important expression of power, but the patrons themselves differed

widely in their approaches to art, and while some were men of genius, most, of course, were not. The three patrons of great ability—Shah Tahmasp, his nephew Ibrahim Mirza, and Shah 'Abbas—dominate the century's painting and have therefore been our primary concerns. But at various times lesser patrons exercised important influence too, particularly in the latter part of the century. There is, indeed, a great variety of patronage at many levels; we cannot simply demarcate Safavi patronage as that of the royal courts and that of the provincial "schools."

In the capital cities, whether Tabriz, Qazvin, or Isfahan, royal patronage was an erratic affair. Tahmasp's highly educated, youthful taste played a decisive role in the formation of the early Safavi court style. The young monarch was motivated by a purely personal passion for superb books.

A highly restricted art form, the royal book was intended solely for princes, dignitaries, and perhaps favored artists, but not for a wider public. And as it was Tahmasp's personal and very patrician involvement which determined the great range and success of this enormous burst of artistic creativity, so too it was his disinterest which could end it. With his change of temperament and personality between 1545 and 1550 his magnificent ateliers were abruptly disbanded, and most of his artists dismissed from their salaried positions. His taste and enthusiasm, coupled with the resources of the royal library, had combined to make this period from about 1522 to 1545 one of the richest in Iranian history. But having attracted the finest talent in the country to help express his own aesthetic needs, Tahmasp could also part with it as soon as it no longer provided either fulfillment or distraction.

Royal patronage did not always signify the personal interest and intervention of the ruler himself. Princes of the royal family were active and effective patrons as well. Ibrahim Mirza was the guiding spirit behind the creation of the great Freer *Haft Awrang* of Jami. Our sources mentioned Abu'l-Ma'sum Mirza as a lively and engaging patron. Hamzah Mirza, the eldest son of Muhammad Khodabandah, is known to have had a confidential circle which included the painter Siyavush. And even when he was a seven-year-old renegade prince in Khorasan, 'Abbas was patron enough to appropriate Habibullah of Savah.

The bond between patron and painter could be one of intimacy. Aqa Mirak was Shah Tahmasp's boon companion; Siyavush was

close to Hamzah Mirza; and Sadiqi's own account of Isma'il II
leaves little doubt that he was on amiable, personal terms with that
paranoid monarch. The active interest and vital patronage of Tah-
masp was a critical factor in the formation of early Safavi style, and
it is clear that without the personal attention of Ibrahim Mirza the
Freer *Haft Awrang* would have been a much different book.

Then, as now, artists belonged to an unstable profession. When
patronage was ample and the shah or a leading prince took a per-
sonal interest in the arts, a good calligrapher or painter could ride
very high indeed. But when the patron's interest, favor, or energy
waned, he could become destitute overnight.

Calligraphers of note were scattered all over the empire, for a
scribe, much more than a painter, was a necessary functionary of
the state. A local noble's prestige could thrive without his having a
coterie of painters, but it could not survive with poorly written docu-
ments. An incompetent calligrapher's letter to the royal court would
elicit not simply derision; it might be taken as an insult against the
king's reputation. Although calligraphers, doubling often as state
officials, had a greater chance to obtain positions than did painters,
they were also more vulnerable; it was almost inevitable that they
would get involved in politics and thus risk not only their jobs but
their lives.

To a great extent the intellectual and artistic elite of Iran did not
stay on through thick and thin: when times were bad and patronage
scant or unsteady, they could and would pack up and emigrate to
India, or even to the Ottoman or Uzbek courts, to make a living.
When life at the royal court became turbulent, artists could also
find refuge with some of the provincial houses, but many of these,
like that of Khan Ahmad of Gilan, rested on shaky foundations, as
the Safavi order slowly expanded to encompass them.

Persian was the lingua franca of the Near East and India, and
Iranian culture was the symbol of sophistication, at the court if not
at the popular level. Despite the sometimes tight control of the royal
atelier, artists moved constantly throughout Safavi Iran and on to
India, Turkey, and Uzbekistan. Their search for patronage spread
Safavi Iranian culture throughout the Near East and India. What
would Mughal painting have become without the impetus given it
by Mir Sayyid 'Ali and 'Abd al-Samad? How would the far reaches
of the Iranian empire have experienced the stylistic movements of
the Qazvin and Isfahan courts without the migration of artists as

well as the exportation of artworks? Certainly this is one of the principal causes for the remarkable unity of Safavi culture.

When direct patronage from the royal family was slack, as it often was in this period, feudal lords might fill the gap. This give-and-take between the feudal Qizilbash—many of them virtually independent rulers in their own right for much of this period—and the Safavi monarchy was reflected in many aspects of the social system, not least of all in the arts. Under a strong monarch such as Tahmasp most of the gifted painters worked at the royal court. Under a weak shah such as Muhammad Khodabandah talent was spread thin over the whole country. Thus Sadiqi, despairing of support from the court of this latter ruler, was sustained by Amir Khan Mawsillu of Hamadan. Perhaps in the same strait Habibullah of Savah was supported by Husayn Khan Shamlu.

A tributary power such as Gilan, which strayed in and out of the Safavi orbit throughout the sixteenth century, could also serve as an attraction to artists out of work at the royal capital. The great scribe Mir Sayyid Ahmad Mashhadi, disgraced and humiliated by Shah Tahmasp, was offered an honorable and lucrative position at the court of Murad Khan in Mazandaran. Two painters—'Abd al-Jabbar and Khwajah Nasir—served under the gifted patron Khan Ahmad in Gilan.

Other areas of Iran functioned on a somewhat more stable basis. A few cities and provinces, like Shiraz and Khorasan, had their own rich cultural heritages and supported active ateliers, some apparently dependent upon the local nobility or governors, and others evidently active as independent workshops with sufficient capital and clientele to undertake the production of manuscripts for sale.

Except for the chaotic interlude under Shah Muhammad Khoda-bandah, the Safavi state after 1540 strengthened its hold over Iran. Beginning under Shah Tahmasp and culminating in the revolution from above instituted by Shah 'Abbas, a new order was created which drew the provinces tightly together under firm royal control. As a result, the culture of the capital city—either Qazvin or Isfahan—spread throughout the empire. This is one of the causes of the relative paucity of provincial styles in later Safavi painting. It is also why even the usually independent Shiraz school approached the Qazvin style so closely by the end of the sixteenth century. Political unity is not an isolated factor, and in the hands of men who were also great patrons its meaning was not to be separated from cultural

unity. The two went hand in hand. By the end of the sixteenth century when Isfahan, located in the geographic center of the resurgent empire, became the new capital, it was Isfahan's culture which was to become synonymous with Safavi culture.

Perhaps this too is the reason the picture of provincial patronage and lesser aristocratic patronage is so meager and confused. These less exalted patrons had to accept the leftovers from the court feasts. When a great patron ceased his activity, a provincial center could flourish, but only under a brilliant prince, as Mashhad did under Ibrahim. For all his generosity Khan Amad in Gilan could not really compete. Nor could Husayn Khan Shamlu, whose favorite artist was snatched from him with so little ceremony.

There were significant changes in the economic and social structure of Iran. 'Abbas had a vital interest in increasing commerce within Iran and promoting trade outside it. Iran's need for a more stable economic existence was so pressing that 'Abbas was even willing to compel entire Armenian merchant communities to settle in Isfahan in order to further commerce. He welcomed Christian trade delegations from Europe and did his utmost to comply with their wishes. And, of course, his strong economic sense was directed toward the arts as well. In the past, though Iran had produced significant pottery and textiles of its own, it had also imported these arts from the Far East. In particular, Iranians had developed a marked taste for Chinese ceramics. Determined to reverse their hitherto somewhat baneful effect upon Iran's wealth, Shah 'Abbas set up textile factories under his direct patronage in many of Iran's chief cities—Yazd, Isfahan, Kashan, and Mashhad, among others —and promoted the production of ceramics, especially of a distinctly Chinese type, to satisfy Iranian and foreign taste for these wares.

But the art of the precious book had never belonged to this category of economic industrial or utilitarian arts. Royal books had been made for royal pleasure or for royal gifts to foreign potentates. Even the work of highly productive ateliers like those in Shiraz was probably largely for home consumption and, even if exported, could not have been of significant benefit to Iran's economy.

Thus the art of the book was a noncommercial art, and though 'Abbas clearly had a highly developed and very refined aesthetic for paintings and for precious manuscripts, the illustrated book was of much less immediate use to him. A strong and independent extro-

vert personality, he did not need to seek retreat and solace in paint-
ing, as had Shah Tahmasp. His earliest manuscript patronage, the
1587–97 *Shahnamah,* took place before he had seized effective
control of his own government and while he, like the youthful Tah-
masp, was still under the domination of his Qizilbash advisers. But
by the early 1590s he was unquestionably the real ruler of Iran.
'Abbas pursued his national interests with enormous vigor and
great intelligence, mixed with a brutal, but eminently practical
ruthlessness. His passion was to be politics, not art.

Patronage under Shah Tahmasp had been largely a matter of
personal aesthetic gratification. His early reign had been constantly
troubled by insurrection and plagued by invasion, and the arts of
painting and calligraphy had served as refuges for the beleaguered
young ruler. Thus in the first twenty years of his reign his own aes-
thetic satisfaction was of enormous personal significance, and this
very secretive monarch was willing to expend vast sums from the
royal treasury to produce sumptuous manuscripts.

Shah 'Abbas represented a wholly new direction of patronage.
True, he had strong aesthetic likes and dislikes. Riza's painting, for
instance, could move him intensely, for the reliable Qazi Ahmad
reports that "on one occasion [Riza] made such a portrait that the
monarch kissed his hand." And, equally, the monarch so admired
the work of his great calligrapher, 'Ali Riza, that he is said to have
sometimes even held the candle by which the scribe worked. He was
also ready to forgive both misdemeanors and serious crimes com-
mitted by his artists. But Shah 'Abbas did not view patronage as a
tool for satisfying his personal aesthetic needs alone. He was not
willing to drain his treasury to gratify his taste.

'Abbas was a much more "public" ruler, an autocrat with a strong
plebeian streak and with a sense of social responsibility very much
in line with the contemporary European concept of the enlightened
despot. He spent much more on his public buildings—on the roads,
bridges, forts, and caravanserais he built all over Iran to further
trade—than he ever did on his private buildings, such as the monu-
mental Masjid-i Shah, Isfahan's great royal mosque, or the gemlike
chapel of the Masjid-i Shaykh Lotfallah. And his patronage of the
art of the book pales before his support of weavers and potters in
many centers throughout the country.

Then too, large, splendid manuscripts took time, and 'Abbas was

a monarch who acted as if he had very little time. He liked "rush" work and badgered the builders of the Masjid-i Shah to finish the mosque far ahead of schedule. Drawings and single-page paintings took far less time to produce and could still be satisfactions of a high order. They were also less costly.

Shah 'Abbas's patronage can be divided into three areas. The first and least extensive was spurred by his personal taste. Like other members of the royal court he favored particular painters, scribes, and other artists, and he took care to support certain ones—such as the painter Riza and the scribe 'Ali Riza—through the vicissitudes of their difficult lives.

The second type of patronage might better be called art politics, and here he favored painting and architecture in the mode of his Timurid revival. In this category fall the 1614 *Shahnamah* and the 1612–38 Masjid-i Shah, both of which can be viewed as vivid demonstrations of 'Abbas's historical identifications and of his political ambitions for Iran.

The third type of patronage absorbed most of the state funds. The prodigious building campaign which 'Abbas undertook throughout Iran was not designed to provide aesthetic gratification or statements of official convictions but rather to create useful and economically productive structures—caravanserais, bridges, forts, and roads. His patronage of ceramic and textile workshops in most of the country's major cities can be viewed in the same light; they were profitable export arts.

Under Tahmasp the resources of the state had existed for the aesthetic fulfillment of one man. Under 'Abbas the state became an entity in itself, and the monarch served it more than it served him. The immensely greater resources of 'Abbas's Iran were employed to strengthen the nation rather than to please the shah. Unlike Shah Tahmasp, Shah 'Abbas filled the role of enlightened despot. Royal policy in the later reign of Tahmasp and under Isma'il II and Muhammad Khodabandah's Queen Khayr al-Nasa' Begum had been pointing in this direction, away from the feudal society which had dominated early Safavi Iran. Under Shah 'Abbas this new form of monarchy was realized. Royal power became autocratic power, and the arts were no exception to its rule.

The proliferating bureaucracy centered in Isfahan must have agreed too. There are only a few known or likely instances of their

patronage of precious books, but there are many extant examples of their patronage of less expensive single-page paintings, drawings, and calligraphies. Some of the work they collected surely was not of the same high quality as that of the royal and aristocratic patrons whom they were in part supplanting, and this could be an explanation for the existence of some very mediocre albums. At any rate it seems to be another cause of the proliferation of single-page drawings, paintings, and calligraphies in the seventeenth century.

But other fluctuations in patronage could have caused it as well. Perhaps the market for paintings and drawings was now more stable than the patronage of the court. Perhaps the artists, even those in the royal employ, could get better prices in the bazaar than they could in the court. Sadiqi's drawings had a ready market in India as well as in Iran. And from his own words it is obvious that artists knew dealer–merchants who sold their work in the Isfahan bazaar.

The former often intimate working relationship that had existed between patron and artist changed too. There were artists who no longer felt the need for a definite patron. Sadiqi was independent enough to commission his own manuscript, and Riza functioned so poorly under the royal aegis that he incurred the indulgent shah's disfavor. This greater independence may have meant less collective work too. In the seventeenth century there were fewer collaborative efforts of painters, calligraphers, and illuminators working together to produce a fine book. Earlier, a creative patron had often been the guiding spirit for this kind of project, but in the 1600s talent had become specialized, singular, and far more individualized.

Our three artists reacted in various ways to these changes and experienced different fates within the changing system. Siyavush spent almost his whole life under the shelter of the royal mantle. Temperamentally he was suited to the type of patronage which had existed in Shah Tahmasp's youth and under which so many great artists—Mir Musavvir, Sultan Muhammad, Aqa Mirak, Muzaffar 'Ali, and Mirza 'Ali, among others—had flourished and produced their finest work. He was the kind of artist who needed and found a secure and apparently unassailable niche at the royal court. Even when his royal confidant Hamzah Mirza was assassinated, Siyavush continued to thrive. That he survived well under 'Abbas makes it clear that to some degree at least this old-fashioned kind of patronage continued to survive at the end of the century.

Sadiqi came to art late and spent a good portion of his life in a

search for better patronage. Not favored with royal notice as a youth, as had been Siyavush, he had to struggle for position. While the Georgian artist's career ran smoothly and untroubled from his boyhood as Tahmasp's page to his old age as a retired but still widely respected artist under 'Abbas, Sadiqi's career was continually subject to vicissitudes of fortune. Succeeding as an artist under Tahmasp in the 1573 *Garshaspnamah,* he was near the top of his profession under Isma'il II and then fell precipitously out of favor under Muhammad Kohdabandah. He was evidently in despair of his career when he was "picked up" by a feudal lord in a lesser city, Amir Khan Mawsillu in Hamadan. Wandering over Iran in search of greater security and more munificent patronage for about eight years, he finally came into 'Abbas's service, first in Khorasan and then in Qazvin and Isfahan. By any reckoning he was an enormously productive man: we have not only his painting in the 1573, 1576–77, 1579, and 1587–97 manuscripts, as well as many drawings and paintings over the same stretch of time, but also his prolific writings, numbering in all some eleven books in poetry and prose.

Riza was outwardly less insecure and less troubled, but his life was fraught with personal problems. He was an artist unable to adjust to the exigencies of royal patronage. He contributed to only four known manuscripts, and the greater part of his oeuvre was in the form of single-page drawings and paintings, some of which were clearly done for the monarch himself but many of which were undoubtedly finished for other patrons.[1]

Another marked change in artistic theory equated the art of the painter with that of the calligrapher. Before the sixteenth century calligraphy had been accepted as the highest form of visual expression in Islam. By the end of the century this attitude had made way for a new theory of the qalam. In Qazi Ahmad's 1596–97 treatise 'Ali is declared the patron of both writing and the graphic arts and

1. The four manuscripts are the 1587–97 *Shahnamah;* the c. 1595 *Qisas al-Anbiya;* the 1614 (1023) *Diwan* of Mir 'Ali Shir Nawa'i in the Rothschild Collection, Paris (reproduced in Colnaghi, nos. 43 i–ix); and the 1631/32 (1041) *Khusraw and Shirin* (Victoria and Albert Museum, 364–1885). A fifth manuscript, a 1608 (1017) *Diwan* of Mir 'Ali Shir Nava'i (Topkapi Palace Museum, E.H. 1641), contains seven superb miniatures which B. W. Robinson has attributed to Riza in *Studies on Isfahan, Iranian Studies* 7 [1974]: 501.

One signed drawing in the collection of Ralph Benkaim, Beverly Hills, Calif., bears an inscription identifying one of the two men depicted as a visitor to Isfahan from India. Did Riza at this time (about 1625) earn at least part of his living drawing portraits of visiting worthies?

is even said to have been a painter himself.[2] This view, absolutely heretical to the rest of Islam, was clearly not only the product of heterodox Shi'a thought but also of the ancient and still strong devotion to the graphic and figural arts in Iran.

There was also a change in artistic self-awareness. Before the sixteenth century signed works were relatively rare. But throughout the century, from Bihzad's work at the beginning to Riza's work at the end, there is a proliferation of paintings and drawings bearing the names of the artists who did them. And the seventeenth century provides us with almost a superfluity of signed work: Riza is very careful to identify his work and often to supply us with information about the subjects themselves. The work of the great masters of the mid-seventeenth century—Muhammad Qasim, Muhammad Yusuf, Muhammad 'Ali, and 'Ali Quli Jabbahdar—is identified with equal care. Another artist, Mu'in Musavvir, not only signs his work precisely but also, in at least one major instance, provides us with a lengthy description of the contemporary event he is depicting.[3]

Whether or not the artists themselves actually signed all the sixteenth- or seventeenth-century work bearing ascriptions to them is not in itself important. What is significant is that it was considered at least useful, if not perhaps even necessary, for a work of art to be identified by its artist's name. Art was no longer anonymous. Instead it was the work of individuals whose uniqueness was recognized not only by themselves but also by their contemporaries. No fourteenth-century librarian thought it worthwhile to inscribe the pages of the Demotte *Shahnamah* with the names of the men who illustrated them. For sixteenth- and seventeenth-century connoisseurs and collectors it became crucially important to have this kind of information.

As a result, it was an age of connoisseurship, evident not only in Iran but also in the refined sensitivity of a Jahangir or a Shah Jahan

2. See B. N. Zakhoder's introduction to Qazi Ahmad, pp. 22–24. Writing fifty-two years before Qazi Ahmad, Dust Muhammad in his *Account of Past and Present Painters* (published in L. Binyon, J. V. S. Wilkinson, and B. Gray, *Persian Miniature Painting,* p. 183) voiced the same view that the first to reveal the glories of painting and illumination was 'Ali, "whose pen opened the gates of these two arts to mankind, and who produced several leaves known to painters as Islami."

3. His drawing of a lion attack, Museum of Fine Arts, Boston, 14.634. Published in A. K. Coomaraswamy, *Les miniatures orientals de la collection Goloubew,* no. 84; E. Grube, *Muslim Miniature Painting,* no. 117; and A. Welch, *Shah 'Abbas,* no. 75.

in seventeenth-century India. In Iran, it was the great age of the muraqqa', the album, and album-making was recognized as a high art form. Dust Muhammad, one of Tahmasp's panoply of artists, was a highly skilled muraqqa'-maker. Did not Ibrahim Mirza painstakingly put together a great muraqqa' of the works of Bihzad, as well as another splendid album containing one-half of the known specimens of writing by Mir 'Ali? Sadiqi Bek himself probably compiled the pages of the great album in the Bibliothèque Nationale. And a gifted, unidentified master created the sustained magnificence of the "Shah Tahmasp" album in Istanbul, surely one of the greatest of muraqqa', where calligraphies, illuminations, and miniatures have been arranged in the most intricate and refined visual harmony.

The proliferation of albums is also indicative of another major development. Images have now become independent entities, existing apart from the texts which they formerly illustrated. In fourteenth- and fifteenth-century painting the relationship between text and image had been intimate and usually precise. By the middle of the sixteenth century the connection is obviously strained. Extraneous subject matter is often interjected into manuscript illustrations, presumably through the artist's or patron's initiative. And many paintings and drawings are produced which have minimal or no connection with any text at all (e.g., plate 6 and figs. 5, 19, 24, and 56). Clearly, images no longer need to be justified as mere complements to words.

Perhaps the taste for muraqqa' derived at least in part from the great variety of images and calligraphies that they could present. Perhaps they also owed their existence to the Safavi interest in "art history," which encouraged the preservation within the albums' pages of so many great works of Timurid painting.

Undoubtedly it was partly to supply this new art form—the muraqqa'—that so many artists turned to individual pages rather than to whole manuscripts. Muraqqa'-making was an art form in which less-exalted patrons could participate, and some of the surviving albums indicate that these new patrons had very little training, often very little taste, and perhaps also quite meager resources. Single pages of drawings and paintings could be sold at relatively low prices. A whole illustrated manuscript could never be priced as low, no matter how mediocre its workmanship.

Closely connected with the interest in artistic identity and person-

ality was the sixteenth-century concern for "art history." Tahmasp's brother Sam Mirza wrote an account of celebrated poets and painters. Dust Muhammad, Shah Tahmasp's painter, calligrapher, and muraqqa'-maker, left us his *Account of Past and Present Painters.* Babur, educated as thoroughly as any Persian prince, learnedly discussed Bihzad in his *Memoirs,* while his cousin, Muhammad Haydar, wrote an account of the Herat school of painters whose work he undoubtedly knew at first hand. The Ottoman emissary at the royal court in Qazvin, Mustafa 'Ali, included useful information about Safavi artists in his *Manaqib-i Hünerweran* of 1586.[4] The late sixteenth century itself is ably covered by Qazi Ahmad and Iskandar Munshi. But most significant, Sadiqi Bek records not only the careers and characters of his contemporaries but also gives us precious information about his own life and personality. The first person figures prominently in his work. It is not only his ego which is apparent but also his strong sense of being an "artist" and of "art" being something apart from other occupations, something nobler and more edifying.[5]

The content of painting and drawing has altered too by the end of the century. In the earlier decades of the sixteenth century content had still been a significant part of a picture's meaning. By the end of the century this importance has been greatly diminished. Although

4. Edited by M. Kamal-Bey, Istanbul, 1926.

5. Is this evolution of artistic self-awareness in part responsible for the rise in number of troubled artists in the sixteenth century? Compared with earlier accounts, sixteenth-century records abound in reports of temperamental, neurotic, and even psychotic personalities among its artists. Even a cursory glance at some of the leading artists leaves us with the very distinct impression that the growth of artistic individuality and self-consciousness brought with it a rise in disturbed artists.

Hasan Baghdadi was a dangerous personality from birth and offered his fellow human beings nothing but malevolence. He attempted to kill his father, who then offered a bounty for his head. He counterfeited the seal of Shah Isma'il II but escaped with his life. After being befriended by an innocent and naïve young man, Hasan responded to his kindness by seducing and making off with one of his slave girls.

'Abd al-'Aziz and 'Ali Asghar abducted one of Shah Tahmasp's favorite catamites and headed for the Indian border; they forged the shah's seal on the way in order to make a false letter of credit.

Riza wasted his talent, spurned the shah's avid and sympathetic interest, and cultivated evil ways, until he "spoil[ed] his disposition" and became "ill-tempered, peevish, and unsociable."

And, of course, Sadiqi Bek himself stands as a clear example of a man not at ease with himself or with his associates.

Riza is a master at representing specific content in the 1587–97 *Shahnamah,* his talent and energies turn more toward countless representations of idyllic beautiful youths posing in admiration of their own perfection. With the decrease in the production of illustrated manuscripts there is a corresponding and related decrease in works containing recognizable and significant content. Riza did not create this taste. With his ample genius he was equally adept at representing scenes of the most highly charged content in the 1587–97 *Shahnamah* and at depicting vapid but richly sensuous, idealized forms. With the major exception of Mu'in Musavvir's great *Shahnamah* illustrations in the later seventeenth century, Safavi art moves strongly in the direction of art for art's sake, and though this is surely one of the perennial tendencies in Iranian painting, it is magnified in the seventeenth century.

Form itself changes too, of course. We have followed the transition of form from Sadiqi's early work in the 1573 *Garshaspnamah* to Riza's work about 1595. Line has become more flowing, more fluidly calligraphic. Sadiqi's linear rhythms tend to merge into cerebral, abstract values. Riza's do not. His line is more naturalistic and for all its calligraphic sweep is ultimately more closely related to living forms. The palette becomes far more varied in Riza's work than in either Siyavush's or Sadiqi's. Pigment is thicker and more luminous. In his hands color regains much of the richness it possessed in the first half of the sixteenth century, but its harmonies are less subtle. Textures are also richly developed. In Sadiqi's work they are still much of a kind, but in Riza's we find thick folds, furry collars, bulky turbans, diaphanous films, and rolling velvets. Textures become increasingly soft and sensuous, whether in lush grasses, rocky surfaces, or tactile folds of cloth.

Siyavush adheres strongly to the earlier heroic models of Iranian painting. Early in his career Sadiqi does as well. His later work, however, utilizes other subjects—genre scenes at which he seems adept and idyllic subjects where he seems often ill at ease. His younger colleague Riza moves easily from one to the other, and while he is obviously a superb illustrater of the heroic ideals of Iran in the 1587–97 *Shahnamah,* he is equally at ease with gentler, more urbane, and erotic content. In his work human forms become softer, youths adopt more willowy postures, and their poses are refined and easy. But by 1598 Riza is still very much a Qazvin artist. A new canon of beauty has not evolved; instead, he is carrying the Qazvin

style to the limit of its pictorial expressiveness. The differences we cite between Siyavush and Sadiqi and Riza are not so much differences of style as differences of genius.

Though his earliest work in the 1587–97 *Shahnamah* is taut with energy and vital motion, Riza turns his later sixteenth-century figures into studies in elegant indolence. He bestrides the turn of the century like the great master he is, transforming the art of his elders and fixing the art of his followers. Siyavush he only mildly touches. But Sadiqi is challenged. The older artist's response is rarely a match for the younger's. Where it is, it sets him alongside Riza as the other great artist of the late sixteenth century.

Appendix 1: Proposed Chronology of Sadiqi's Life

1533	birth in Tabriz
1543	in Abarquh
1553	death of Sadiqi's father
1553–59	travels and resides in Ottoman territory, chiefly Aleppo and Baghdad
1559–65	in the service of amirs in Iran
1565–68	with Mir San'i in Tabriz
1568–76	with Muzaffar 'Ali in Qazvin
1576–77	in atelier of Isma'il II in Qazvin
1577–79	in the service of Amir Khan in Hamadan
1579	in Qazvin
1580–81	in Gilan
1582–83	in the service of Iskandar and Badr Khan Afshar
1583–85	in Astarabad and Yazd
1585–87	in the service of Prince 'Abbas in Herat
1587–98	in the service of Shah 'Abbas in Qazvin
1610	death in Isfahan

Appendix 2: Chronology and Present Location of Sadiqi's Principal Works

1573 *Garshaspnamah*
 Garshasp fights the dog-heads (British Museum Or. 12985, folio 45b): figure 12

1576–1577 *Shahnamah*
 Faridun receives the ambassador from Salm and Tur (Collection of Prince Sadruddin Aga Khan, Geneva): plate 5
 Zal returned to Sam by the simurgh (Colnaghi, no. 19 vii, not reproduced)
 *Zal before Rudabah's castle (*Collection of Ralph Benkaim, Beverly Hills, California): figure 14
 Rustam kills the mad elephant (Private collection, Italy)
 Afrasiyab confers with Pashang (Collection of Prince Sadruddin Aga Khan, Geneva): plate 4
 Rustam, Rakhsh, and the dragon (reproduced in Colnaghi, no. 19)

c. 1577–78, *A seated princess* (Private collection, Cambridge, Mass.): figure 18

1579 *Habib al-Siyar*
 An outdoor entertainment (Present location unknown): figure 17

c. 1580, *Young woman* (Bibliothèque Nationale, Paris, sup. pers. 1171, folio 32a): figure 21

c. 1587–97 *Shahnamah*
 Zal before Rudabah's castle: figure 37
 King Sarv, his daughters, and the three sons of Faridun: figure 38
 The simurgh carries Zal to her nest: plate 11 (All three at Chester Beatty Library, Dublin, MS 277)

c. 1590, *Seated young man with sprig of flowers* (Bibliothèque Nationale, Paris, sup. pers. 1171, folio 44b): figure 22

c. 1590, *Seated young man with wine cup* (Bibliothèque Nationale, Paris, sup. pers. 1171, folio 3b): figure 23

1593 *Anvar-i Suhayli,* 107 miniatures (Collection of the Marquess of Bute): figures 42–55, plates 12 and 13

1593–94, *Portrait of Timur Khan Turkman* (Oriental Institute of the Academy of Sciences, Leningrad): figure 11

c. 1595, *Seated man* (Museum of Fine Arts, Boston, 14.636): figure 24

c. 1595, *Animal sketches* (Private collection, Cambridge, Mass.): figure 27

c. 1595, *Man on horseback attacked by a dragon* (Collection of Prince Sadruddin Aga Khan, Geneva): figure 28

c. 1600, *Man in a landscape* (Private collection, Iran): figure 57

c. 1605, *Lion tamer* (Fogg Art Museum, Harvard University, Cambridge, Mass.)

Other paintings and drawings bearing Sadiqi's name are discussed by I. Stchoukine in his excellent study, *Les peintures des manuscrits de Shah 'Abbas,* pp. 76–79.

Appendix 3: Other Late Sixteenth-Century Painters

Besides Siyavush, Sadiqi, and Riza many other painters were active in the royal atelier from 1576 to 1598. Some major figures—Shaykh Muhammad, Muhammadi, and Habibullah—are discussed in my article, "Painting and Patronage under Shah 'Abbas." Others, less celebrated perhaps but still worthy of attention, are considered briefly below. I am indebted here, as elsewhere, to B. W. Robinson for his kindness in sharing with me his forthcoming article, "Isma'il II's Copy of the *Shahnamah*."

Naqdi

Mentioned in a very cursory manner by Iskandar Munshi as one of the "other artists and painters" in the atelier of Isma'il II, Naqdi is one of the most talented men in the monarch's employ. He is a fine draftsman and colorist, superbly trained, probably by either Mirza 'Ali or Shaykh Muhammad. His human figures tend to be rather slender and have the long necks and thin faces characteristic of Qazvin painting. The rather pin-headed persons who often people his paintings are generally repetitive and rarely individual. His rock forms are rendered with somewhat deeper and more elaborate color than Siyavush's.

Seven of the miniatures from the 1576–77 *Shahnamah* account for the total of his presently known work.

> *Zahhak enthroned* (Collection of Prince Sadruddin Aga Khan, Geneva): **figure 58**
> *Jandal before Sarv* (reproduced in Colnaghi, no. 19): **figure 59**
> *Zal presented to Sam* (Metropolitan Museum of Art, New York): **figure 60**
> *Rudabah and Sindukht* (reproduced in Colnaghi, no. 19 viii)
> *Rustam and Kay Qubad* (Colnaghi, no. 19 ix, not reproduced)
> *Isfandiyar kills two kylins* (Collection of Prince Sadruddin Aga Khan, Geneva): **plate 14**
> *Bizhan captured in Manizhah's chambers* (Chester Beatty Library, Dublin, MS 256): **figure 61**

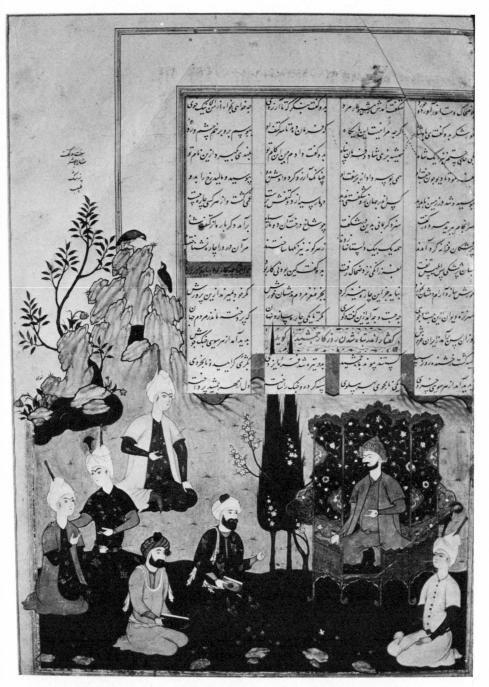

Fig. 58. NAQDI. *Zahhak enthroned*. From the 1576–77 *Shahnamah*.

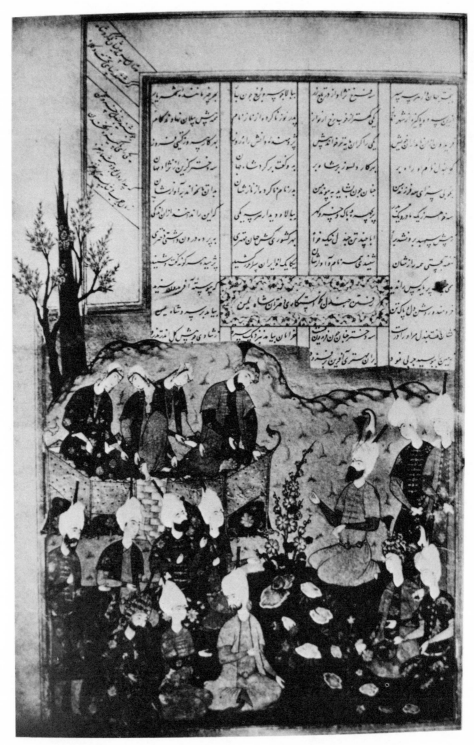

Fig. 59. NAQDI. *Jandal before Sarv*. From the 1576–77 *Shahnamah*.

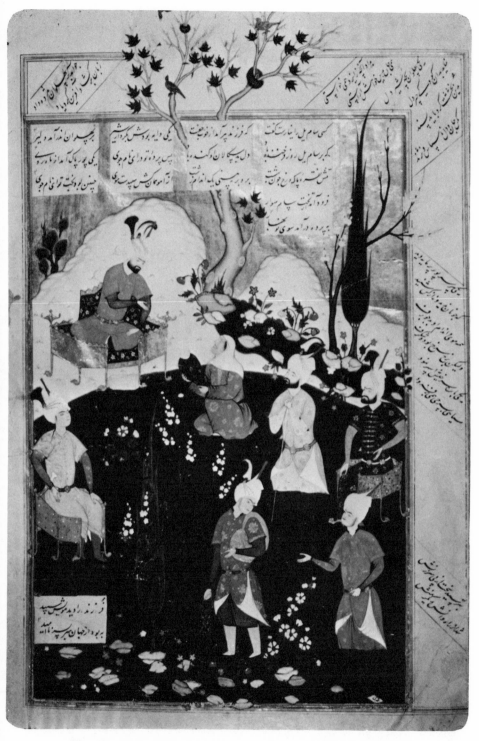

Fig. 60. NAQDI. *Zal presented to Sam*. From the 1576–77 *Shahnamah*.

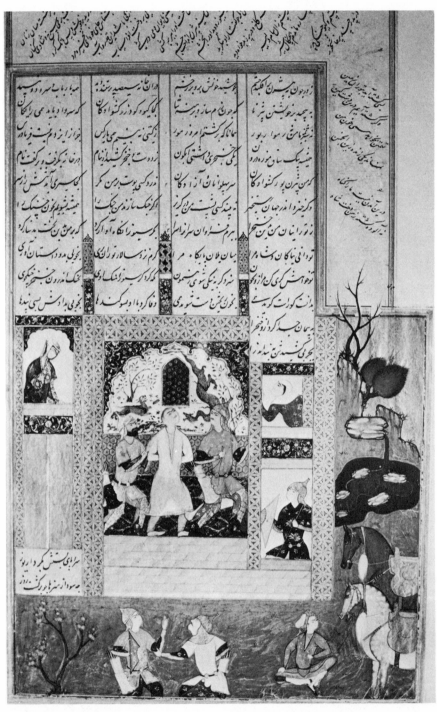

Fig. 61. NAQDI. *Bizhan captured in Manizhah's chambers.* From the 1576–77 *Shahnamah.*

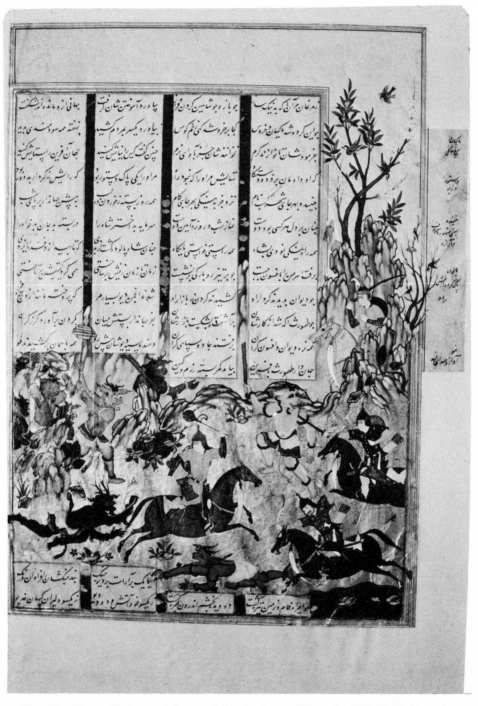

Fig. 62. MURAD DAYLAMI. *Tahmuras fights the demons*. From the 1576–77 *Shahnamah*.

Murad Daylami

Although this master is one of the finest painters in the late sixteenth century, we have no literary information about him. It is likely that he was trained by Mirza 'Ali, for his landscapes recall the melodic, lyrical sweetness of his work. Murad is also a master capable of conveying a high sense of drama and physical action. With a very proficient technique, he is adept at both intricate detail and strong compositions, and his work is all on a uniformly high level.

It is not clear whether Murad Daylami is to be associated with the master whose name, Murad, appears on two other known works—a fine painting of a curlew (Topkapi Palace Museum, H. 2155, folio 18b) and a chained lion (Museum of Fine Arts, Boston, 14.582; published in A. K. Coomaraswamy, *Les minatures orientales de la collection Goloubew,* pl. XVIII).

Five miniatures from the 1576–77 *Shahnamah* bear the name Murad.

> *Tahmuras fights the demons* (Chester Beatty Library, Dublin, MS 256): **figure 62**
> *The murder of Iraj* (Chester Beatty Library, Dublin, MS 256): **plate 15**
> *Bizhan finds the wounded Gustaham* (reproduced in Colnaghi, no. 19 xviii)
> *Isfandiyar fights the dragon* (Colnaghi, no. 19 xxi, not reproduced)
> *Isfandiyar kills two lions* (Collection of Prince Sadruddin Aga Khan, Geneva): **plate 16**

Zayn al-'Abidin

According to both Qazi Ahmad and Iskandar Munshi, Zayn al-'Abidin was the grandson and pupil of Sultan Muhammad and rose to the highest levels in the royal atelier. Qazi Ahmad praises him for his portraiture, gilding, and painting and indicates that he spent his entire life in the employ of the shahs. Iskandar Munshi goes into considerable detail about the artist's personality:

> [Zayn al-'Abidin] was sober in character, pure and upright; he was invariably prudent and courteous; he was honored both by high and low; he was a good artist and an agreeable companion and his nobility was without compare, and he was a virtuous painter; his pupils carried on the work of the atelier, but he himself always enjoyed the patronage of the princes and nobles and grandes.

He became a member of the royal library staff during the reign of Isma'il II. He was not only a painter but also a calligrapher, and the 1586

(994) *Shahnamah* in the British Museum (Add. 27302) bears his name as its scribe. His fame as an illuminator must also have been considerable, for the superb illuminated heading in the 1587–97 *Shahnamah* in the Beatty Library is his work. This talented and admirable man was responsible for five surviving paintings.

> 1573 *Garshaspnamah: Battle between Nariman and the Khaqan* (folio 90b, published in B. W. Robinson, *Persian Miniature Painting,* no. 48 and pl. 24)
>
> 1576–77 *Shahnamah:*
> *Firdawsi and the court poets of Ghazna*
> *Zahhak addresses his subjects*
> *King Sarv and the sons of Faridun*
> *Isfandiyar kills Bidarafsh*
> (All four pages are reproduced in Colnaghi, nos. 19, iii, iv, vi, and xx.)

Mihrab

There is no literary information about this painter whose slender figures seem to be influenced by Siyavush. His compositions tend to be conventional and unimaginative, though he is technically proficient in painting. He completed three pages for the 1576–77 *Shahnamah.*

> *Faridun crosses the Abi-iDarya* (Chester Beatty Library, *Dublin,* MS 256): **figure 63**
> *The Persian army besieged on Mt. Hamawan* (reproduced in Colnaghi, no. 19 xvii)
> *Rustam attacks an opponent* (Collection of Prince Sadruddin Aga Khan, Geneva): **figure 64**

Burji

Like Mihrab, Burji is an artist known only for his work in the 1576–77 *Shahnamah.* His figures are thin and long necked with wan faces. Only one miniature from the manuscript bears his name: *Court scene* (present location unknown): **figure 65**

'Ali Asghar

This elusive master is accorded ample mention by both Qazi Ahmad and Iskandar Munshi. According to them, he came from Kashan, was in the ateliers of both Ibrahim Mirza and Isma'il II, and excelled in the painting of streets and trees. He was father of Riza, but it is unclear how great his influence on the art of his gifted son may have been. B. W. Robinson

has located one painting which bears this painter's name and was originally part of the 1576–77 *Shahnamah*.

> *Iskandar building the wall against Gog and Magog* (reproduced in *Sale Catalogue,* Palais Galliéra, Paris, June 19, 1970, lot 52).

The same author has tentatively attributed the manuscript's frontispiece to 'Ali Asghar (reproduced in Colnaghi, no. 19 ii).

'Abdullah Shirazi

Known to have served under Ibrahim Mirza for twenty years before joining the royal atelier of Isma'il II, 'Abdullah Shirazi was more famed as an illuminator than as a painter. B. W. Robinson in his excellent article on the 1576–77 *Shahnamah* argues convincingly that he is responsible for a strongly Shirazian, unsigned painting in the 1576–77 *Shahnamah: The battle of Kay Khusraw and Afrasiyab* (Chester Beatty Library, Dublin, MS 256: **figure 66**

Muhammad Isfahani

According to Iskandar Munshi, this painter was a member of the atelier of Isma'il II. He had studied with 'Abd al-'Aziz, one of the foremost early Safavi painters, and had served as a mural painter as well as a manuscript illustrator. Sadiqi knew him somewhat and reports that he was a painter who was living in Mashhad. He was a poet as well and had the takhallus (pen name) of Rahi (Sadiqi Bek, *Majma'*, p. 264). He apparently did not participate in the work on the 1576–77 *Shahnamah,* but other works bearing his name are known. All are single pages representing standing or seated figures. His work is characterized by a rather hard, dry style of drawing and by simple, though effective, colors. Four pages, all painted about 1565–75, bear his name.

> *Standing young man with sprig of flowers* (Museum of Fine Arts, Boston, 14.590; published in Coomaraswamy, pl. XXXI, no. 40)
> *Youth and old man* (Topkapi Palace Museum, Istanbul, H. 2156, folio 20a): **figure 67**
> *Young man and woman* (Topkapi, H. 2156, fol. 161b): **figure 68**
> *Young man with falcon* (Topkapi, H. 2161, fol. 174b)

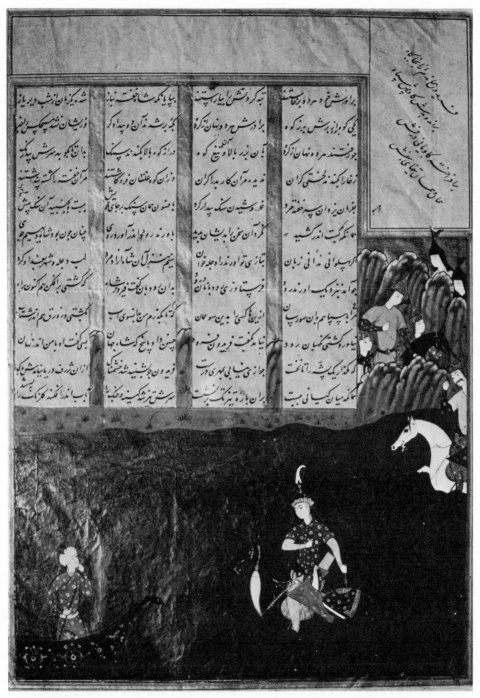

Fig. 63. MIHRAB. *Faridun crosses the Ab-i Darya.* From the 1576–77 *Shahnamah.*

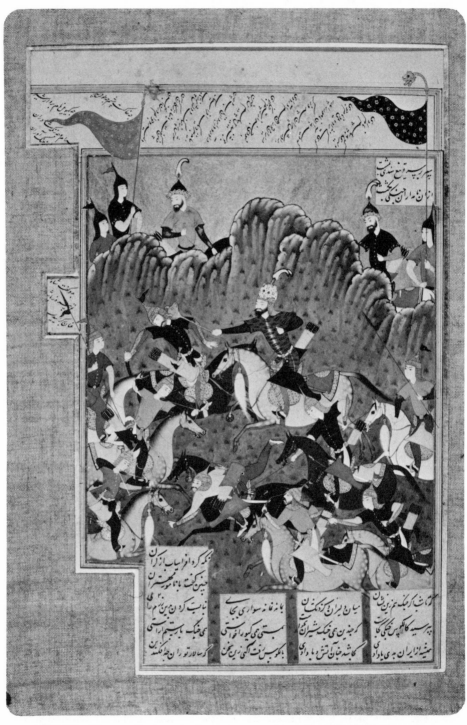

Fig. 64. MIHRAB. *Rustam attacks an opponent*. From the 1576–77 *Shahnamah*.

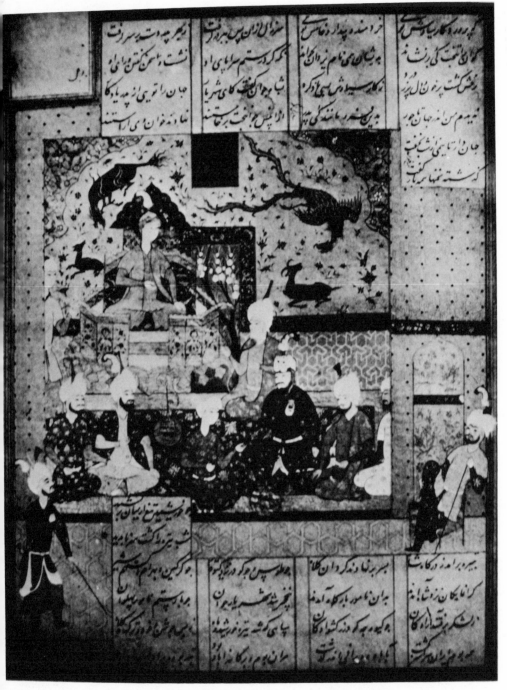

Fig. 65. BURJI. *Court scene.* From the 1576–77 Shahnamah.

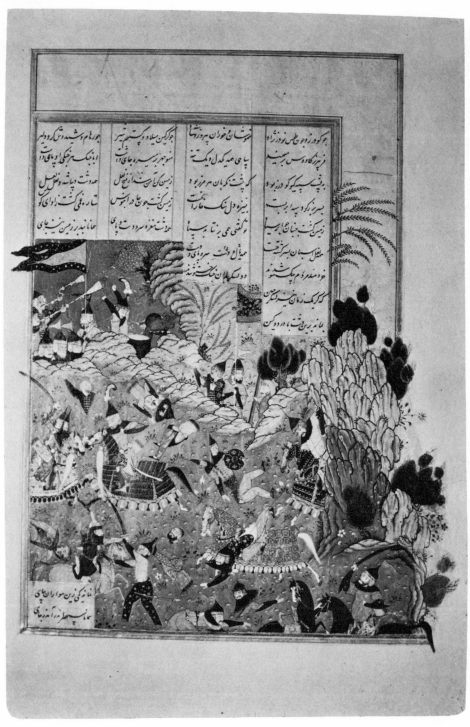

Fig. 66. 'ABDULLAH SHIRAZI. *The battle of Kay Khusraw and Afrasiyab.* From the 1576–77 *Shahnamah.*

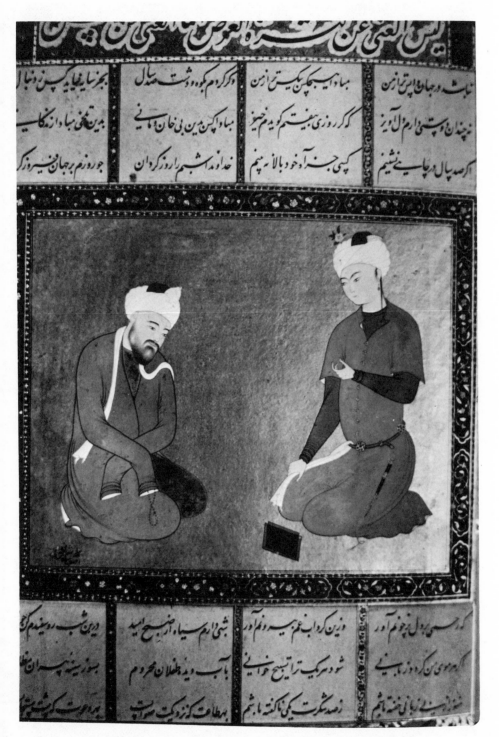

Fig. 67. MUHAMMAD ISFAHANI. *Youth and old man.* Circa 1565–75.

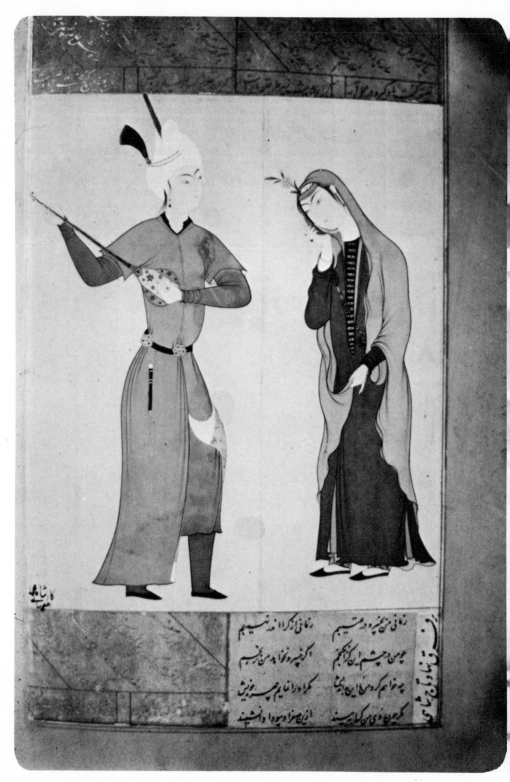

Fig. 68. MUHAMMAD ISFAHANI. *Young man and woman.* Circa 1565–75.

Selected Bibliography

Arberry, A. J.; Blochet, E.; Robinson, B. W.; and Wilkinson, J. V. S. *The Chester Beatty Library, A Catalogue of the Persian Manuscripts and Miniatures.* 3 vols. Dublin, 1959–62.

Arnold, T. W. *Painting in Islam.* Oxford, 1928; reprint, New York, 1965.

Ashrafi, M. *XVI Century Miniatures Illustrating Manuscript Copies of the Works of Jami from the USSR Collections.* Moscow, 1966.

Bellan, L. L. *Chah 'Abbas I.* Paris, 1932.

Binyon, L. *The Poems of Nizami.* London, 1928.

———; Wilkinson, J. V. S.; and Gray, B.; *Persian Miniature Painting.* London, 1933; reprint, New York, 1971.

Blochet, E. *Les enluminures des manuscrits orientaux de la Bibliothèque Nationale.* Paris, 1926.

———. *Musulman Painting.* London, 1929.

Browne, E. G. *A Literary History of Persia.* 4 vols. London and Cambridge, 1908–24.

Colnaghi. *See* Robinson et al. *Persian and Mughal Art.*

Coomaraswamy, A. K. *Les miniatures orientales de la collection Goloubew au Museum of Fine Arts de Boston, Ars Asiatica* 13, Paris and Brussels, 1929.

Falsafi, N. *Zindigani Shah 'Abbas Awwal.* Tehran, 1956–63 (1334–41).

Gandjei, T. "Notes on the Life and Work of Sadiqi: A Poet and Painter of Safavid Times." *Der Islam* 52, no. 1, Berlin, 1975.

Ghani, M. A. *A History of Persian Language and Literature at the Mughal Court.* 3 vols. Allahabad, 1929–30; reprint, Farnborough, 1972.

Gray, B. *Persian Painting.* Lausanne, 1961.

Grube, E. *The Classical Style in Islamic Painting.* Venice, 1968.

———. *Muslim Miniature Painting.* Venice, 1962.

———. "The Spencer and the Gulestan Shah-nama." *Pantheon* 22 (1964): 9–28.

Guest, G. D. *Shiraz Painting in the Sixteenth Century.* Washington, D.C., 1949.

Hinz, W. "Schah Esma'il II, Ein Beitrag zur Geschichte der Safaviden." *Mitteilungen des Seminars für Orientalische Sprachen* (1933): 19–100.

Iskandar Munshi. *Tarikh-i 'Alam-ara-yi 'Abbasi.* Tehran, 1955–57 (1334–36).

Ivanov, A. A., and Akimushkin, O. F. *Persidskie miniaturi XIV–XVII v.* Moscow, 1968.

_____; Grek, T. B.; and Akimushkin, O. F. *Album indiskikh i persid-skikh miniatur XVI–XVIII v.* Moscow, 1962.

Malcolm, J. *The History of Persia.* London, 1829.

Marteau, G., and Vever, H. *Miniatures persanes exposées au Musée des Arts Décoratifs.* 2 vols. Paris, 1912.

Martin, F. R. *The Miniature Paintings and Painters of Persia, India, and Turkey.* 2 vols. London, 1912; reprint, 1971.

———, and Arnold, T. W. *The Nizami Ms. in the British Museum (Or. 6810).* Vienna, 1926.

Qazi Ahmad. *Calligraphers and Painters.* Trans. from the Persian by V. Minorsky. *Freer Gallery of Art Occasional Papers* 3, no. 2 Washington, 1958.

Robinson, B. W., *A Descriptive Catalogue of the Persian Paintings in the Bodleian Library.* Oxford, 1958.

_____. *Miniatures persanes.* Geneva: Donation Pozzi, Musée d'Art et d'Historie, 1974.

_____. *Persian Drawings.* New York, 1965.

_____. *Persian Miniature Painting.* London, 1967.

_____. "Two Persian Manuscripts in the Library of the Marquess of Bute, Part II: *Anwar i Suhayli* (Bute MS 347)." *Oriental Art* 18, no. 1 (Spring, 1972).

_____; Falk, T.; Sims, E.; Fehérvári, G.; and King, O. *Persian and Mughal Art.* London: P. and D. Colnaghi and Co., (1976).

Röhrborn, K. M. *Provinzen und Zentralgewalt Persiens im 16. und 17. Jahrhundert.* Berlin, 1966.

Roemer, H. R. *Der Niedergang Irans nach dem Tode Isma'ils des Grausa-men.* Göttingen, 1939.

Sadiqi Bek. *Majma' al-Khawass.* Introduction and translation from Chaghatay Turkish by A. R. Khayyampur. Tabriz, 1948.

_____ *Qanun al-Suvar.* Edited by A. U. Kaziev. Baku, 1963.

Sakisian, A. *La miniature persane.* Paris and Brussels, 1929.

Savory, R. M. "The Development of the Early Safavi State under Isma'il and Tahmasp." Ph.D. dissertation, Oxford University, 1958.

Schroeder, E. *Persian Miniatures in the Fogg Museum of Art.* Cambridge, Mass., 1942.

Schulz, P. W. *Die persisch-islamische Miniaturmalerei.* 2 vols. Leipzig, 1914.

Stchoukine, I. *Les peintures des manuscrits Safavis de 1502–1587.* Paris, 1959.

_____. *Les peintures des manuscrits de Shah 'Abbas I à la fin des Safavis.* Paris, 1964.

Survey of Persian Art. Edited by A. U. Pope and P. Ackerman. 6 vols. Oxford University Press, 1938; reprint, Tokyo, 1964.

Welch, A. *Catalogue of the Collection of Islamic Art of Prince Sadruddin Aga Khan.* 2 vols. Geneva, 1972.

_____. *Shah 'Abbas and the Arts of Isfahan.* New York, 1973.

_____. "Painting and Patronage under Shah 'Abbas I." *Studies on Isfahan, Iranian Studies* 7 (1974): 548–507.

Welch, S. C. *A King's Book of Kings.* New York, 1972.

_____, and Dickson, M.B. "The Houghton *Shahnamah.*" Forthcoming.

List of Indexed Painters and Calligraphers

PAINTERS

'Abd al-'Aziz
'Abd al-Jabbar
'Abd al-Samad
'Abdullah Shirazi
'Ali Asghar
'Ali Quli Jabbahdar
Aqa Hasan Naqqash Haravi
Aqa Mirak
Burji
Dust Muhammad
Ghiyath Naqshband, Khwajah
Habibullah of Savah
Hasan 'Ali
Hasan Muzahhib, Ustad
Haydar 'Ali
Husayn Bek
Khalil Mirza Shahrukhi
Mihrab
Mir Musavvir
Mir Muzaffar Yazdi
Mir Sayyid 'Ali
Mirza 'Ali
Muhammad 'Ali
Muhammadi
Muhammad Isfahani
Muhammad Qasim
Muhammad Yusuf
Mu'in Musavvir
Murad Daylami
Muzaffar 'Ali
Naqdi
Nasir ibn 'Abd al-Jabbar, Khwajah
Riza
Sadiqi
Shah Quli
Shaykh Muhammad
Shaykh Zadah
Siyavush
Sultan Husayn Tuni, Mawlana
Sultan Muhammad
Zayn al-'Abidin

CALLIGRAPHERS

'Abd al-Hadi Qazvini
'Abdi, Mawlana
Ad-Ham of Yazd, Mawlana
'Ali Riza
'Ayshi ibn 'Oshrati
Dust Muhammad
Hakim Rukna
Ibrahim, Mawlana
Ikhtiyar, Khwajah
Kamal Sabzavari, Shaykh
Khalil ibn 'Ali al-Darab Astarabadi
Majd al-Din Ibrahim
Malik Daylami, Mawlana
Malik Muhammad Haravi, Khwajah
Maqsud, Mawlana
Mir 'Ali
Mir Husayn al-Sahvi al-Tabrizi
Mir Ibrahim
Mir 'Imad
Mir Khalilullah
Mir Mansur
Mir Mu'izz al-Din Muhammad
Mir San'i
Mir Sayyid Ahmad
Mirza Ahmad
Muhibb 'Ali
Muhammad Amin 'Aqili
Muhammad Amin Mashhadi
Muhammad Husayn, Mawlana
Muhammad Khandan
Na'im Muhammad al-Husayni al-
Tabrizi
Qazi 'Abdullah of Khoy
Rustam 'Ali
Shah Mahmud Nishapuri

Shahra-Mir Qazvini
Sultan 'Ali
Sultan Husayn Tuni, Mawlana
Sultanum Khanum

Wali Jan
Yulquli Bek Shamlu
Zayn al-'Abidin
Ziya al-Din Muhammad al-Agrahi

Index

Abarquh, 43

'Abbas I, Shah: patron of poetry, 8–9; patron of calligraphy, 10; and Siya-vush, 15, 19, 30, 35, 38, 39, 40, 107; and Sadiqi, 15, 54, 56, 66, 67, 68, 69, 70, 85–86, 100, 106–07, 108, 120, 122, 182, 197, 203; and Riza, 15, 104, 105, 106, 108, 112, 120, 122, 145, 194; summary of political policies, 15–16, 189; and Mahdiquli Khan, 47 n; and Khorasan rebellion, 64, 165, 166, 180; and Habibullah of Savah, 66, 173; policies as patron, 149, 178–85; and Farhad Khan, 174–75; and Khan Ahmad, 177; education of, 178–79; military policies, 183; and Armenians, 193; trade contacts with Europe, 193; commercial policies, 193, 195; artistic policies, 193–95; and 'Ali Riza, 194; taste for single-page paintings and drawings, 195

'Abbasnamah, 70

'Abd al-'Aziz: scandal surrounding, 11, 200 n; Sadiqi's description of, 73; relationship with Shah Tahmasp, 153; teacher of Muhammad Isfahani, 162, 214

'Abd al-'Aziz Khan Uzbek, 175

'Abd al-Ghafur, Mawlana, 61

'Abd al-Hadi Qazvini, 153 n

'Abd al-Jabbar, 177, 186, 192

'Abd al-Samad, 7, 191

'Abdi, Mawlana, 153 n

'Abdullah Khan Uzbek, 176

'Abdullah Shirazi, 20, 162, 214

Abu'l-Fazl, 9

Abu'l-Ma'sum Mirza, 178, 190; possible patronage of, 169–70

Abu Talib ibn Mirza 'Ala al-Dawlat, 28–29

'Adeli. See Isma'il II

Ad-Ham of Yazd, Mawlana, 172

Afshars: origins, 1; Sadiqi not member of, 55 n; rebellion of (against Shah

Muhammad Khodabandah), 64

'Ahdi, 45

Akbar (Mughal emperor), 12

Aleppo, 45

'Ali Asghar, 79, 122, 152 n, 162, 200 n; scandal surrounding, 11; and 1576–77 Shahnamah, 20, 57; father of Riza, 104–05; 152 n; career and works, 213–14

'Ali ibn Abi-Talib, 1, 197–98

'Ali Khan, 172

'Ali Khan Mirza, 61

'Ali Quli Jabbahdar, 198

'Ali Quli Khan Shamlu, 64, 66, 166, 173, 174, 178–79

'Ali Riza: Shah 'Abbas's high regard for, 67, 69, 70, 194, 195; Sadiqi's enmity with, 67–70; serves under Farhad Khan, 174

Allahvardi Khan, 180, 181

Amasiya, Peace of, 159

Amir Khan Mawsillu: and Sadiqi, 58–60, 85, 90, 192, 197

Anvar-i Suhayli (1593): 67, 149; description and analysis of, 125–42

Aqa Hasan Naqqash Haravi, 173–74

Aqa Mirak, 59, 151, 190, 196; compared with Siyavush, 26; compared with Sadiqi, 41; boon companion of Shah Tahmasp, 153; career, 156, 157

Arasbar, 171

Armenians, 193

Art history, Safavi interest in, 199–200

Asad, Mawlana, 59

Astarabad, 171; battle of, 56, 64; city of, 64–65

Autobiography: importance of in Sadiqi's writings, 41–42

'Ayshi ibn 'Oshrati, 155

Babur (Mughal emperor), 43, 178, 200

Badi' al-Zaman Mirza, 54, 168

Badr: son of Mawlana Nami, 48–49

Badr Khan Afshar, 64

Baghdad, 45

Bahram Mirza, 6, 187; father of Ibra-
him Mirza, 150; as patron, 152, 167;
replaced as governor of Khorasan,
163; Sadiqi's description of, 167;
brother of Sultanum Khanum, 170
Baqi Chelebi, 45
Bihzad, 41, 68, 152 n, 182, 198; in
Tabriz, 3; compared with Sadiqi, 41;
Sadiqi's respect for, 50; and work in
Metropolitan *Mantiq al-Tayr,* 184
Biography: increasing significance of,
41–42
Bureaucracy: its patronage of art, 195–
96
Burji: role in *1576–77 Shahnamah,* 20,
57, 162; analysis of works, 213

Calligraphers, emigration of, 9–13, 14
Calligraphy, patronage of, 9–10, 191
Chaghatay Turkish, 43
Chaldiran, battle of, 2

Deccan: emigration of Iranian artists
to, 7, 8, 10
Diwan of Hafiz (*1593*): 182–83, 184
Dust Muhammad, 41, 170, 198 n, 199,
200

Fahmi. *See* Muhammad Khodabandah
Farhad Khan Qaramanlu, 67, 174–75,
180
Farrukh Bek: brother of Siyavush, 19;
retirement in Shiraz, 19; under pa-
tronage of Shah Isma'il II, 20, 162;
under patronage of Hamzah Mirza,
168
Fatima: sister of Shah Tahmasp, 60
Fayzi, 9
Faza'i of Hamadan, 47

Garmrud, 171
Garshaspnamah (*1573*): 57, 162, 197,
201; analysis of work of Muzaffar
'Ali and Sadiqi in, 75–77
Ghani Lahiji, Mawlana, 178
Gharibi Kashi, 64
Ghazali, Mawlana, 12, 73
Ghazi Garay Khan Uzbek, 176
Ghiyath Naqshband, Khwajah, 65
Ghulams, 181
Gilan, 168, 176, 177, 191, 192, 193;
Sadiqi in, 61–64

Habib al-Siyar of Khwandamir (*1579*):
Siyavush's work in, 28, 30; Sadiqi's
work in, 60–61, 85
Habibullah of Savah, 66, 173, 179, 190,
192; work in Metropolitan *Mantiq
al-Tayr,* 184
Hafiz-i Sabuni, 47
Haft Awrang of Jami, Freer, 6, 20, 52,
151, 190, 191; its calligraphers and
painters, 151–58
Hakim Rukna, 11, 153
Hakim Shifa'i, 9
Halaki Hamadani, Mawlana, 58–59
Hamadan, 85, 90, 192, 197; Sadiqi re-
sides in, 58–60
Hamti Isfahani, 172
Hamzah Mirza 173 n, 190, 191; patron
of Siyavush, 18, 19, 30, 196; as heir
apparent, 166, 168, 179; patronage,
167, 168–69; murdered, 180
Hasan 'Ali, 18
Hasan Mirza, 165, 168
Hasan Muzahhib, Ustad, 19 n, 20, 162,
200 n; Sadiqi's description of, 73–74
Hatim Bek Ordubadi, 180, 183
Hatim Tayy, 175, 176
Haydar 'Ali, 50, 152 n
Haydar Mirza, 160, 168, 177
Herat, 3, 64, 66, 164, 167, 178, 179,
182
Humayun (Mughal emperor), 7, 8, 9,
170
Husayn Bayqara, Sultan, 182
Husayn Bek, 13
Husayn Bek Yuzbashi, 168, 177
Husayn Khan Shamlu, 173, 179, 192,
193
Husayn Mirza, 168

Ibrahim, Mawlana, 13
Ibrahim 'Adil Shah II, 10
Ibrahim Mirza, 6, 77, 152 n, 162, 167,
168, 176, 178, 190, 191, 193, 199; as
patron of Freer *Haft Awrang,* 13,
151–57; Sadiqi's description of, 52,
158; birth, 150; education, 150–51;
political career, 151, 157; patronage,
153–58; death of, 158; patron of 'Ali
Asghar, 213; patron of 'Abdullah
Shirazi, 214
Ikhtiyar, Khwajah, 166–67
Imam Riza, shrine of (Mashhad): 'Ali
Riza's inscriptions for, 70; Ibrahim

Mirza superintendent of, 151
India, 6–12, 13, 170, 191, 199
Intermarriage: of families of Safavi artists, 152–53
Iran: political history under Safavis, 1–6, 13–15, 158–61, 163–66, 178–81; emigration of artists and poets, 6–12
Isfahan, 15, 16, 171, 172, 181, 182, 190, 191, 192, 193, 197
Iskandar Khan Afshar, 64
Isma'il I, Shah, 161, 183; reign and policies, 1–3
Isma'il II, Shah, 6, 14, 100, 152 n, 168, 169, 170, 177, 189, 191, 212, 213; patron of Mir Sayyid Ahmad, 10–11; patron of Siyavush, 19; patron of *1576–77 Shahnamah*, 20–28; and Ibrahim Mirza, 52; and Mirza Salman, 52–53; patronage, 57, 77–79, 153, 158–63; and Hasan Muzahhib, 73; dispersal of his *kitabkhanah*, 107; history of reign, 158–61; his poetry, 159, 160; Sadiqi's description of, 159, 160, 161; drug addiction, 160, 161; murder of relatives, 161; attack on Safavi political structure, 161; possible Sunni inclinations, 161; death of, 161; rivalry with Muhammad Khodabandah, 164, 165; political policies, 195; patron of Naqdi, 206; of 'Ali Asghar, 213; of 'Abdullah Shirazi, 214; of Muhammad Isfahani, 214
Ismi Khan Shamlu, 173
Istanbul, 152 n, 177

Jahangir (Mughal emperor), 68–69, 198; and Hakim Rukna, 11
Jahi. *See* Ibrahim Mirza
Jalal al-Din Muhammad, 68
Jamshid Khan, 62
Jangnamah, 70
Jani, 59

Kamal Sabzavari, Shaykh, 153 n
Kami, Mawlana, 64
Karbala', 45–46
Kashan, 213
Khalil ibn 'Ali al-Darab Astarabadi, 172
Khalil Mirza Shahrukhi, 68
Khalil Zargar, 62
Khamsah of Nizami: *1539–43* British

Museum copy, 79, 154, 156; *1572–81* Morgan Library copy, 171–72
Khan Ahmad, 162, 168, 186, 191, 192, 193; Sadiqi's description of, 62; political career, 176–77; patronage, 177–78
Khan 'Alam, 68–69
Kharqah-i Namah for Shah 'Abbas, 69–70
Khayr al-Nasa' Begum, 165, 170 n, 173; murder of, 58; political policies of, 195
Khodabandalu, 43
Khorasan, 66, 172, 180, 181, 190, 192, 197; Isma'il Mirza (governor), 159; Muhammad Khodabandah Mirza (governor), 163–64; rebellion in, 166; 'Abbas Mirza (governor), 178–79

Mahdiquli Khan, 46
Mahmud Khan, 177
Majd al-Din Ibrahim, 170 n
Majma' al-Khawass, 66, 67, 77; discussed 70–74
Malik Daylami, Mawlana, 150, 151, 152–53 n, 163; career, 154–55; calligrapher for Qazi-yi Jahan, 171
Malik Muhammad Haravi, Khwajah, 167
Mantiq al-Tayr of 'Attar: Metropolitan Museum copy, 184
Manuscripts: decline in royal patronage of, 150, 196
Maqsud, Mawlana, 10
Mashhad, 70, 152, 162, 163, 176, 193; home of Mir Sayyid Ahmad, 10; Ibrahim Mirza (governor), 151; Shrine of Imam Riza, 151, 174; production of Freer *Haft Awrang* in, 152, 154–57; Shah Mahmud Nishapuri retires in, 154
Masjid-i Shah, Isfahan, 194, 195
Masjid-i Shaykh Lotfallah, Isfahan, 194
Ma'sum Bek Safavi, 168
Mazandaran, 176, 192; Sadiqi in, 61–64
Mihrab, 162; and *1576–77 Shahnamah,* 20, 57; his works, 213
Mir 'Ali, 9, 70, 155, 199; and Muzaffar 'Ali, 51
Mir 'Aziz Kamanchahi, 59–60
Mir Haydar Kashi, 64

Mir Husayn al-Sahvi al-Tabrizi, 86 *n*
Mir Ibrahim, 59
Mir 'Imad: and 'Ali Riza, 67 *n;* scribe of *1573 Garshaspnamah,* 158; serves under Farhad Khan, 174
Mir Khalilullah, 10
Mir Mansur, 9
Mir Muhammad Aywaghali: lampooned by Sadiqi, 72; qurchi of Hamzah Mirza, 168
Mir Muhammad Mu'min Astarabadi, 168
Mir Mu'izz al-Din Muhammad, 187
Mir Musavvir, 152 *n,* 153, 156, 196; moves to India, 7
Mir Muzaffar Yazdi, 30 *n*
Mir Qurbi, 43
Mir San'i, 47–50, 72, 79
Mir Sayyid Ahmad, 10–11, 153, 163, 175, 192
Mir Sayyid 'Ali, 73, 142, 152 *n,* 156, 191; moves to India, 7; career in Iran, 11–12; Sadiqi's description of, 12
Mirza Ahmad, 167
Mirza 'Ali, 50, 152 *n,* 186, 196; compared with Siyavush, 28; his single-page drawings and paintings, 86; Sadiqi's artistic debt to, 90; career, 156, 157; probable teacher of Naqdi, 206; probable teacher of Murad Daylami, 212
Mirza Salman, 52–53
Mughals: as patrons, 7, 8, 9, 10, 11, 14; Shah 'Abbas's contacts with, 181
Muhammad 'Ali, 198
Muhammad Amin 'Aqili, 173
Muhammad Amin Mashhadi, Mawlana, 10
Muhammad Bek Amani, 65
Muhammad Bek Khalifat al-Kholafayi: Sadiqi's description of, 172–73
Muhammad Haydar, 200
Muhammad Husayn, Mawlana, 163
Muhammad Husayn, Mirza, 9
Muhammadi, 66, 174 *n*
Muhammad Isfahani, 73, 162; and Shah Isma'il II, 20; career and works, 214; Sadiqi's description of, 214
Muhammad Khandan, 155
Muhammad Khan Sharaf al-Din Oghli Tekkelu, 173, 174 *n*

Muhammad Khodabandah, Shah, 6, 15, 173, 177, 189, 192, 197; and Mirza Salman, 52–53; does not complete *1576–77 Shahnamah,* 57–58, 85; his wife murdered, 58; rebellion of Afshars and Shamlus against, 64; neglects *kitabkhanah,* 107; as governor of Khorasan, 159, 163–64; history of reign, 163–66; poetry of, 164, 165; Sadiqi's description of, 166; patronage, 166–67; deposed, 180
Muhammad Munshi, Mirza, 163
Muhammad Pasha, 45–46, 49; Sadiqi's description of, 45–46
Muhammad Qasim, 198
Muhammad Yusuf, 198
Muhammad Zaman, 108
Muhibb 'Ali, 52; and Freer *Haft Awrang,* 152–53
Muhtasham, 6–7, 186
Mu'in Musavvir, 198, 201
Mulla Ghururi, 186
Mu'min Husayn, Mawlana, 65 *n*
Murad Bek: Sadiqi's description of, 54
Murad Daylami, 162; and *1576–77 Shahnamah,* 20, 57; career and works, 212
Murad Khan, 10, 192; Sadiqi's description of, 61–62
Muraqqa', 69, 185, 187, 199
Murshid Quli Khan Ustajlu, 179–80
Murtaza Quli Khan, 64
Mustafa 'Ali, 200
Mustafa Mirza, 64; Sadiqi's description of, 53
Muzaffar 'Ali, 21, 22, 26, 28, 73, 150, 151, 152, 156, 157, 158, 162, 196; teacher of Siyavush, 17, 19; compared with Sadiqi, 41; Sadiqi's respect for, 49; summary of career, 50; as teacher of Sadiqi, 50–52; Sadiqi's description of, 51; Sadiqi's attitude toward, 72–73; as possible director of *1576–77 Shahnamah,* 79

Na'im Muhammad al-Husayni al-Tabrizi, 126
Najaf, 45–46
Nami, Mawlana, 48–49
Naqdi, 162; and *1576–77 Shahnamah,* 20, 57; career and works, 206
Nasir ibn 'Abd al-Jabbar, Khwajah,

162, 168, 177, 192; under patronage of Shah Isma'il II, 20
Nizam Shah, Sadiqi's description of, 7
Nur al-Din, 170
Nur al-Din Muhammad, 64
Nur Kamal family, 172

Ottomans, 183, 191; as patrons, 13; Safavi conflicts with, 159; *1584* invasion of Iran, 179; embassy to Shah 'Abbas, 181

Painters: emigration from Iran, 11–13, 14; disturbed personalities among, 200 *n*
Panahi, 59
Pari Khan Khanum, 52, 160, 170 *n*
Poets: emigration from Iran, 6–13, 14

Qahqahah, 159, 160
Qa'in, 151
Qamati Gilani: lampooned by Sadiqi, 72
Qandahar, 168
Qanun al-Suvar: discussed 70–72. *See also* Sadiqi
Qarrad, profession of, 145
Qasim 'Ali, 13
Qasim Bek Sehaf, 74
Qasim Kahi, Mawlana, 8
Qazi 'Abdullah of Khoy, 167
Qazi-yi Jahan, 170, 183; possible influence on Safavi painting, 5–6, 171; Malik Daylami serves under, 154–55
Qazvin, 9, 10, 66, 166, 171, 176, 179, 186, 190, 191, 197; Mir Sayyid Ahmad recalled to, 11; Muhibb 'Ali recalled to, 153; Malik Daylami recalled to, 155; palaces of the Dawlatkhanah and the Chehel Sotun in, 155; garden of Sa'adatabad in, 155, 163; Ibrahim Mirza recalled to, 157; political turbulence in, 160; manuscripts produced in during reign of Shah Muhammad Khodabandah, 167; Morgan *Khamsah* produced in, 172; accession of 'Abbas in, 180; no longer capital, 181
Qazvin style in painting, 26, 86–90, 182, 201, 206
Qilich Bek, 46
Qiwam al-Din Baghdadi, Ustad, 73
Qizilbash, 159, 160, 189, 192; rivalry with Tajiks, 3, 160; murder of Khayr al-Nasa' Begum, 165; rebellion in Khorasan, 179–80; persecution of by Murshid Quli Khan, 180
Qum, 173

Rahi. *See* Muhammad Isfahani
Rashid al-Din, 185
Rashki, Mawlana, 59
Rayy, 171
Riza, 152 *n*, 183, 198, 200 *n*, 201–02; summary of career, 15, 197; compared with Siyavush, 32, 35, 38, 202; and Sadiqi, 66, 100–04, 106, 108 *n*, 114, 117–25, 126, 129, 132, 147; and Shah 'Abbas, 100, 107, 194–96; variations on his name, 100 *n;* aesthetics of his painting, 101; Qazi Ahmad on, 104–05; and 'Ali Asghar, 104–05, 213; Iskandar Munshi on, 105; anonymous follower of, 108, 122; and *1587–97 Shahnamah,* 108–17; prolific in single-pages, 144–45; and c. *1595 Qisas al-Anbiya,* 144–45; character, 149
Rustam 'Ali, 52, 150, 152

Sabk-i Hindi, 9
Sabzavar, 151, 167
Sadiqi, 153, 162, 183, 191, 192, 197, 199, 200; summary of career, 15; his literary works, 41, 42, 70–74; autobiographical materials, 41–42, 70–74; Iskandar Munshi on, 42; Qazi Ahmad on, 42; youth, 42–43; member of Khodabandalu, 43, 55 *n;* military pursuits, 44; travels in Ottoman empire, 45–46; pilgrimage to Karbala' and Najaf, 45–46; early artistic career, 47; and Mir San'i, 47–50, 72; and Muzaffar 'Ali, 50–52, 72–73; and Ibrahim Mirza, 52, 158; sarcasm, 52–54, 72–74; and Shah Isma'il II, 57, 159, 160, 161; and *1576–77 Shahnamah,* 57–58, 77–85; in Hamadan, 58–60, 85; and *1579 Habib al-Siyar,* 60, 85; travels in Iran, 61–66; in *kitabkhanah* of Shah 'Abbas I, 66–70, 107–08, 143–44, 182; and *1573 Garshaspnamah,* 75–79; qualities of his art, 80, 86, 90, 94, 122, 144, 147, 149, 200–02; influenced by Siyavush, 80–85; influenced by Riza, 85, 101–04, 106,

Sadiqi (*continued*)
 108 *n*, 114, 117–25, 126, 147, 201–
 02; single pages, 86–94, 147, 187;
 and *1587–97 Shahnamah*, 106–08,
 117–25, 147, 182; and *1593 Anvar-i
 Suhayli*, 125–42; and Shah Muham-
 mad Khodabandah, 166
Sa'di Quds Sarah, Shaykh, 65
Safi al-Din, Shaykh: founder of Safa-
 vis, 1
Safi Mirza, 72
Sahabi, Mawlana, 46, 49
Salim al-Anami, 172 *n*
Sam Mirza, 167, 200
Shah Jahan, 198
Shah Mahmud Nishapuri, 153 *n*, 186;
 career, 152–53
Shahnamah of Firdausi, 12 *n*
—Houghton copy of, 12 *n*, 79, 122,
 151, 156, 157
—*1576–77* copy of for Shah Isma'il II,
 20, 206, 212, 213, 214; Siyavush's
 work in, 21–28; Sadiqi's work in, 77–
 85
—c. *1587–97* copy of for Shah 'Abbas
 I, 66, 106–25, 183, 185, 201–02, 213;
 Sadiqi's work in, 106–08, 117–25,
 147, 182; Riza's work in, 108–17,
 201–02
—*1430* copy of for Baysunghur Mirza,
 184
—*1614* copy of for Shah 'Abbas I,
 184–85
—*1586* copy of, 212–13
Shah Quli, 13
Shahquli Sultan, 54, 178
Shahra-Mir Qazvini, 153 *n*
Shah Rukh, 183
Shah Vali, 59
Shamlu, 1, 43, 64
Sharaf-i Jahan, 6 *n*
Shaybani Khan, 2
Shaykh Muhammad, 20, 50, 86, 153 *n*,
 156, 157, 162, 206
Shaykh Zadah, 13, 175, 176
Shi'ism, 1, 170
Shiraz, 17, 19, 30 *n*, 192
Shirvan, 171
Sifat al-'Ashiqin of Hilali, 172 *n*
Signatures: problem of authenticity of,
 24 *n*; proliferation of in sixteenth
 century, 41, 198
Simnan, 174

Single-page paintings and calligraphies,
 154; development of as art form, 86,
 185–88; increase in importance of,
 150. *See also* Riza; Sadiqi; Siyavush
Sistan, 168
Siyavush, 153, 162, 190, 196, 197, 201–
 02; summary of career, 15; Qazi
 Ahmad on, 17; Iskandar Munshi on,
 17; youth, 18; training under Hasan
 'Ali, 18; serves under Shah Tahmasp,
 18–19; brother Farrukh, 19; training
 under Muzaffar 'Ali, 19; serves under
 Shah Muhammad Khodabandah, 19;
 retirement in Shiraz, 19; serves un-
 der Shah Isma'il II, 19, 20–28; serves
 under Shah 'Abbas I, 19, 30, 32, 38,
 40, 107; associated with Hamzah
 Mirza, 19, 30, 169; and *1576–77
 Shahnamah*, 20–28, 57, 77; and *1579
 Habib al-Siyar*, 28–29, 30 *n*, 60;
 drawings by, 30–38, 86; influence on
 Sadiqi, 80–85; compared with Naqdi,
 206
Sulayman, Sultan, 159
Sultan 'Ali, 51
Sultan Husayn Tuni, Mawlana, 174
Sultan Muhammad, 152 *n*, 153, 156,
 196; compared with Siyavush, 28;
 signed work, 41; compared with
 Sadiqi, 41, 122
Sultanum Khanum, 170–71
Sunnism, 1, 161

Tabriz, 1, 42, 49 *n*, 66, 74, 171, 190
Tahmasp, Shah, 77, 150, 156, 159, 161,
 168, 176, 178, 183, 187, 189, 190,
 191, 192, 199, 200; policies, 3–4;
 character, 3–5; interest in painting
 and calligraphy, 3–6, 153, 194, 195;
 as patron of Siyavush, 18–19, 196,
 197; and Humayun, 170; and Sul-
 tanum Khanum, 170
Tajiks, 60, 160; uneasy relations with
 Qizilbash, 3, 160; as patrons, 60,
 171–72; increased power under Shah
 'Abbas, 181
Tekkelu, 58, 64, 167
Timurid revival, 182–85, 195
Timur Khan, 62 *n*
Turbat-i Zava, 167
Turcomans, 1
Turkman, 58, 64

Turkman, Mawali, 53
Turkman, Mawlana, 168

'Ubayd Khan Uzbek, 175–76
Uzbeks, 3, 181, 183, 191; as patrons, 13, 175–76

Wali Jan, 13

Yazd, 65–66

Yulquli Bek Shamlu, 66, 74, 174, 179
Yusuf Khan ibn Quli Bek Afshar, 172

Zayn al-'Abidin, 152 n, 162, 170 n; and 1576–77 Shahnamah, 20, 162; and 1573 Garshaspnamah, 57; and 1587–97 Shahnamah, 106; and Shah 'Abbas, 107; careers and works, 212–13
Ziya al-Din Muhammad al-Agrahi, 60